Issue | 142

RADICAL HISTORY *Review*

Visual Archives of Sex

Visual Histories of Sex

Collecting, Curating, Archiving

Heike Bauer, Melina Pappademos, Katie Sutton,
and Jennifer Tucker

Today, a growing number of scholars are placing images and visual practices at the center of critical historical inquiries of sex and sexualities—a response both to changes of historiography and to increased access to visual archives and the proliferation of digitized images related to sexuality in recent years. At the convergence of multiple historical fields, a new body of critical histories of sexual desire, subjectivity, embodiment, and power is transforming the boundaries of historical interpretation—providing new temporal and geographical frames for investigating the historical relationships of sex and visual production, generating radical new lines of historical inquiry, and reshaping visual and queer studies.[1]

The contributors to this issue ask: What new questions and challenges for the study of sex and sexual science are posed by critical studies of the visual? How are new historical and visual methodologies changing the contours of knowledge about the politics of sex and sexuality in the past? What—and where—are new methodologies still needed?

To begin to untangle some of these questions, "Visual Archives of Sex" aims to illuminate current research that centers visual media in the history of sexuality and interrogates contemporary historiographies. The contributions to this issue attend to the visual to complicate historical understanding of sexuality and the histories of sex that constitute knowledge of the past. If "queer things cannot have

Radical History Review
Issue 142 (January 2022) DOI 10.1215/01636545-9397002
© 2022 by MARHO: The Radical Historians' Organization, Inc.

straight histories," as Daniel Marshall, Kevin P. Murphy, and Zeb Tortorici have argued in their analysis of queer archives and archiving, then the history of "sex" itself is arguably the queerest thing of them all.[2] Spanning a wide range of phenomena—from bodies, desires, and sexual practices to the affective, social, and political vicissitudes of identity—sex is a queer subject for historians because it has no straightforward archival presence. Its imprint on the past can be found in a wide range of sources associated with social and cultural history, the history of science, medicine and technology, material history, and the history of ideas. It intersects with histories of gender, race and racism, class, and disability and is concerned with the production and experiential realities of sexual lives, ideas, and bodies, and their affective reach.

A New Visual History of Sexuality?

Visual analysis has come to play a significant role in a number of areas of radical inquiry, including fields cognate to the history of sexuality, such as histories of science and medicine, slavery, and the body.[3] Despite the proliferation of recent curatorial work on gender and sexual histories, however, many historians of sex have yet to engage fully with new visual methods and archive theories. Initially, at least, the history of sexuality as a field was constituted primarily as a history of words and discourses, influenced by Michel Foucault's critique of the discursive production of sexuality in modern Western science.[4] Studies of the emergence of the modern sexual vocabulary in Europe and the United States—terms such as *homosexuality* and *fetishism*—have since generated valuable insights into the formation of collective modes of identification, including in terms of the political gains, necessities, and limits of focusing on issues of taxonomy and a common language of sex.[5]

The interventions of historians working on different regions of the world, in turn, have expanded the geopolitical and temporal frames of investigation beyond Europe and North America to investigate the complex entanglements of Western "sexuality" in colonialism and anticolonialism.[6] Furthermore, scholarship on gender, and especially transgender, has challenged the privileging of sexuality itself in studies of the development of a modern way of thinking about "sex," including in relation to the natural environment.[7] Yet if "the historiography of sexology is young," as Kirsten Leng and Katie Sutton have observed in their recent reassessment of the field, sex itself remains a slippery subject for historians.[8] A site of regulation as much as an expression of intimate desires, sex is both a discursive construct and a deeply experienced reality around which all kinds of social fantasies congeal—a queer temporality that forges ahistorical, anachronistic, and cross-temporal affective connections.

The very question of what counts as sexual "history" is itself contested, not only because of the complexity of the subject but also because of the relationship of sexual pasts to the present day—what critic Elizabeth Freeman calls an

"erotohistoriography" that reaches across time.[9] What counts for some people as sexual history today because it took part before they were born remains part of the lived experience of an older generation whose sexual and political coming of age took place during the second part of the twentieth century. It is a profound critical challenge to acknowledge such different temporal relationships to the present without falling back onto Enlightenment chronologies of (sexual) progress. Furthermore, classification schemes for databases, which are hierarchical in nature, "don't do well" with the "unfixedness" of social identities.[10]

Sex, Power, Archives

"Archives are not inert historical collections," noted the historian Stuart Hall, adding, "They always stand in an active, dialogic, relation to the questions which the present puts to the past."[11] Archives play an important role in shaping and negotiating both lived histories and access to (and understanding of) the recent and distant past. As what Ann Cvetkovich calls "repositories of feelings," they are also sites of institutional power and manifestations of colonial ordering practices.[12] Historical records relating to sexual matters may be constituted around archives that attest to long histories of oppression and violence. They range from premodern religious doctrine on sexual sin to modern homosexuality trial records, and they cover topics as diverse as the classification of sexual types and behaviors in modern medicine and science and the colonial and racial laws circumscribing love and desire. Yet the issue of the archive concerns not only those that historically have served the church and the nation-state. More fundamentally, the term now encompasses private as well as public collections and, indeed, "unofficial, idiosyncratic, and personal collections of material."[13] Moreover, a focus on a range of media draws our attention to the "sheer heterogeneity of visual archives" in which sexually explicit images occur.[14]

For many historians today, the meanings of these ephemeral "archives of feeling" open up histories of queer resistance and hope, creativity, and pleasure in the face of severe censorship and other restrictions.[15] As Amy L. Stone and Jaime Cantrell observe, "The archive supposedly creates some order and legibility to what was previously hidden and illegible."[16] Archives thus can offer glimpses of the experiential and affective dimensions of lives lived in the past, often in conditions that sought to deny their existence. Unpacking the historical meanings and effects of visual archives of sex also invites us to reflect on the affective and experiential registers of sources that speak in startlingly immediate ways.

Intersectional Frameworks

There is expansive opportunity to speculate within and across visual archives of sex to exhume sites of desire and myths inscribed on sexualized and racialized bodies. Such critical inquiries into visual sex can, potentially, destabilize Western norms,

forms of whiteness, and Euro-centric universalisms, including unseating the primacy of the white male gaze and its attendant violence (both discursive and physical), which fundamentally erase Black, Indigenous, People of Color (BIPOC), especially BIPOC women's, affective lives. Where scholars research the structures and quotidian practices of racial and economic exploitation, visual archives offer an opportunity to challenge narratives of domination and control and to contend with women's and non-white men's lives. Rather than othering racialized populations, casting their desires as diseased and perverse and their bodies consumable (visually and otherwise) for others' pleasure, visual culture can speak to the proliferation among marginalized populations of joy, pleasure, resistance, and the active refusal to accept the erasure of one's own humanity. Decades ago, Audre Lorde spoke to the colonization of women's bodies and disjunctures that violate human needs, in *Uses of the Erotic, the Erotic as Power* (1978): "The principal horror of any system that defines . . . human need to the exclusion of the psychic and emotional components of that need . . . is that it robs our work of its erotic value, its erotic power and life appeal and fulfillment."[17] Through our contributors, this issue argues that visual culture pulls back the curtain on what is visible and who sees, knows, controls, and holds power in everyday relations. That is, we expose some of the tensions that lie between the externally visible and internal processes of thinking.

Visual culture studies have mapped onto Black studies in wonderfully revealing ways. Scholars, such as historical archaeologist Whitney Battle-Baptiste and race and feminsit studies scholar Britt Rusert, have examined antiracism, self-representation, and the politics of seeing to produce excellent work.[18] The collection of images—richly tonal photographs and infographics—demonstrates the sheer depth of analytic force freed by visual landscapes to recover Black experiences. A question is raised as a central concern across several of the issue's contributors: what scholarly terrain in studies of racism/antiracism, Blackness, and self-representation might be tilled using visual archives of sex? The battle over representation and political norms (perversion and control versus agency and desire), through visual interrogatives, signifiers, metaphors, and positionality, shows both the power of looking and how visual archives of sex are always racialized, and vice versa. The visual is a lens onto the human condition—the degree of (in)compatibility between what is externally visible and processes internally felt. Scholars of race, Blackness, gender, and sexuality can use these insights to foreground intersecting identities alongside a long, concomitant history of antiracist activism. Thus, read on a visual plane, Black intimations, desires, and the repudiation of myths of inhumanity and perversion refine and expand our understanding of strategies of resistance. This reconfiguration of historical methods destabilizes racialist narratives, particularly whiteness, revealing that white male supremacy is neither normative nor omnipresent. Further, visual archives can recover multiple proximities between Blackness and sex and their

many paths toward social justice. As rukus! curator, theater director, and filmmaker Topher Campbell posits in this issue, grappling with race and the erotic by archiving visual sex practices is integral to the struggle for racial and sexual justice in the United Kingdom. The mission of the rukus! project, a rich visual archive of Black LGBTQ+ individual and community lives, is to collect, preserve, exhibit, and otherwise make available for the first time to the public, historical, cultural, and artistic materials related to the Black lesbian, gay, bisexual, and transgender communities in the United Kingdom through exhibitions, film screenings, and other events.[19]

More broadly, visual sources are greatly impacting intersectional frameworks of analyses, perhaps because they offer Black studies and intersectional studies so many opportunities to construct histories of intersecting racial and sexuality politics. They can confirm the disjuncture between affective experiences and the images deployed on behalf of power: to control, quantify, and dehumanize. Of course, images are politicized, the meaning of their revelations generally struggled over. Thus scholars must also consider the ways visual culture supports racialization and control within regimes of power, as Derek Conrad Murray comments to Alexis Boylan in this issue:

I have a lingering concern about the overexposure of African descended folks worldwide, who find themselves the subject of a rapacious Western image culture that consumes black bodies for entertainment purposes . . . as an affective visual spectacle. In many respects, that societal thirst—and the plethora of images it generates—is confused for racial progress, because it grants visibility and provides support and pathways to success for a select few. If we look at African-American life as a totality, and not just the elite . . . we obviously see a disjuncture between the deluge of images of black bodies, contrasted by rampant disenfranchisement.

This *RHR* issue, then, engages non-white, antiracist, and feminist ways of "seeing" sexuality that challenge norms and myth making drawn from the apparent meanings of archived images. The methods and theories presented here open new pathways to consider what mutual entanglements exist between Black studies and sexuality analytics. How might they, together, elevate scholarly debates and enrich narratives about style, struggle, and the human condition, particularly those that support social justice movements?

Pornography and Archives

The marginalization of visual histories of sex has at times been facilitated by the large-scale exclusion of such materials from traditional archives, or their relegation into locked cupboards and roped-off areas, such as the British Library's Private Case of erotic printed books from the seventeenth to twentieth centuries (access restrictions have now been removed and the collection fully cataloged).

Even as they "preserve traces of the past," Tim Dean points out, archives are distinguished by "differing degrees of publicness: the more sensitive their holdings the harder they are to access."[20] The Kinsey Institute at Indiana University, for example, represents a rare university archive to collect sexual ephemera, joining dedicated sex museums and other "alternative archives" such as queer and LGBTQ collections, frequently staffed by volunteers, in carrying much of the weight of preserving sexual pasts.[21] For a brief window of time, from the 1940s to the 1960s, for example, prison wardens and guards shipped seized materials to the Kinsey Institute, creating a unique archive of objects that indicate how, as Lisa Z. Sigel shows, prisoners "created and articulated desire, bodies, and pleasures, how they wrote and drew themselves and others, how they plotted and narrated stories, and how they responded to the surveillance that they knew was taking place."[22] Both the erotic and the pornographic have hovered at the margins of the historiography of sexual science, in which research into historical connections with the adult entertainment industry remains in its infancy. This is despite a strong tradition of sexologists' engaging with media and erotica that move beyond the strictly "scientific," whether by publishing in North American erotic magazines such as *Forum* and *Playboy* in the 1970s and 1980s, as Janice Irvine examines,[23] joining the editorial boards of titillating mid-century popular science magazines such as *Sexology* in the 1950s, or going back even further, by turning for evidence to the explicit images and materials circulated in the erotic book trade of the late nineteenth and early twentieth centuries.[24]

Yet the histories of people, bodies, and desires that do not match the norms of their time are not just found in official documents. For this reason, José Esteban Muñoz argues, it is necessary to pay attention to "ephemera of evidence": a method of historical inquiry that "does not rest in epistemological foundations but is instead interested in following traces, glimmers, residues, and specks of things."[25] This includes the need to attend to fleeting, unconventional forms of evidence, while insisting on how even evidence of the erasure of histories of non-normative desires and sexualities can promote productive historiographical reflection.

Digital Technology and Media Histories

New critical approaches to visual materials offer one way of following the often elusive traces of sexual pasts—beyond the sexological frameworks that have come to dominate modern ways of thinking about sex. For example, historian Cait McKinney's queer history of lesbian media technologies coined the term *information activists* to describe a series of social movement organizations and individuals in the United States and Canada "who responded to their frustrated desire for information about lesbian history and lesbian life by generating that information themselves."[26] Late twentieth-century radical feminists, she shows, designed "complex multimedia practices" to circulate information that was difficult—or even impossible—to come

by otherwise. Historicizing feminism and other social movements means explorations with a range of materials and processes—such as community-generated databases, newsletters, and other information—as conditions of possibility. "Queer digital archives built by community groups," McKinney writes, "find ways to maintain traces of how objects were used by activists, such as the high-resolution photographs of actual [cassette] tapes that accompany each streaming audio file produced by the Lesbian Herstory Archives." Digitization in turn changes the kinds of encounters we have with objects because, "quite simply, the different media *feel* different."[27]

Art historians and literary and cultural critics working broadly in the field of queer history have explored how sex entered the archive on a more intimate level via cultural production, as mimetic evidence of something that is lived, experienced, and fantasized about. Here, and in the burgeoning scholarship on transgender, visual materials, including film, photography, drawings, paintings, and other graphic materials, have increasingly come to play an important role in examinations of the material as well as affective realities of archival objects and their role in mediating access to the past and its present-day manifestations. GerShun Avilez's recent study of what he calls the "injury-bound" Black queer body, for instance, tracks the Black queer body's spatiality in the United States through various visual modes, from modes of perception to state surveillance, to reveal the paradoxical simultaneousness of Black American queer invisibility and hypervisibility.[28] A major recent reappraisal of nineteenth-century German sexual science and its legacies, in turn, interrogates the central role of visuality in shaping German sexual identities and the archives formed around them. It develops the notion of "looking through sex" as a methodological tool for revealing histories that have been hidden or overlooked. Yet the phrase *looking through* also means not seeing what is there. The contributors to this special issue pursue the critical pleasure of examining visual materials for evidence of queer and trans life in the past, or tracing histories of sexualized and racialized violence and exploitation in haunting objects as seemingly "innocent" as a glamour shot or swimwear advertisement. But they also reflect on the critical challenges of "seeing" the images as they are and were intended at the point of production.

Attention to such methodological challenges is vital for understanding the knotted visual histories of sex and how they are circumscribed by circumstance, including technological and financial binds that often remain unnoticed—for example, economic and other constraints that require original color images to be reproduced as black-and-white images (as for some color images in this volume). As Derek Conrad Murray points out in this issue, photography is a widely used if not oversaturated means of aesthetic (self) expression. In the history and historiography of sex, however, photography occupies a complex, and to some extent more elite, position. It was established as a technology of (dis)identification at a time when the newly coined modern sexual classifications, especially the vocabulary of same-sex sexuality, started to gain widespread traction. In the West, the coeval development

of modern photography and sexuality intersected in numerous ways. On the one hand, photographs played a diagnostic role in scientific endeavors to categorize sexual types. The influential Institute of Sexual Science in Berlin, for example, which was at the heart of international sex research before World War II, used photographs of individuals to illustrate the theory, first developed by Institute founder Magnus Hirschfeld, of *sexuelle Zwischenstufen*, or the idea that there exists near infinite variation in sex and gender. The institute's use of photographs as evidence is indicative of the normative deployment of photography in the establishment of scientific truth and authority. Yet the sexological turn to photography nevertheless also enabled what we might call a form of queer self-fashioning. Many of the photographic subjects represented themselves in ways that felt appropriate to them, documenting their own self-expression and thus contributing to the development of a particular kind of record of Berlin's sexual subcultures.

While these images indicate some of the productive intersections between medical and sexual subcultures, the deployment of photographs as a diagnostic tool also perpetuated the medical objectification of certain subjects. The institute's pioneering work on intersex, while foundational to the development of a modern understanding of the existence of variation in "sex characteristics," illustrates this point. It visually reduced the subject to a mere body part by training the photographer's lens on the subject's genitals, a reminder that visual materials are not neutral illustrations of certain practices or circumstances. The use of photography in the institute clinic, a space that was overtly dedicated to sexual reform through scientific evidence, reinforces that visual materials cannot serve a merely illustrative role in historical analysis. Instead, historians must pay close attention to the production of images, their context, and the implication of the viewer, historical and contemporary, in meaning production. How, then, to approach visual materials that merge intensely personal and more public displays of sexual identity and desire? How do the questions about access and interpretation that radical histories of sexuality have grappled with in textual contexts shift when our focus moves to visual fragments and archives?

These are difficult questions, and ones that historians have not always answered particularly well. Photographs, as Julia Adeney Thomas observes, have the capacity to "disarm" historians, to "drive us crazy" in the way they "flirt" with the viewer,[29] at once seeming to offer an immediacy of access to the past yet also resisting those attempts at knowledge—what Elizabeth Edwards refers to as their "historical seduction."[30] Are there new ways of looking at, feeling, and even "listening" to the visual to uncover histories that are hidden as well as those in plain sight? Tina Campt has suggested that one might "listen through" seemingly banal or "flat" images; she takes the example of passport photographs of mid-century Black British men migrating from the Caribbean, for example, to see their subjects as much more than "mute supplicants of governmentality."[31] Becoming attuned to their "quiet

frequencies," she proposes, opens windows onto marginalized histories of Black self-fashioning and resistance: of masculinity, respectability, mobility, and citizenship. Attending carefully to such layerings or frequencies becomes especially pertinent when it comes to dealing with erotic images. These, after all, have the potential to open up histories of desire and pleasure, sensuality and the illicit—aspects of the sexual past that have been persistently downplayed in the historiography. "Why are more sexually charged images still so peripheral," Jennifer Evans insists, "considering the enormous potential of these sources in unveiling not only the shape and face of moral panic, but also the more pleasant of human capacities, including intimacy, physical and emotional compatibility, attraction, and desire?"[32] At the same time, inquiring into the role of photographs as historical evidence opens up crucial questions for historiography more broadly. By "exposing the questions we ought to raise about all historical evidence," as Jennifer Tucker and Campt observe, "photographs reveal not simply the potential and limits of *photography* as a historical source, but the potential and limits of *all* historical sources and historical inquiry as an intellectual project."[33] While the visual archives examined in this issue are not limited to lens-based images, these reflections provide a suitable frame of reference for thinking about the value of turning in earnest to visual sources in expanding our knowledge of sexual pasts. Indeed, some of the most exciting methods and approaches to the study of photography in visual archives of sex may come not from the direction of history and theory of photography, or even from art history, but from social and cultural historians attending to what people in different times and places made and consumed, bought and circulated, preserved, and discarded.[34]

Overview

The contributions to this special issue present a series of fresh, theoretically engaged contributions to the visual history and historiography of sex. They highlight the complex circulations and changing meanings of visual media for different audiences over time and ask, often in very different ways, how images help us arrive at more critical and radical histories of sex.

In the opening roundtable, "Curating Visual Histories of Sex," four curators of recent exhibitions that focused on sexuality, queer, and trans experience reflect on the dynamics and challenges of showcasing sexual histories to broad publics in museum and gallery spaces. They emphasize the rich collaborations with trans and queer activist communities that informed their approaches, while also reflecting frankly on ongoing tensions around who has the capacity to represent histories of nonnormative gender and sexual experience, and how. These discussions point to the shifting parameters of viewership across time, and across generational divides in the present, with viewers of different ages bringing to their exhibition experience very different histories of encounter with the medical profession, political activism, or racial discrimination, to name only a few relevant positionalities. The experience

of younger viewers critical of the representation of trans surgeries in the traveling exhibition *TransTrans: Transatlantic Transgender Histories*, Annette Timm reflects, thus sat in tension with the responses of older trans people for whom the exhibition prompted the sharing of personal memories, reflections, and images. Jeanne Vaccaro, curator of *Bring Your Own Body*, also explicitly sought ways of telling stories such as that of activist Chloe Dzubilo for a new generation, forging connections between her historical struggles and "contemporary movements for housing justice, transgender liberation, and AIDS organizing." Together with Meg Slater from the curatorial team behind *Queer*, a critical revisiting of the collection at the National Gallery of Victoria, Australia, and Ashkan Sepahvand, curator and artistic director of *Odarodle*—an explicitly "postcolonial perspective" on the collection in the Schwules Museum (Gay Museum) in Berlin—they reflect on how visual materials enable the telling of different kinds of sexual histories in ways that resist pathologization, sensationalism, and appropriation, and the unique experiential and affective encounters made possible for visitors within the exhibition space.

The four feature essays explore visual archives and the ways in which they shape radical histories of sexuality across contexts, ranging from the post–World War II militarized Pacific to a mid-century British murder trial, and from photographs of transwomen in late Franco-era Spain to East German homemade gay pornography. In "Bikinis and Other Atomic Incidents," Sunny Xiang arrives at the question of visual archives via swimsuit advertisements and synthetic fabrics, showing how figures such as the white, female "bikini blonde" functioned as hypervisual iterations of "atomic culture." The radical swimwear's "exotic geographic referent," the Bikini Atoll, worked to subtly legitimize US atomic power and racialized militaristic imperialism in the mid-century nuclear Pacific. It did so in ways that were not so much invisible, as previously argued, but rather "conspicuously incidental," while advertising for new synthetic fibers and intimate foundation wear worked to simultaneously introduce American society to an "atomic" vocabulary and to promote cold war values—"freedom, comfort, and protection"—among the American public.

The complex overlaying of white, blonde, female sexuality with difficult histories of violence, domination, and victimhood connects Xiang's analysis to art and visual historian Lynda Nead's examination of photographs of Ruth Ellis, the last woman hanged in Britain, in 1955, for murdering her male lover following years of domestic abuse. Nead's feminist visual analysis teases out how the meanings of photographs of the glamorous, sexy, socially aspirational, and working-class model and nightclub hostess frequently exceed that which is directly pictured. These photographs, reproduced innumerable times as they circulated through the world press, raise important questions around gender and sexuality and how these traversed mobilities constrained or enabled by class, respectability, criminality, and whiteness. "A Bruise, a Neck, and a Little Finger" homes in on a series of amateur glamour

shots taken in Ellis's flat, provoking us to reflect on the ways in which sex and desire might be considered to be "in" the archive—how we look for it, and when we believe ourselves to have found it—as well as what these photographs might tell us about women's lives in postwar Britain.

A similar challenge to how historians approach visual archives emanates from Javier Fernández Galeano's thoughtful exploration of "The Hermeneutics of Trans Visual Archives in Late Franco-Era Spain." Galeano homes in on the "running mascara" evident on police mugshots of working-class trans women in the early 1970s. At a time of sharp legal discrimination, these photographs are contrasted with more personal images and documents created, like Ellis's, in both more quotidian and intimate settings. Drawing on the existential significance of visibility theorized in recent trans scholarship, Galeano "listens" to these vernacular photos for the "fissures" between state narratives and individual subjectivity to situate them as "material performances" of trans subjectivity. Rather than simply illustrating the effects of state-sanctioned transphobic violence, he reads these visual archives for the way they very deliberately celebrate "joy, sisterhood, and intimacy as tenets of a livable life."

The capacity of visual archives, often quotidian and handmade, to offer access to hidden histories of pleasure and sensuality in the face of restrictive political structures is likewise central to Kyle Frackman's analysis in "Homemade Pornography and the Proliferation of Queer Pleasure in East Germany." Gay erotica produced under 1970s state socialism blended visual genres and registers—amateur snapshots taken in living rooms and bedrooms sit alongside cut-outs from commercial porn magazines—and were circulated and recirculated through underground queer networks. Frackman offers a queer lens on sex in socialist East Germany, showcasing "a clandestine yet joyful" gay sexual culture, in a time and place in which the private realm took on heightened significance for self-expression. Such images represent precisely the kind of "sexually charged" sources that, as noted above, scholars like Jennifer Evans urge historians of sexuality to take more seriously, with a view to telling histories of desire and celebration rather than just repression or violence.

Community initiatives such as "living archives" are often places of resistance to historical erasure and injustice. This is the case with the rukus! archive project: a rich visual archive launched in London in 2005 by photographer Ajamu X, and filmmaker and theater director Topher Campbell, whose conversation with artist-scholar Conor McGrady is featured in this issue. The archive's mission is "to collect, preserve, exhibit, and otherwise make available for the first time to the public historical, cultural, and artistic materials related to the Black lesbian, gay, bisexual, and transgender communities in the United Kingdom through a variety of activities and events (exhibitions, film-screenings, oral history work, presentations, etc.)."[35] With intellectual origins in the work of Stuart Hall and British cultural studies more

generally, the project establishes a critical dialogue both with mainstream heritage practices and dominant Black and queer identity discourses. For as its cofounders Ajamu X and Campbell point out, sifting through the past to recover "what isn't there but was" can be an act of "collective rebellion": it constitutes a form of "queer archive activism," defined by Alexandra Juhasz as "a practice that adds love and hope to time and technology."[36]

Campbell and Ajamu X hold up the collection as a deeply political project: a strategy for invisibilized Black British LGBTQ+ communities and a riposte to the way in which white mainstream straight and LGBTQ+ cultures actively erase Black queer communities in the UK, the rukus! archive is foundational to self-representation, to seeing, and to being seen, for these communities. The archives are important not least because sexual minorities use them as "a form of cultural memory"; the archive holds the potential for identifying, preserving, and interpreting the traces of subjugated knowledges, and to research on what are sometimes known as "migrant archives," counterarchives, and queer archives.[37]

A second set of essays and interviews also reflects on the themes of this issue. David Serlin's conversation with "queer Latinx medievalist" and art historian Richard Betancourt on Byzantine art and sexuality leaps back across the centuries to consider representations of the sexual in early Christian iconography. Betancourt's method of close visual analysis resists the "normative filters—both methodological and ideological" that have shaped dominant interpretations of well-known works. Doing so enables him to access a greater complexity, even a fundamental queerness, to past negotiations of sex than historians have tended to acknowledge. Canonical depictions of Mary's Annunciation, for example, frequently brush aside discussions of "consent" based on the presentist assumption that such a thing did not yet exist. Seeing queerness in the medieval archive, Betancourt argues, means "disorienting and disabling" those filters, looking closely, and remaining open to the possibility of surprise.

Two reflective essays then explore, first, how and why pornographic visual cultures seem to pose such problems for queer historiography and, second, the challenges and dynamic richness of engaging closely with images in the space of the university classroom. In "Sexing the Archive: Gay Porn and Subcultural Histories," João Florêncio and Ben Miller confront the frequent reluctance of historians of queer lives and sexualities to delve into sexually explicit sources, or to see them as integral to histories of queer politics. Pornography's dual status as both documentary and fantasy certainly complicates its use as historical evidence of affect and intimacy—not least by implicating the bodies and emotions of historians themselves. Yet to ignore such sources, these authors insist, "threatens queer history by writing sex out of it." Sarah Jones, too, confronts the value of embracing rather than avoiding such sources. In "Teaching the History of Sexuality with Images," she explores how

using visual objects in the classroom can break open feelings of awkwardness and embarrassment to enable more radical speculation, personal discovery, and debate: debate about what constitutes an archive, what is left out, and how to critically navigate materials with the potential to shock, offend, or perpetuate individual or collective traumas or exploitation.

Bookending this "Reflections" section, Alexis Boylan's wide-ranging discussion "The Cost of That Revealing" with artist and scholar Derek Conrad Murray extends from the social inequalities highlighted by COVID-19 and the Black Lives Matter campaign to the ubiquity and politics of the selfie—including the work, featured in this issue, of former student Vivian Fu—the increasing neoliberalism of the university sector, and Murray's critical reappraisal of photographer Robert Mapplethorpe's Black male nudes in his new book *Mapplethorpe and the Flower*.[38] Like Betancourt, Murray emphasizes the need to resist the "noise" of conventional readings to work toward a deeper, more usable approach to visual culture—and again, this involves a "return to the object," as he puts it, to produce scholarship with truly radical potential. It is necessary, Murray insists, to resist overly "reverential" scholarly traditions that repeatedly produce a distorted colonialist, whitewashing approach toward the Western art "canon": "I've had to unlearn the kinds of devotion and deference towards the ideas of preeminent thinkers, so I could actually locate the omissions, blind spots and erasures that have, in many instances, led us astray." This discussion demands a much sharper critique of today's "too invasive, too panoptic and voyeuristic" Western culture of visual representation—a culture of "ceaseless observation" that has repeatedly fetishized the Black body and turned this figure into an object of consumption and spectacle. In this context, he insists, "the right to opacity can function as resistance to imposed legibility and ideological reduction."

Derek Conrad Murray's productive questioning of the "logics of constant visibility" offers at once a lens through which to view the contributions to this issue as a whole and a striking counterpart to the politics of visibility developed by writer, performer, video maker, and sex worker activist Carol Leigh, a.k.a. Scarlot Harlot, in the second and last of this issue's "Curated Spaces" sections. Responsible for coining the term *sex work* in the 1970s, here Leigh walks us through a section of her own visual archive of the "whore gaze." Traversing several decades of sex work and anti-homophobic and pro-sex activism as a self-proclaimed "Jewish intellectual red diaper baby" of the Holocaust generation, Leigh takes us to places such as the Venice Biennale in 2001, which saw the birth of the Red Umbrella movement for the rights of sex workers, just as Slovenian artist Tadej Pogačar's *CODE:RED* provided a rallying point for the World Congress of Sex Workers and the first Red Umbrellas March—a symbol of collective struggle and resistance against sex worker stigmatization.

Cover Photograph by Artist Vivian Fu

This issue's cover image, titled "Self-Portrait," by the brilliant photographer Vivian Fu, seems especially representative of the themes raised herein. This striking, even lingering, image suggests the creation or construction of archives (here, photographic) and the nature of their curation even before they exist—the desire of the artist-technician's eye to reveal, display, or converse with the human condition. This image also reflects both subjects' visibility and invisibility by placement in relationship to the photographer. Fu herself is shaded, partially visible in the foreground while in the background there is a blurred but suggestive silhouette. This affective choice connects the quotidian acts of living (with a lover) to a specific moment, caught on film. The figure seems human, sprawled on a bed unclothed—distanced from the photographer who is recorder of a scene and initiator of a visual archive (of sex?). It suggests the illusiveness and complexity of considering the past through visual archives.

Heike Bauer is professor of modern literature and cultural history at Birkbeck College, University of London. She has published widely on sexology, literature, and the modern history of sexuality, and on the rise of queer and feminist graphic novels. Her most recent book is *The Hirschfeld Archives: Violence, Death, and Modern Queer Culture* (2017; available open access: www.oapen .org/search?identifier=628406). She is now at work on a cultural history of the dangerous dog.

Melina Pappademos is associate professor of history and the director of the Africana Studies Institute at the University of Connecticut, Storrs. She researches the social and cultural history of race and political mobilizations in the Caribbean and Latin America. Her first book, *Black Political Activism and the Cuban Republic* (2011), won the Southern Historical Association's Murdo J. Macleod Best Book Prize. Her second book project examines political symbolism during Cuba's turbulent 1930s and 1940s.

Katie Sutton is associate professor of German and gender studies at the Australian National University. She is the author of *Sex between Body and Mind: Psychoanalysis and Sexology in the German-Speaking World, 1890s–1930s* (2019) and *The Masculine Woman in Weimar Germany* (2011), and articles on the history of gender, sexuality, and sexology in early twentieth-century Germany, including interwar trans subcultures.

Jennifer Tucker is associate professor of the history of technology and feminist, gender, and sexuality studies at Wesleyan University. She has published widely on photography, Victorian visual culture, museums, the role of evidence in jury trials, environmental law, guns and society, and public history. Her books include *Nature Exposed: Photography as Eyewitness in Victorian Science* (2006) and *A Right to Bear Arms? The Contested Role of History in Contemporary Debates on the Second Amendment* (2019).

Notes

1. Murphy, Tortorici, and Marshall, "Queering Archives: Historical Unravelings."
2. Marshall, Murphy, and Tortorici, "Queering Archives," 1.
3. Brown, *The Repeating Body*; Tucker, *Nature Exposed.*

4. Foucault, *History of Sexuality*.
5. Bauer, *English Literary Sexology*; Bauer, *Hirschfeld Archives*; Beccalossi, *Female Sexual Inversion*; Chiang, "Liberating Sex, Knowing Desire"; Damousi, Lang, and Sutton, *Case Studies*; Doan, *Disturbing Practices*; Kahan, *The Book of Minor Perverts*; Kunzel, *Criminal Intimacy*; Leng, *Sexual Politics and Feminist Science*; Love, *Feeling Backward*; Spector, Puff, and Herzog, *After the History of Sexuality*; Sutton, *Sex between Body and Mind*.
6. Arondekar, *For the Record*; Bauer, *Sexology and Translation*; Chiang, *After Eunuchs*; Fuechtner, Haynes, and Jones, *A Global History of Sexual Science*; Kozma, *Global Women, Colonial Ports*; Mitra, *Indian Sex Life*; Pande, *Sex, Law, and the Politics of Age*.
7. Chiang, *Transtopia in the Sinophone Pacific*; Halberstam, *Wild Things*; LaFleur, *The Natural History of Sexuality in Early America*; Manion, *Female Husbands*; Stryker, *Transgender History*.
8. Leng and Sutton, "Histories of Sexology Today."
9. Freeman, "Time Binds, or Erotohistoriography."
10. McKinney, *Information Activism*, 197.
11. Hall, "Constituting an Archive," 92.
12. Cvetkovich, *Archive of Feelings*, 7.
13. Dean, "Introduction," 10.
14. Dean, "Introduction," 18.
15. Werbel, *Lust on Trial*; Cvetkovich, *Archive of Feelings*, 7.
16. Stone and Cantrell, "Something Queer at the Archive," 5.
17. Lorde, *Uses of the Erotic*, 3.
18. Battle-Baptiste and Rusert, *W.E.B. Du Bois's Data Portraits*.
19. X, Campbell, and Stevens, "Love and Lubrication in the Archives."
20. Dean, "Introduction," 3.
21. Tyburczy, "All Museums Are Sex Museums"; Evans, "Seeing Subjectivity," 434.
22. Sigel, *People's Porn*, 23.
23. Irvine, *Disorders of Desire*.
24. Bull, "More than a Case of Mistaken Identity," 12.
25. Muñoz, "Ephemera as Evidence," 10.
26. McKinney, *Information Activism*.
27. McKinney, *Information Activism*, 157.
28. Avilez, *Black Queer Freedom*, 11.
29. Thomas, "Evidence of Sight," 151.
30. Edwards, "Thoughts on Photography," 24–25.
31. Campt, *Listening to Images*, 9.
32. Evans, "Seeing Subjectivity," 434–35.
33. Tucker, with Campt, "Introduction."
34. Tucker, "Visual and Material Studies"; Tucker, *Nature Exposed*; Tucker, "The Historian, the Picture and the Archive."
35. X, Campbell, and Stevens, "Love and Lubrication in the Archives," 271.
36. X, Campbell, and Stevens, "Love and Lubrication in the Archives," 272–73.
37. Dean, "Introduction," 10–11.
38. Murray, *Mapplethorpe and the Flower*.

References

Arondekar, Anjali. *For the Record: On Sexuality and the Colonial Archive in India*. Durham, NC: Duke University Press, 2009.

Avilez, GerShun. *Black Queer Freedom: Spaces of Injury and Paths of Desire*. Urbana: University of Illinois Press, 2020.

Battle-Baptiste, Whitney, and Britt Rusert. *W.E.B. Du Bois's Data Portraits, Visualizing Black America: The Color Line at the Turn of the Twentieth Century*. New York: Princeton Architectural, 2018.

Bauer, Heike. *The Hirscheld Archives: Violence, Death, and Modern Queer Culture*. Philadelphia: Temple University Press, 2017.

Bauer, Heike, ed. *Sexology and Translation: Cultural and Scientific Encounters across the Modern World*. Philadelphia: Temple University Press, 2015.

Beccalossi, Chiara. *Female Sexual Inversion: Same-Sex Desires in Italian and British Sexology, c. 1870–1920*. Basingstoke, UK: Palgrave Macmillan, 2012.

Brown, Kimberly Juanita. *The Repeating Body: Slavery's Visual Resonance in the Contemporary*. Durham, NC: Duke University Press, 2015.

Bull, Sarah. "More than a Case of Mistaken Identity: Adult Entertainment and the Making of Early Sexology." *History of the Human Sciences* 34, no. 1 (2021): 10–39.

Campt, Tina. *Listening to Images*. Durham, NC: Duke University Press, 2017.

Chiang, Howard. *After Eunuchs: Science, Medicine, and the Transformation of Sex in Modern China*. New York: Columbia University Press, 2018.

Chiang, Howard. "Liberating Sex, Knowing Desire: *Scientia Sexualis* and Epistemic Turning Points in the History of Sexuality." *History of Human Sciences* 23, no. 5 (2010): 42–69.

Chiang, Howard. *Transtopia in the Sinophone Pacific*. New York: Columbia University Press, 2021.

Cvetkovich, Ann. *An Archive of Feelings: Trauma, Sexuality, and Lesbian Public Cultures.* Durham, NC: Duke University Press, 2003.

Damousi, Joy, Birgit Lang, and Katie Sutton, eds. *Case Studies and the Dissemination of Knowledge*. New York: Routledge, 2015.

Dean, Tim. "Introduction: Pornography, Technology, Archive." In *Porn Archives*, edited by Tim Dean, Steven Ruszczycky, and David Squires, 1–28. Durham, NC: Duke University Press, 2014.

Doan, Laura. *Disturbing Practices: History, Sexuality, and Women's Experiences of Modern War*. Chicago: University of Chicago Press, 2013.

Edwards, Elizabeth. "Thoughts on Photography and the Practice of History." In *The Ethics of Seeing: Photography and Twentieth Century German History*, edited by Jennifer V. Evans, Paul Betts, and Stefan-Ludwig Hoffmann, 23–36. New York: Berghahn, 2018.

Evans, Jennifer. "Seeing Subjectivity: Erotic Photography and the Optics of Desire." *American Historical Review* 118, no. 2 (2013): 430–62.

Foucault, Michel. *The History of Sexuality, Volume 1: An Introduction*. Translated by Robert Hurley. London: Penguin Books, 1990.

Freeman, Elizabeth. "Time Binds, or Erotohistoriograpy." *Social Text* 84–85, no. 23 (2005): 57–68.

Fuechtner, Veronika, Douglas E. Haynes, and Ryan M. Jones, eds. *A Global History of Sexual Science, 1880–1960*. Oakland: University of California Press, 2017.

Halberstam, Jack. *Wild Things: The Disorder of Desire*. Durham, NC: Duke University Press, 2020.

Hall, Stuart. "Constituting an Archive." *Third Text* 15, no. 54 (2001): 89–92.

Irvine, Janice. *Disorders of Desire: Sexuality and Gender in Modern American Sexology.* Philadelphia: Temple University Press, 2005.

Kahan, Benjamin. *The Book of Minor Perverts: Sexology, Etiology, and the Emergences of Sexuality.* Chicago: University of Chicago Press, 2019.

Kozma, Liat. *Global Women, Colonial Ports: Prostitution in the Interwar Middle East.* New York: SUNY Press, 2017.

Kunzel, Regina. *Criminal Intimacy: Prison and the Uneven History of Modern American Sexuality.* Chicago: Chicago University Press, 2008.

LaFleur, Greta. *The Natural History of Sexuality in Early America.* Baltimore, MD: John Hopkins University Press, 2018.

Leng, Kirsten. *Sexual Politics and Feminist Science: Women Sexologists in Germany, 1900–1933.* Ithaca, NY: Cornell University Press, 2018.

Leng, Kirsten, and Katie Sutton. "Histories of Sexology Today: Reimagining the Boundaries of *Scientia Sexualis.*" Introduction to *History of Human Sciences* 34, no. 1 (2021): 3–9.

Lorde, Audre. *Uses of the Erotic, the Erotic as Power.* Pamphlet. Brooklyn: Out & Out Books, 1978.

Love, Heather. *Feeling Backward: Loss and the Politics of Queer History.* Cambridge, MA: Harvard University Press, 2009.

Manion, Jen. *Female Husbands: A Trans History.* Cambridge: Cambridge University Press, 2020.

Marshall, Daniel, Kevin P. Murphy, and Zeb Tortorici. "Queering Archives: Historical Unravelings." *Radical History Review,* no. 120 (2014): 1–11.

McKinney, Cait. *Information Activism: A Queer History of Lesbian Media Technologies.* Durham, NC: Duke University Press, 2020.

Mitra, Durba. *Indian Sex Life: Sexuality and the Colonial Origins of Modern Thought.* Princeton, NJ: Princeton University Press, 2020.

Muñoz, José Esteban. "Ephemera as Evidence: Introductory Notes to Queer Acts." *Women and Performance: A Journal of Feminist Theory* 8, no. 2 (1996): 5–16.

Murphy, Kevin P., Zeb Tortorici, and Daniel Marshall, eds. "Queering Archives: Historical Unravelings." Special issue, *Radical History Review,* no. 120 (2014).

Murray, Derek. *Mapplethorpe and the Flower: Radical Sexuality and the Limits of Control.* New York: Bloomsbury Visual Arts, 2020.

Pande, Ishita. *Sex, Law, and the Politics of Age: Child Marriage in India, 1891–1937.* Cambridge: Cambridge University Press, 2020.

Sigel, Lisa Z. *The People's Porn: A History of Handmade Pornography in America.* London: Reaktion, 2020.

Spector, Scott, Helmut Puff, and Dagmar Herzog, eds. *After the History of Sexuality: German Genealogies with and beyond Foucault.* New York: Berghahn, 2012.

Stone, Amy L., and Jaime Cantrell. "Something Queer at the Archive." In *Out of the Closet, into the Archives: Researching Sexual Histories,* edited by Amy L. Stone and Jaime Cantrell, 1–22. New York: SUNY Press, 2015.

Stryker, Susan. *Transgender History.* Berkeley, CA: Seal, 2008.

Sutton, Katie. *Sex between Body and Mind: Psychoanalysis and Sexology in the German-Speaking World, 1890s–1930s.* Ann Arbor: University of Michigan Press, 2019.

Thomas, Julia Adeney. "The Evidence of Sight." In "Photography and Historical Interpretation," edited by Jennifer Tucker. Special issue, *History and Theory* 48, no. 4 (2009): 151–68.

Tucker, Jennifer. *Nature Exposed: Photography as Eyewitness in Victorian Science*. Baltimore, MD: John Hopkins University Press, 2005.

Tucker, Jennifer. "The Historian, the Picture and the Archive." *Isis* 97 (March 2006): 111–20.

Tucker, Jennifer, with Tina Campt. Introduction to "Photography and Historical Interpretation," edited by Jennifer Tucker. Special Issue, *History and Theory* 48, no. 4 (2009): 1–8.

Tucker, Jennifer. "Visual and Material Studies." In *New Directions in Social and Cultural History*, edited by Sasha Handley, Rohan McWilliam, and Lucy Noakes, 129–42. London: Bloomsbury Academic Press, 2018.

Tyburczy, Jennifer. "All Museums Are Sex Museums." *Radical History Review*, no. 113 (Spring 2012): 199–211.

Werbel, Amy. *Lust on Trial: Censorship and the Rise of Obscenity in the Age of Anthony Comstock*. New York: Columbia University Press, 2018.

X, Ajamu, Topher Campbell, and Mary Stevens. "Love and Lubrication in the Archives; or, rukus!: A Black Queer Archive for the United Kingdom." *Archivaria* 68 (Fall 2009): 271–94.

Curating Visual Archives of Sex

A Roundtable Discussion

Ashkan Sepahvand, Meg Slater, Annette F. Timm,
Jeanne Vaccaro
Compiled by *Heike Bauer* and *Katie Sutton*

Heike Bauer and Katie Sutton: *What prompted you to put together your exhibition?*

Jeanne Vaccaro (JV): I came to curatorial practice unexpectedly and in an effort to work through the complexities generated by the archives of sex/gender, identity, and difference. Organizing *Bring Your Own Body* was my first curatorial endeavor. I was on a research fellowship at Indiana University and had the great fortune of working in the archives at the Kinsey Institute, which houses foundational collections of mid-century American sexology. Going through hundreds and thousands of documents—letters, newspaper clippings, hospital memos, photographs—was exciting but also isolating. I was struck by my sense of remoteness both internally (emotionally) and geographically, meaning these materials were noncirculating. There are real questions of access and ethics that emerge when we talk about archival materials being held in university libraries and special collections: Who can enter the building? Who has the credentials and sense of entitlement to do so? This is compounded by the way race and class privilege, sex/gender, and disability impact access to elite institutions. Even I, who had been comfortably working in archives for over a decade (my work-study job in college was in special collections), often felt

Radical History Review
Issue 142 (January 2022) DOI 10.1215/01636545-9397016
© 2022 by MARHO: The Radical Historians' Organization, Inc.

lost, disoriented, and overwhelmed by archival research. This informed my sense that I had an ethical responsibility to leverage my position of privilege within academic institutions to make these materials accessible to a wider public.

At the same time, in 2015, the so-called transgender tipping point was in full swing, and there was a burgeoning impulse within museums and art spaces to include trans and gender-nonconforming artists, although in ways that often felt singularizing and tokenizing. I wanted to organize an exhibition that put contemporary trans artists and culture makers into conversation with archival collections and histories, but in a way that showed the density and multiplicity of trans experiences and identities. Taken together with the visual archives, the contemporary art in *Bring Your Own Body* (*BYOB*) illustrated a wide range of aesthetic, political, and social strategies for articulating the experiences of transgressing sex and gender. I did want this exhibition to stake a claim for these kinds of artistic interventions within the canons of gender and art history.

Meg Slater (MS): Around the time of the Australian national vote in favor of marriage equality in 2017, two of the curators of *Queer*, Angela Hesson (curator, Australian Art) and Myles Russell-Cook (curator, Indigenous Art), who are also the editors of the National Gallery of Victoria's (NGV) annual peer-reviewed journal, *Art Journal*, decided to dedicate a future issue of the journal to exploring queer stories in the NGV collection. Angela and Myles quickly recognized the potential to take what they had developed for *Art Journal* off the page and onto the gallery's walls, and with that came the development of an exhibition proposal.

The curatorial team was expanded to better represent the gallery's collection areas, and the diversity of the exhibition's subject. Ted Gott (senior curator, International Art), Pip Wallis (curator, Contemporary Art), and I joined the team. Beyond our knowledge of the NGV's collection, each member of the curatorial team has a long-standing interest in and passion for queer histories. Having the opportunity to come together and mine the NGV collection through a queer lens has been incredibly rewarding. *Queer* has grown from a series of commissioned journal articles (which will be published in 2022), to the current checklist of around four hundred artworks spanning antiquity to the present day, which will be organized thematically and presented across the third floor of the NGV International building.

Annette Timm (AT): Let me begin by saying that my curation experience has been highly collaborative, and that my answers today are my own personal responses and concentrate on the portion of the exhibition for which I was responsible. My co-curators, Michael Thomas Taylor, Rainer Herrn, and Alex Bakker, may well have answered differently!

The journey to creating *TransTrans* was complex. Three of the four of us had already worked together on a previous exhibition, and since we enjoyed the experience immensely, we were keen to do it all again. But our primary reason for

choosing the exhibition format was our conviction that trans history has to be told in ways that engage directly with the trans communities in our present time and spaces. Exhibitions, much more than published scholarly work, allow—they really demand—space for conversation between the words on the wall and the readers of those words; they force an economy of expository baggage (the dense scholarly apparatus that we are so fond of), which actually encourages reflection about the immediate public impact of historical knowledge. We were aware from the beginning that the history we were presenting would be painful to many—that what we consider history reads like an intimate excavation of lived experience for trans people today.

For the version that took place in Calgary, I therefore assembled an advisory board of community members, to whom I provided an outline of our plans before they were very advanced. We wanted to discuss which aspects of this history might cause pain before our visitors were confronted with the images. I believe that an exhibition provides specific opportunities for such discussions and for working through what can at first seem like a conflict between how historians present their arguments about sexuality and the feelings and vocabularies of those currently experiencing the sometimes traumatic effects of sexualized social mores.

Ashkan Sepahvand (AS): I want to preface this with two points: firstly, the position at the Schwules Museum that eventually led me to present *Odarodle: An imaginary their_story of naturepeoples, 1535–2017* was initially announced as a job funded by the German Federal Cultural Foundation. Secondly, I am an artist, and though my background involves academic training and curatorial experience, I approached my position at the museum as an artist would in making a work.

In 2016 the Schwules Museum, in an attempt to open itself up to a more "queer" spectrum of representation and activity alongside its long-established program mainly involving gay, white men, and their interests, advertised a temporary post to develop a project that would cast a "postcolonial perspective" on the museum's archives, collection, and history. I got the job, mainly by playing the identity card, emphasizing my embodiment as queer, brown, polylingual, and multinational. To be quite honest, I had heard of the Schwules Museum in all of my years living in Berlin, but no one I knew had actually been there. Its premise felt, on the one hand, rather quaint—a kind of "pat on the back" regurgitation of gay nostalgia—and on the other hand a bit outdated in its revalorization of gay and lesbian liberation as a fait accompli. I was attracted to the proposal of a "postcolonial perspective" not so much in the form of generating a reparative reading but as a way to offer "another vision" of a possible museum yet-to-be, one that associates what Aisha Ariella Azoulay calls "potential history" with queer artistic practice.[1]

Initial conversations with staff and board members circulated around an institutional urgency to connect with contemporary discourses on race and

representation, diversity, and inclusivity. It was quickly obvious that when it came to the museum's exhibition history and archive, such topical perspectives were relatively absent. There were some who felt that these lacunae needed to be exposed, and that a didactic approach would be necessary to reeducate the public and reinform the past. I didn't agree. What does it mean to simply present revised information, to state officially what is already known unofficially, other than generating good publicity and a clear conscience for the institution? What would it mean, instead, to propose a work that asks those who encounter it to do the work or, as Donna Haraway would say, "to stay with the trouble?"

An uncanny observation during my first few months greatly intrigued me. I came across the documentation for the Schwules Museum's foundational exhibition in 1984, *Eldorado: Homosexual Women and Men in Berlin; History, Everyday Life, Culture, 1850–1950*, presented then at the Berlin Museum (a municipal history museum formerly in West Berlin). As the first major institutional representation of gay and lesbian cultural history in Germany, it contributed towards establishing a set of canonical tropes, while visually it organized itself around expository displays of historical images and objects. These included a number of so-called environments, scenes from everyday queer life such as the gay boudoir, the lesbian café, or the cruising grounds of the Tiergarten, recreated as theatrical, panoramic settings. I was shocked and amused—for me, this was no different from what you would see at an ethnological (or even, natural history) museum! Except instead of Europeans showing African villages or Jurassic landscapes you had homosexuals showing themselves and their surroundings. Why this decision to enact self-ethnography? Sure, one could argue that the gesture of showing the Other loses its greater violence when "we" represent "ourselves," reclaiming the agency to reveal "the way we really are." But who is doing the looking? What about the violence contained within the "eye" of the liberal subject's gaze, the habituated projections of the public imagination? Doesn't this just lead to the continued reification of alterity?

These questions served as the drive behind *Odarodle*. With it, I wanted to propose a thought exercise, to imaginatively consider the Schwules Museum as an ethnographic collection, an institution that, in its self-representation of a kind of people and a certain othered form-of-life, carries on, however unwittingly, historical practices of ethnological display that affirm the bourgeois consumption and categorization of difference. *Odarodle* is not only "Eldorado" spelled backward, it is a topsy-turvy reenactment of a historical exhibition, turning its aesthetic sensorium inside out. I wanted foremost to create a situation where it was possible to (un)learn what Sylvia Wynter powerfully terms "the coloniality of being" through sensing and feeling otherwise. To attempt this, I invited artists from my extended community in Berlin, mainly queer and mostly non-German, to create and exhibit new works that departed from or incorporated the museum, its holdings, narratives, and

gestures. Thus the museum became both medium and material for an artistic intervention, one that emphasized the perceptual conditions for reception.

HB and KS: *How is the storytelling in your exhibition shaped by the emphasis on visual materials? What do images allow that words or other source types might not, particularly when it comes to the archiving of sex?*

MS: Artworks are subjective and open to interpretation, enriching their narrative capability. They can tell stories or represent ideas in ways that other formats cannot, namely, through visual and experiential means. By juxtaposing, recontextualizing, and thematically grouping artworks, unique and often unexpected connections can be made between them, their makers, and the ideas they embody. In the case of *Queer*, these and other visual and experiential strategies will highlight the breadth and complexity of queerness.

Emphasis on visual materials is particularly powerful when exploring how sex is represented in artworks. Although *Queer* explores ideas and histories beyond sex, sensuality, and desire, these are important aspects of queer identity and will be considered throughout the exhibition. From classical Greek vases linked to same-sex desire, to the intimate female nudes captured by German photographer Germaine Krull in the early twentieth century, to photographs by Tehran-born, Melbourne-based artist Hoda Afshar, of men embracing in a bathhouse, *Queer* will highlight various ways in which queer sex is imbued and explored in NGV collection artworks. This aspect of queer identity is also one that historically has been censored due to prejudice and discrimination, and we aim to bring to the surface what has previously been suppressed.

AT: I can say without hesitation that the knowledge we gained and conveyed in our exhibition and subsequent book[2] was fundamentally shaped by the fact that we began our research with the intention of staging an exhibition rather than writing a monograph or scholarly article. Knowing that we needed visual material completely changed our approach in the archives. When Michael Thomas Taylor and I visited the Kinsey Institute archives, we immediately asked to see the boxes of Harry Benjamin's personal effects. As a historian focused on writing books and articles, it simply would not have occurred to me to shuffle through boxes that contained, among other things, shaving equipment, cameras, and vacation slides if we were not planning an exhibition. It was this search that led me to the discovery of a collection of stereoscopic slides that our more traditional documentary research led us to believe must be of the trans women Benjamin had met and studied in California in the early 1950s.

Piecing together the story of these beautiful, personal, and poignant slides led me to the story of the woman I called Carla Erskine (because the Kinsey Institute insists on anonymity). In the letters that Carla wrote to Benjamin, I found

evidence that she was the photographer behind those beautiful slides and that many of them had been taken in the San Francisco apartment of Louise Lawrence, a trans woman whose work as Alfred Kinsey's research assistant had already been documented in Joanne Meyerowitz's *How Sex Changed: A History of Transsexuality in the United States*.[3] While I was researching Carla's story, Michael searched through the extensive image library and found other fascinating connections to the research that Rainer Herrn had done for his books about the history of transsexuality in Germany and the interwar magazine *Das 3. Geschlecht* (*The Third Sex*), a fascinating visual archive in its own right. Using the same image archive, Alex Bakker later found more details about the history of the Dutch trans women whose lives he had researched for his book about trans history in the Netherlands, and the two of us managed to unravel some of the personal connections in all of these stories simply because we recognized the people in the photographs we had found.

In short, the only reason we were able to make these connections is because we began with the intention of presenting things visually. Speaking only for myself, I know that without this quest, I would have gotten bogged down in Harry Benjamin's handwritten and very statistically oriented notes. I would have missed most of the story. The entire experience underlined how critical visual information is to the history of sexuality. It convinced me that the serendipity that influences all historical research can be helped along with attention to the visual and to the personal stories that make for much better exhibition material.

In the exhibition itself, we made the imagery central to the logic of the spatial flow and visitor experience. This might be true of all exhibitions, but it really did structure how we presented the knowledge we had gathered. In both Calgary and Berlin (which had different and complex spatial challenges), we tried to organize the visual experience in ways that echoed our individual and collective research findings. Multiple images of the same person appeared in different settings in order to emphasize the way that knowledge about sexuality travels transnationally and historically. We chose the title *TransTrans* with the intention to emphasize movement and the flow of ideas, not only across time and space but also through translation and transitory personal relationships.

JV: The archives of sexology were not used in this exhibition as evidence of some truth or definitive way of being transgender in the past. If anything, the stories that emerge out of the vernacular and sexological photography, newspaper images, newsletters, and community magazines demonstrate that no singular way of being gender nonconforming could categorize a time period, and that gender identity diagnoses fail to capture experience. One of the stories that *BYOB* aimed to tell was therefore found in the wide inclusion of images, everything from living room snapshots showing trans women gathering and making community together, the

lecture slides of Harry Benjamin, and mug shots of African American trans women criminalized for crimes we can surmise might be related to sex work or the three-piece rule.

The images related to Harry Benjamin are especially instructive, in that we associate Benjamin with a violent legacy of diagnosis. While the photography coming out of his archive doesn't change that perspective entirely, it does give us a complex view into the social worlds that shaped his thinking.

AS: I wanted the exhibition-goer to encounter the exhibition not with their head but with their body and through their senses. In order to hold the complexity of association, translation, and opacity informing the project, it felt important to devise a framework that could gently host disorientation. I was truly fascinated, albeit uneasy, with the "environments" that were arranged for the original *Eldorado* exhibition: these were able to perform historical content and generate an atmosphere of experience.

For me, the artistic positions in the exhibition, the inclusion of archival materials, and the design of the space all worked together, much like in theater, to create an ambience. It was an ambiguous mood, however, a space where the visual and sensory stimuli may have been individually familiar but together created an unknowable, almost surreal setting. The outer walls of the museum space were left untouched, a decision to communicate the exhibition structure as independent, even alien from its host institution. The use of neutral white light was eschewed in favor of specific, colored lighting for each room, not only drawing attention to the effect this had on the viewer's perception and cognition but also altering the artworks themselves, animating their mediation as exhibited interfaces and making explicit their participation in a greater dramaturgy. At no point in the space was a comprehensive view of the exhibition possible, nor were the artistic positions placed in clear, geometric succession, requiring visitors to move around and attend to a constant corporeal unfolding.

Hospitality is worth mentioning here, particularly in relationship to storytelling. The first work that visitors to *Odarodle* encountered was the video *Welcome Address* by Vika Kirchenbauer. A flatscreen TV hung at the entrance to the space, above a neon sign announcing *Odarodle* as if it were a nightclub, like the original 1920s *Eldorado*. At first glance the work appears almost like a media gimmick from the museum's communications or education department. Instead of a wall text or press release to provide some basic information about the show, there is a video of the curator (me!) moving around the museum's archival storage, greeting and welcoming everyone, seemingly about to tell us all we need to know as we prepare to "understand" the exhibition. The address provides a disappointment. It is composed of various scripted registers of official institutional speak that feel increasingly disingenuous, though subtly drawing attention to the different locutionary positions

that constitute and contradict an embedded speaker. As the video is set on loop, throughout one's time in the exhibition its message will be heard over again: "Welcome, everyone is welcome." Directed towards the "public" and repeated in the background, these words provide ambient friction against and around the images, materials, and bodies in the space. Who are you, what is this, what are the intentions and investments that gather here? The humor and irritation Vika's work insists on vis-à-vis hospitality productively seduces visitors towards an increasing sense of complicity in their own confusion.

In that regard, my authorial presence in *Odarodle* is translated into a hosting presence quite literally on the margins of the space, but also as a spoken, sonic reminder that you are being hosted. That as a guest, you have responsibilities, but in fulfilling these, you shall receive. This goes back to my interest in encounter as a viscerally affected and affecting, somatic relation.

HB and KS: *Your reflections so far on using visual materials to shape stories and histories of sexuality point to not only the act of seeing but also a multisensorial, affective experience for visitors moving through the exhibition space. In what ways do you think that such emotional and sensorial engagement opens up different, perhaps more productive ways of negotiating sexual histories?*

AT: As Ashkan has so eloquently explained, exhibitions need to play with all of the senses. We consciously set out to stimulate our visitors' emotional response through physical stimuli, sound, and spatial arrangements. I was inspired by my own emotional response to the slides Carla had sent to Benjamin. My first impression was that I was looking at family photos. Anyone unfamiliar with the context would simply have assumed that someone had photographed visiting family members. Even before I knew who the people in the slides were, I became very excited when I noticed that many of them were taken on the same couch in front of a very distinctive curtain. I came up with the idea of spatially recreating this moment of discovery and recognition by juxtaposing reproductions of the slide images with a facsimile of the living room. In both Calgary and Berlin, visitors walked past the original slides and turned a corner to see the recreated living room, with the visual clue of the curtain making the link.

In an interesting coincidence, one inspiration for the living room was Jeanne Vaccaro's *BYOB* exhibition in New York, which Michael and I had both managed to visit. My favorite installation in *BYOB* was Mx. Justin Vivian Bond's *My Model/My Self*, which featured a gauzy canopy encircling a chandelier and some everyday private objects, all surrounded by a living-room-like corner that was wallpapered with the artist's own image. The space felt intimate, even as the curtain prevented the visitor from actually entering what the artist called "a private state of grace."[4] I loved the feeling of intimacy this awakened but wanted Carla's living room in our

exhibit to feel more welcoming and inclusive. Rainer, Michael, and I felt strongly that we had to avoid mimicking a museum-style diorama, which in this case would have been like a voyeuristic peek into the world of the trans other. Our fears were very similar to Ashkan's reaction to the original *Eldorado* exhibition. We wanted to make sure not to produce the modern version of the nineteenth-century *Völkerschau*—the exhibition of actual humans in zoos for the purposes of racial exoticization. Carla's living room instead invited visitors to enter—to sit down on the couch and use a photo-booth setup (in Calgary) or their own phones (in Berlin) to take pictures of themselves. The gesture was an invitation to feel the comfort of the plush couch and the safety of the intimate space, encouraging an identification with the universal human need for acceptance.

As a further attempt to juxtapose the past and the present, we thought carefully about the sounds that would float across the exhibition space and about how the interplay of sound and images would affect visitors' emotional reactions to the material. Both of the incarnations of *TransTrans* included video installations (*Carla's Couch* in Calgary, and *Carlas Wohnzimmer* in Berlin), which were filmed using the same living room sets and which connected the historical material to present-day gendered and trans experience. We self-consciously ensured that the only sounds that visitors heard in the exhibition spaces came from these videos. As visitors viewed images from *Das 3. Geschlecht*, they learned about the collaboration between Benjamin and Kinsey. In the Berlin exhibit, as they read Alex's story about the trans people whose connections helped them find their way first to the Netherlands and then to Casablanca for treatment, they were followed by the voices of trans people today. While the second version of the video was much more professionally and artistically produced (by Brian Andrew Hose and Sabrina Rücker) than my amateur effort in Calgary, both served the purpose of encouraging a dialogue between the past and the present and foregrounding a conversation guided by present-day trans individuals.

AS: Most standard exhibitions treat the visitor as a captive consumer. The visitor is provided with explanatory texts and display formats that purport to easily communicate their message and intention. The visitor is expected to ingest all of this, guided towards the correct way of viewing and thinking. The works are spoken for and over, and the visitor is dominated via the institution's seemingly friendly authority. For me, the language of encounter has less to do with meaning and everything to do with touch. As a host, I reach out and want to touch the guest with a gesture. As a guest, I want to be touched, nourished, attended to in a way where I not only know it, but feel it. Of course, in order to be touched, you have to be given the proper conditions to feel comfortable and open, to desire touch, even if it isn't always comfortable. In fact, discomfort may yield to a transformative antagonism, one that if you consider S&M practices and their choreographies of consent nevertheless is able to

exhibit emotional intelligence, knowing how far to push, or when it's time to stop, take a break, or leave the session altogether. So moving away from the impersonality of mere consumption and the dominance of capture, the intimate encounter of hospitality asks us to tune into the relational conditions for receptivity, hoping for a certain endurance of the senses during and well after the occasion. I find Elizabeth Freeman's concept of "erotohistoriography" to account for queer visual practices that employ sensuality to address historical material very helpful here. How does an exhibition create conditions for "bodying-forth" an encounter that is moving, that moves? How to nourish the senses past their initial disorientation towards a reorientation that can be held, that holds?

JV: Mounting the exhibition in university galleries attached to academic institutions allowed for the gallery to become another of the institution's pedagogical spaces, where classes and conversations could take place and dialogue could be generated through close reading of images as significant historical texts. Visitors to the gallery were almost entirely always drawn to what we called an archival library, with copies of *Transvestia*, *Glad Rag*, *Transisters*, and more displayed openly for people to read and peruse. It was telling that there was a universal desire to be with historical materials that are very rarely available and accessible to the public. While people like KJ Rawson have recently launched critically innovative digital repositories that make vital documents of early trans histories available for pedagogical, political, and social arenas, there is still something differently "felt" when we physically touch archival materials. This is not to place some essential value on embodiment or designate what is "the real," but leafing through issues of Virginia Prince's *Transvestia* is a powerful testament to the act of making that record and the physical act of production that brought the magazine into the world and then, through elaborate circulation networks of trans people, into the hands of readers. When an eighteen-year-old college student would visit the exhibition and hold one these magazines in their hands, it was powerful to watch the sensory experience of ingesting history. Finding a seat in the gallery and watching this happen over and over again was deeply powerful for me as a teacher, and it gave me the profound sense that curatorial work brings enormous pedagogical value to the table.

There was another densely sensory experience we laid out for visitors in the gallery, and that was an installation of denim dick sculptures by performance and visual artist Navild Acosta. These human-sized sculptures, measuring over six feet long and two feet wide, functioned as art objects but also as museum benches in the gallery, giving visitors a place to rest and sit. I am put in mind of artist Shannon Finnegan's chaise lounges that explore disability access in art and museum spaces. Museums are hierarchical and elitist institutions that make many people feel unwelcome. Finding tactile, concrete ways to increase accessibility is the responsibility of all curators.

MS: One of the central aims while developing *Queer* has been to draw out connections between NGV collection artworks and the queer stories they carry. Through various modes of research, from diving into artist biographies and online archives to having conversations with artists, academics, and community leaders, we have broadened our understanding of hundreds of collection artworks and the unique links between them. It is our hope that this process will open up alternative ways for our audiences to interpret museum collections, in this case by exploring the queer histories, identities, and ideas represented in the NGV collection.

For example, while it may seem inconsequential, we hope that by pairing a women's smoking suit designed by Yves Saint-Laurent with a photograph by Brassaï of Le Monocle, a former lesbian bar in Paris that operated during the interwar years, visitors to *Queer* will engage with a facet of queer culture that spans centuries—gender-queer dressing and expression. The women and gender-nonconforming individuals depicted in Brassaï's images of Le Monocle proudly display new modes of queer sensibility that emerged in the early twentieth century. As documented in Brassaï's photographs of the bar, *garçonnes* and *femmes* regularly populated the progressive establishment. A *garçonne* would sport a monocle, top-coat, or military uniform and a cropped hair style, and was often accompanied by a *femme* dressed in a highly feminine, often revealing evening gown. By defiantly queering their gender expression, the bar's patrons created a safe and celebratory queer space. The suit designed by Laurent was never worn by one of the women or gender-nonconforming individuals who patronized Le Monocle. Actually, it was designed by Laurent in 1972, some forty years after Brassaï's infamous photographs were captured. However, the suit represents the influence of Le Monocle's patrons, whether it be direct or indirect, on queer creators throughout the twentieth century and into the present day. When displayed together, the Brassaï photograph and Laurent suit visually represent important moments and connections in a long history of queer rebellion and rejection of heteronormativity through dress and other modes of expression, which remains a defining feature of queer culture and community today.

The same can be said for the many other juxtapositions and groupings of artworks spanning subjects, identities, geographies, time lines, and media that have been formulated through curatorial research and will be presented throughout *Queer*. These and other display strategies demonstrate the unique potential for artworks and exhibitions to create links between seemingly disparate histories and ideas in an emotional and sensorial way.

HB and KS: *Were there any aspects of your exhibition that were particularly challenging or controversial, and what lessons might we take from this for constructing ethical sexual histories?*

AT: Yes, and I will say quite bluntly that these lessons were painful. Although we were definitely aware of the ethical problems created when cis curators present trans history, before the exhibition in Calgary even opened, we received a complaint from local trans activists who were concerned that our team had not paid attention to the very understandable demand that there should be "nothing about us without us." The process of forming an advisory board had already begun, but we redoubled our efforts to reach out to trans community members and scholars, particularly Aaron Devor, founder and inaugural chair of Transgender Studies and founder of the Transgender Archives at the University of Victoria, Canada, for advice. We asked to meet with the complainants but received no response, so I met with student representatives on campus. Without claiming that this was a perfect response, we certainly learned that having good intentions about how one presents the history of any oppressed minority is not enough.

There were similar painful and instructive experiences in Berlin, beginning with the filming of the interviews for *Carlas Wohnzimmer.* Brian and Sabrina made a concerted effort to assemble a diverse group, but finding trans People of Color who would agree to participate was a challenge. One individual was angry to find out that the filmmakers had been commissioned (and were being paid), while the interviewees were being asked to volunteer their time. This seemed particularly ethically problematic to someone who had already been marginalized as a person of color within Berlin's performance and art world. We found this critique absolutely justified, but we had not calculated these payments into our funding model, and we could not repair the damage once it had been done.

After the exhibition opened, we heard from voices within the Schwules Museum that we had not done enough to integrate the history of trans men and trans People of Color. There was also concern about the focus on medicalization. The first problem arose as a consequence of the specific story we set out to tell—a story of transnational transmission of knowledge and one that we had found primarily in the archives of doctors and sexologists in countries where People of Color generally lacked the financial and social capital to access medical services, particularly those that involved transatlantic travel. For people living in what is now a very multicultural city, our story seemed remarkably and unjustifiably white. We should have found ways of making these exclusions clear, and perhaps we could have mitigated the damage by pushing the story past the 1950s. By the 1960s, trans People of Color were starting to make their way to Harry Benjamin's offices, and they were finding ways of financing the treatment they sought. If we had been less focused on transnational currents, we might also have found trans People of Color in a different historical record—in the evidence of less medicalized spaces, such as the streets of cities like New York or in private diaries and correspondence.

A similar absence marked the early history of trans men in the story we told, since surgical techniques were developed much later for them. These people seem

absent to us only because many of them lived unassuming and entirely private lives. We could find private stories of trans women, like Carla, because she did gain access to medical services and therefore left an archival record. The stories of trans men also exist (and Kinsey was clearly wrong to believe that they were vastly outnumbered by trans women), but the search for these stories has to be crafted very differently. Ironically, the stories of trans men are harder to find in the historical record because these individuals were more successful at passing without medical treatment than trans women. I say "ironically" because, when we addressed these concerns by pointing out that passing leaves behind fewer archival traces, our complainants were surprised to learn that one of us, Alex Bakker, is a trans man. The conversation could hardly take place without an otherwise unnecessary outing. As a historian, Alex is very aware of the absences in the historical record and the difficult conflicts between the terminologies and self-identifications of the past and present. He has immersed himself in the needs and concerns of trans people of the past, and he does not expect these to mirror his own.

We had more space to discuss these issues in our book, *Others of My Kind*, and to address our own positionality. We might now certainly make different choices for the exhibition, but we also feel that all trans stories—including medicalized ones and those involving white but very often extremely underprivileged subjects—deserve to be told.

JV: Exhibiting archival images of early transgender history in the United States was full of ethical dilemmas and challenges, but I ultimately think that making materials with violent histories available to the public is part of the process of deflating the negative power of these documents. Kinsey's photographic records were very difficult to work with. We did not know the identity of almost any of the people documented in these photographs. What was our ethical obligation as curators if we could not receive explicit permission from the subjects to be included and on display? Of course we can imagine most of these people are no longer living, given the era of the photographs, but questions of security and privacy were central to our thinking.

Organizing an exhibition on transgender art and history as a cis curator was something I did with great caution and consideration. I come to this work from a political and activist orientation, and with the belief that transgender liberation is a collective project. That said, it was very important to me to partner with activist and social justice groups organizing in the present moment, to connect these histories to contemporary struggles and participate in movement building through the exhibition.

MS: One challenge has been the limitations inherent in shaping an exhibition about a seemingly limitless subject with necessarily limited means of a permanent museum collection, with all its attendant gaps and imbalances. This led us to

structure *Queer* thematically, rather than chronologically, so as not to imply the impossible: an encyclopedic presentation of queer history. A thematic structure has allowed us a great deal of flexibility and possibility. We have been able to draw connections between beloved and lesser-known artworks spanning time lines and geographies.

Beyond the artworks on display, interpretive materials ranging from in-gallery texts and tours to panel discussions and an exhibition publication will be utilized to acknowledge some of what cannot be represented on the gallery walls. The NGV collection has been growing since the gallery's inception in 1861. During those 160 years, various collecting priorities have shaped the collection. There have also been shifts in social attitudes to queerness and LGBTIQA+ identities. In the past, queer stories have been suppressed and queer works overlooked due to prejudices of the time. Identifying and discussing these absences will be just as important as displaying artworks with queer stories.

We have addressed such challenges through an open and continuous dialogue with queer and LGBTIQA+ individuals and community groups. Recognizing that we are representing concepts and identities that have historically been institutionally ignored or underrepresented—either through oversight or intent—we are looking and engaging beyond the institution. While *Queer* is a collection exhibition, we are finding it rewarding and fruitful engaging peers and community, hearing their perspectives and seeking their input through processes of collaboration and consultation.

AS: To expand on public reception feels important here, as the main challenge, controversy even, concerns the range of reactions to the exhibition within the museum itself. As a decentralized institution with limited permanent staff, most of whom are administrative assistants, a large community of volunteers, mainly older, white, gay men, and an unpaid board with individual programming interests, there isn't the same kind of hierarchical curatorial "checks and balances" process at the Schwules Museum as at more conventional institutions. This offers great opportunity for developing projects independently, but it also leads to misunderstandings and intrigues. There had already been for some time growing tensions between members who wanted to keep the museum's identity stably located in its adjacency to male homosexuality and those who wanted to question and expand its scope to account for greater diversity and more queerness. Though *Odarodle* certainly was not the initial trigger, it did incite internal reactions of confusion, rejection, and incomprehension. This was to be expected from the "old guard," to be sure: one founding member remarked that the museum had generously made its materials available to me, and in the end I ungratefully "appropriated" these towards my project's own speculative ends. More disturbing, however, was the sense from the more liberal contingent within the institution that the complexity of the project was undesirable, as it could

not easily be summarized and mobilized to provide performative "answers" or to identifiably absolve the museum of its subject's irreparable histories. This attitude became slowly apparent in the lessening amount of care given to the exhibition's publicity, while the research publication that was released almost a year afterward had its funding initially miscalculated, its distribution unaccounted for, and its launch hosted elsewhere. I felt a strong lack of follow-up from the institution. At the same time as I suspected the work was slowly but surely being made invisible, I also saw how the museum extracted usable value from *Odarodle*, replicating decontextualized aspects of its dramaturgy or repeating artists it initially came to know through it, all the while having quietly let go of contact and communication with me.

HB and KS: *From your responses it is clear that the desire to looking back on gender and sexuality in the past cannot be separated from the lives and experiences of people today. What do you think your exhibitions will tell those who encounter them in the future—in, say, ten or twenty years time—about "sex" and sexual politics in the first decades of the twenty-first century?*

MS: One of my co-curators, when asked about *Queer* and what its legacy might be, has noted that in a matter of years, aspects of the exhibition and some of the language we use will likely be obsolete. I agree and believe this to be the case with most explorations of queerness presented in gallery and museum contexts. Beyond the limitations inherent in working with a collection, which I mention in one of my previous responses, queerness by definition is beyond definition. It is constantly shifting and expanding. In this way, queerness cannot be represented in its entirety, nor can it be fixed in time.

Despite the ever-changing nature of queerness, there are countless stories embedded in the NGV collection that are and will remain universally relevant, and we are excited to share these with visitors to *Queer*. We hope the steps taken to recognize the breadth of queer stories present in the collection will inspire sustained engagement with queer histories, identities, and ideas both within and beyond the institution's walls. In this way, we hope that in decades' time, when people reflect on *Queer*, it is seen as an example of the potential for art museums to adapt and connect with queerness in a continuous and meaningful way.

JV: One of the main impulses to do this work had to do with the emergent category of "transgender art," and to interrogate the impulse to canon build in this way. Part of the exhibition research therefore involved looking into past ventures that made claims to transgender art, and to decode the ways gender appropriation has often been made by museums and elite art institutions without any direct, material engagement with or benefit to trans communities. For example, we partnered with the organization Visual AIDS on a public program about the life and legacy of Chloe Dzubilo, whose drawings explored the intersection of gender identity with the

public housing crisis, gentrification of city spaces, displacement of trans people, and HIV/AIDS. Through storytelling by Chloe's friends and collaborators, including T de Long and Justin Vivian Bond, there was a reconstruction of Chloe's experiences for a new generation, but there was also a connecting of her struggles to contemporary movements for housing justice, transgender liberation, and AIDS organizing. I hope when people look back at *BYOB*, the picture of trans activisms, identities, and histories that emerges is densely felt as intersectional and multiple.

AT: I hope that anyone looking back on our exhibition will see an attempt to directly and empathetically confront the painful history of the trans experience in a way that does not sensationalize, exoticize, or simplify it. As I have said, we were not entirely successful in this endeavor, since some trans visitors to the Berlin exhibition, primarily younger visitors, told us that they were triggered by our discussion of surgery and by the key role of medical and scientific experts in the story we told. Older trans people whose opinion we solicited felt quite differently. For example, Nora Eckert, one of the interviewees in *Carlas Wohnzimmer*, walked onto the 1950s film set and said it immediately reminded her of a family living room from her youth. She was comfortable enough with the entire experience to contribute a personal reflection to our jointly authored book, *Others of My Kind: Transatlantic Transgender Histories*. For other collaborators, the impression of empathy that we tried very hard to create required more conversation and personal connection. I am forever grateful to Amelia Marie Newbert, whom I met because she had talked to the members of the Gay-Straight Alliance at my daughter's high school. Amelia agreed to meet with me and initially found my description of the history that we planned to reveal quite painful. But she stuck it out, and we kept talking. She eventually came to trust me and agreed to help us decide which images we could display and how they needed to be contextualized to make the pain worthwhile. This is precisely how she phrased it. Despite her personal discomfort, she insisted that this story needed to be told, and she helped me tell it by using her skills as a theater manager to help me create a film set. She even used the theater's fabric printer to create the curtain that was so central to our exhibition.

All four curators hope that Nora's and Amelia's reactions are a better indication of the legacy of *TransTrans* than some of the angrier responses we heard. As a historian, though, I have come to recognize that we are in a difficult transitional moment when it comes to the precise ways these stories enter the public sphere. There is a recognition that trans people need to tell their own stories (as Nora and Alex have done),[5] and those of us who are not trans perhaps just need to step back. Curating *TransTrans* was an enormously rewarding experience for me, but I have come to believe that it is not the right time for cis people to narrate trans lives. We started this research before the Black Lives Matter movement and in the midst of "the transgender tipping point," both of which have underlined the dangers of

appropriation and misrepresentation. Alex's involvement in Berlin was quite critical for us to move forward with the project, and I could not bear to allow the stories that we had uncovered to go untold. But I believe that scholars and curators really do have to pay attention to the needs, desires, and vulnerabilities of groups to which they do not themselves belong, and building trust takes time. Perhaps in ten or twenty years, we can gaze upon this history with less pain. One can only hope.

AS: I imagine that in the future, growing ecological attunement will allow more intuitive and urgent links to be made between the modern creation of sexual difference (or, alterity) and the disastrous "invention of nature" as separate from the human. That the history of sexuality is tied to a very specific set of conceptual relations with the Earth. I hope that contemporary efforts to activate diversity and multiplicity through the open spectrum of queerness will be seen as a vital continuation of what Saidiya Hartman describes as the "incomplete project of freedom."[6] I wish that for those in the future, queer liberation will address much more than localized sex and embodied identity, and its demands will move beyond inclusion within the modern representational trope of the "citizen." Rather, the work we are doing and hope our exhibitions will continue to do is to demand that we meet the future-imperfect world in all its complexity and that, hopefully, those in the future will see us as timely.

Heike Bauer is professor of modern literature and cultural history at Birkbeck College, University of London. She has published widely on sexology, literature, and the modern history of sexuality, and on the rise of queer and feminist graphic novels. Her most recent book is *The Hirschfeld Archives: Violence, Death, and Modern Queer Culture* (2017; available open access: www.oapen.org/search?identifier=628406). She is now at work on a cultural history of the dangerous dog.

Meg Slater is assistant curator in the International Exhibition Projects Department at the National Gallery of Victoria (NGV). Slater has an interest in the potential for large art museums to center traditionally overlooked subjects through exhibition making and programming, particularly queer histories and identities. Slater works on many of the NGV's major international exhibitions and is part of the curatorial team developing the forthcoming *Queer* (2022). Slater recently completed a Master of Art Curatorship at the University of Melbourne.

Ashkan Sepahvand (°1984, Tehran) is a writer and artistic researcher. His practice is text based and highly collaborative, taking form as publications, performances, situations, and study. He has presented his work at the Fifty-Eighth Venice Biennale, dOCUMENTA (13), Sharjah Biennials X & 13, Gwangju Biennale 11, Ashkal Alwan, Sursock Museum, and ICA London, among others. Currently, he is pursuing a PhD in fine art at the Ruskin School of Art, University of Oxford, where he is a Clarendon-AHRC Scholar.

Katie Sutton is an associate professor of German and gender studies at the Australian National University. She is the author of *Sex between Body and Mind: Psychoanalysis and Sexology in the German-Speaking World, 1890s–1930s* (2019) and *The Masculine Woman in Weimar Germany* (2011), and articles on the history of gender, sexuality, and sexology in early twentieth-century Germany, including interwar trans subcultures.

Annette F. Timm is professor of history at the University of Calgary and editor of the *Journal of the History of Sexuality*. Specializing in twentieth-century German and European history, she is the author of *The Politics of Fertility in Twentieth-Century Berlin* (2010) and coauthor of *Gender, Sex, and the Shaping of Modern Europe: A History from the French Revolution to the Present Day* (3rd edition forthcoming) and *Others of My Kind: Transatlantic Transgender Histories* (2020).

Jeanne Vaccaro is a scholar-curator at the ONE Archives. She teaches trans and queer theory at the University of Southern California, and her publications have appeared in *GLQ*, *TSQ*, and *Trap Door: Trans Cultural Production and the Politics of Visibility* (2017).

Notes

1. Azoulay, *Potential History*.
2. Bakker et al., *Others of My Kind*.
3. Meyerowitz, *How Sex Changed*.
4. Johnson, "Bring Your Own Body."
5. Eckert, *Wie alle, nur anders*; Bakker, *My Untrue Past*.
6. Hartman, "Venus in Two Acts," 4.

References

Azoulay, Ariella Aïsha. *Potential History: Unlearning Imperialism*. New York: Verso, 2019.

Bakker, Alex. *My Untrue Past: The Coming of Age of a Trans Man*. Victoria, BC: Castle Carrington, 2019.

Bakker, Alex, Rainer Herrn, Michael Thomas Taylor, and Annette F. Timm. *Others of My Kind: Transatlantic Transgender Histories*. Calgary: University of Calgary Press, 2020.

Eckert, Nora. *Wie alle, nur anders: Ein transsexuelles Leben in Berlin*. Munich: C. H. Beck, 2021.

Hartman, Saidiya. "Venus in Two Acts." *Small Axe* 12, no. 2 (2008): 1–14.

Johnson, Rin. "Bring Your Own Body." *Brooklyn Rail*, November 5, 2015. brooklynrail.org/2015/11/artseen/bring-your-own-body.

Meyerowitz, Joanne. *How Sex Changed: A History of Transsexuality in the United States*. Cambridge, MA: Harvard University Press, 2002.

Bikinis and Other Atomic Incidents:
The Synthetic Life of the Nuclear Pacific

Sunny Xiang

On March 24, 1959, Pearl S. Buck's first play, *A Desert Incident*, opened on Broadway. Just four days later, the curtains closed to a chorus of backlash. This reception history says as much about the cultural tastes and social mores of the 1950s as it does about the content of Buck's play. Indeed, what may be most remarkable about the resounding failure of *A Desert Incident* is the consistency with which critics took issue with one specific aberration: the apparently inexplicable fact that in a play about US nuclear testing, the female characters all entered the stage wearing swimsuits. Walter Kerr, for example, jokes that Buck's conception of a scientist is "a man who surrounds himself entirely by women who make their first appearances in Bikinis."[1] Along similar lines, Don Ross wonders why two nuclear scientists would have "a conversation about life and death issues while sharing the stage with a blond in a Bikini who flexed her stomach muscles rather fetchingly."[2]

Despite such expressions of incredulity, the bikini blonde was actually a staple of mid-twentieth-century atomic culture. According to Traci Brynne Voyles, "white women's sexuality helped the public acclimate to atomic technology and make sense of what it meant to live in an atomic age." In treating the hypervisualization of white women as a strategy of acclimation to nuclear technology, Voyles also calls attention to the corresponding move of hyperocclusion: "The eroticized specter of white women in the desert worked partly by erasing how the histories of nuclearism, settler colonialism, and racial violence were all deeply intertwined."[3] The fact

Radical History Review

Issue 142 (January 2022) DOI 10.1215/01636545-9397030

© 2022 by MARHO: The Radical Historians' Organization, Inc.

that Buck's critics referenced the bikini swimsuit without recognizing that it is the namesake of an atomic test site in the Marshall Islands shows just how effective white femininity has been in legitimizing US atomic power. In Teresia K. Teaiwa's analysis of the bikini, the United States' spectacle of military prowess and sexual allure is coextensive with its disavowal of racial and imperial violence: "The bikini bathing suit manifests both a celebration and a forgetting of the nuclear power that strategically and materially marginalizes and erases the living history of Pacific Islanders. The bikini emerges from colonial notions that marginalize 's/pacific' bodies while genericizing and centering female bodies."[4]

Building on Voyles and Teaiwa, I want to query how the hypervisualization of gender and sexuality interacted with the more muted forces of imperialism, settler colonialism, and racism during the United States' mid-twentieth-century pursuit of a free world order backed by military might. I am especially compelled by Voyles's and Teaiwa's diagnoses of historical erasure—the erasure of both American empire and Pacific peoples—for such diagnoses recast atomic culture as "a violent unfinishing" and hint at this culture's "absented presences."[5] Erasure, then, is a specific representational scheme that demands an alternate mode of archival encounter. In this essay, it is an incitement to shift the analysis of race and empire from the empirical givenness of absences and presences to the geopolitical pressures that shape habits of perception.

To more concretely explain what I mean, let me return to the bikini blonde that Buck's critics deemed an "incidental distraction."[6] In the first act of Buck's play, we meet not one, not two, but four different versions of this incidental distraction (fig. 1). In a living room surrounded by a desert, the blond in a swimsuit seems to exist for the sole purpose of announcing her incongruity. As a recurring spectacle of the incidental, this figure invites us to interpret the title of Buck's play, *A Desert Incident*, not as a euphemistic description of an atomic bomb but as a literal description of a bikini swimsuit. Of course, what seems even more incidental than the erotic bikini swimsuit is the exotic geographic referent Bikini. Bikini Atoll comes up only indirectly in *A Desert Incident*: we are told that the last time the protagonist had "made a major test he blasted a big island right out of the Pacific Ocean."[7] There is nothing in this play that links Bikini Atoll with the bikini swimsuit. But, I wager, it is precisely Buck's dramatization of Bikini's incidental presence that clues us to how the optics of American nuclearism impacted mainstream representations and normative perceptions of racialized gender.

The visually ubiquitous yet thematically marginal bikinis in Buck's play invite us to take up the incident as a perceptual conundrum. What might it mean to treat the nuclear Pacific as conspicuously incidental rather than grievously invisible in mainstream atomic culture? To answer this question, my essay will track the wide range of fashions that came to be called "bikini." The most counterintuitive case is a

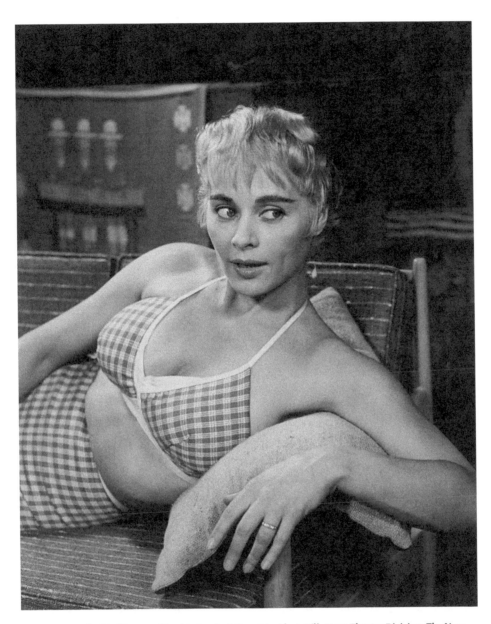

Figure 1. Dorothy Blackburn as Mrs. Horton in *A Desert Incident*. Billy Rose Theatre Division, The New York Public Library.

radiation protective suit designed by Japanese chemist Choichi Tsukada, though most of the bikinis that I discuss fall in the category of women's intimate wear. In drawing on such an archive, I am building my methodology on the belief that American atomic power has broadened the scope of what we typically understand as militarism. The insubstantial and often unseen garments in my study challenge us to consider how

military logistics have influenced the perception of historical meaningfulness—how particular events, subjects, details, or "incidents" have achieved historical legibility. To describe the bikini's racial and imperial dimensions as incidental, then, is not to suggest that race and empire are irrelevant to this garment's cultural import or subordinate to its gender politics, but to ask what the crux of the historical incident, in contradistinction to the fact of the historical event, might reveal about the militarization of racial perception at the dawn of the so-called American Century. By locating the racial politics of American nuclearism in the incidentality of the bikini swimsuit, I seek to complicate the assumption that our analysis of race necessarily begins with empirically accessible and visually indicative traits. Identifying the bikini as an overt but unremarkable incident of racial, imperial, and settler colonial violence, I believe, can offer new insights on the visual interplay between white femininity and primitive sexuality—an interplay that, I argue, was integral to establishing domestic virtue and modern living as atomic age touchstones of "peace."

The following pages take the intimate fashions that go by the name of "bikini" as an unlikely record of the nuclear Pacific. Through these incidental fashions, we can come to understand the disproportionate influence of women's support garments on an atomic age discourse of "better living through chemistry."[8] Beginning in the 1940s, chemically produced fibers such as lastex, nylon, Terylene, and Lycra became the key selling point of exquisitely delicate yet highly structured "foundationwear." These synthetic fibers not only introduced a new atomic vocabulary into American society, but they also inculcated cold war values such as freedom, comfort, and protection—values that appeared as often in fashion advertisements as they did in policy briefs.

Intimate garments made of synthetic blends were deemed "chemical miracles." And yet, these test-tube garments tended to appear in shades such as neutral, nude, and natural. This paradoxical evocation of the artificial and the natural is one defining feature of a cold war period style called "atomic." What I want to show is that an atomic style's preoccupation with artificial nature includes a surreptitious commentary on racialized gender. I will elaborate on this claim through an analysis of the bikini's achievement of propriety within a broader fashion revolution spurred by the use of high-tech fibers in swim, sleep, and support garments. These garments that hug the body and skim the skin were markedly gendered and subtly racialized. Such a dynamic is evidenced not only by the invention of the bikini but also by the contemporaneous circulation of numerous exotically named intimate apparel, such as Bali, Cleopatra, Sari, and Sarong. When encountering such garments, we rarely think about their ethno-racial signifiers. To make sense of this explicit yet incidental racial referencing, I explore how an atomic ideal of nature arose from an imperial desire for security in the face of extreme risk—both the global risk of nuclear war and the domestic risk of sexual promiscuity. In examining how the bikini became a

proper garment that could protect and liberate white femininity, I frame the nuclear Pacific as seemingly incidental but ultimately indispensable to American articulations of freedom.

Nature's Future: Venus Ascending

To begin understanding how gendered representations of tropical islands such as Bikini came to align the atomic subjugation of nature with a sense of boundless possibility, we might look to "Synthetica," an imaginary landmass that appeared in a 1940 *Fortune* article. *Fortune*'s map of Synthetica features countries such as Melamine, Acetylene, Alkyd, and Petrolia and two islands named Nylon and Rayon. This map is accompanied by a caption that describes how "countries march right out of the natural world . . . into the illimitable world of the molecule."[9] Jeffrey Meikle has observed that the shape of Synthetica resembles South America and Africa, colonial strongholds where precious resources could be had only through great cost and effort.[10] But American discussions of synthetics employed the visual vocabulary of European empire as taunt rather than homage. Chemical synthetics, in their ability to generate new forms ex nihilo, not only rescued domestic industries from nature's contingencies, but they also liberated American modernity from a colonial history of exploitative practices. If Enlightenment-era expeditions codified the language of reason, the "world of the molecule" traded on illusion. In opening a frontier that tested the limits of empirical knowledge, the molecule infused quaint tales of territorial conquest with a cosmic element, such that the age of the atom synchronized with that of the space race.

Chemistry's utopian powers of transmutation reached their most cosmic heights in the mundane space of the home, where ordinary housewives became smartly dressed and technologically savvy goddesses. Accordingly, the symbolic embodiment of synthetics during this time was Venus, a classical ideal of chiseled beauty that was reincarnated as a surrealist fantasy of endless mutations. For instance, the same *Fortune* article includes an image captioned "An American Dream of Venus" (fig. 2). An allusion to Salvador Dalí's *Dream of Venus* pavilion, *Fortune*'s sleekly sculpted yet fluidly shapeless Venus is surrounded by, adorned in, and veritably made of plastic.[11] Other synthetic adaptations of Venus include Miss Chemistry, the glamorous woman who, at the 1939 New York World's Fair, emerged from a giant test tube; the "plasticized parody" of Botticelli's Venus that appeared in *Barbarella* (dir. Roger Vadim, 1968); and André Courrèges's invocation of the Hottentot Venus to call for "the liberation of woman's body in our hectic space age."[12] These American Venuses offer racially inflected visions of exploration that transcend physical and biological constraints. Their mythological dimension is what prompted Roland Barthes to describe synthetics as "the first magical substance which consents to be prosaic."[13] In kitchens, living rooms, and bedrooms, these

Figure 2. "An American Dream of Venus," *Fortune*, p. 88.

chemical elixirs displaced solid forms with malleable substances and remade the corporeal body into an exquisite corpse of plastic parts. As Barthes might put it, the atomic mythology of Venus transformed "the reality of the world into the image of the world, History into Nature."[14]

By visualizing the atomic age through Synthetica and Venus, *Fortune* shows how the chemical appropriation of nature begot a sexually loaded and racially suggestive archipelagic imaginary. To a degree, such an imaginary extends earlier representations of distant Pacific isles—primarily Polynesia and specifically Tahiti—as an "Empire of Love."[15] The romantic bent of this French imperial tradition often drew on the figure of Venus to endow the Native islander with a Europeanized nobility. Bikini, however, is an atoll in the Marshall Islands located in Micronesia. Due to their darker complexion, Micronesians have generally been excluded from the Venus canon. What is more, Bikini entered the American consciousness as a Japanese territory and a theater of war. During World War II campaigns, the American press cast Bikini as desolate and depressing rather than a romantic escape.[16] This image of Bikini began changing in the postwar years when the Marshall Islands became a US trust territory. In 1946 Harry Truman's administration selected Bikini as a nuclear test site or, to use the official terminology, Pacific Proving Grounds. To be sure, Bikini was not the only proving ground for nuclear tests, and the United States was not the only empire to conduct such tests. But the military and cultural itinerary of the term *Bikini* makes it especially instructive for showing how the atomic conquest over nature, whether by way of otherworldly bombs or miracle fibers, helped white middle-class citizens understand their freedom as Americans.

Bikini: Skin or Suit?

As Rey Chow has proposed, the "significance of the atomic bomb" is that "everything has become (or is mediated by) visual representation and virtual reality." Chow argues that this instrument of unprecedented and unfathomable power decisively altered "the visual rules and boundaries of war," so that "war was no longer a matter simply of armament" and "became redefined as a matter of the logistics of perception."[17] Most famously, these logistics of perception involved using the bomb as a propagandistic tool to solicit public support: the US government portrayed atomic power as both a weapon of mass destruction and a means of peaceful deterrence. The perceptual problem that is of more interest to me is how the bomb created the impression that history happens when the force of change takes the visual and temporal form of an explosion. This historiographic bias toward violent eventfulness explains why the first Bikini detonations on July 1, 1946, drew "more than half of the world's supply of motion picture film."[18] Yet because of a "Cold War nuclear optic"—an optic that has decontextualized, aestheticized, and naturalized the violence of US nuclear technologies—the Bikini tests, though prolifically documented then, largely go unremembered today.[19] Public memory and scholarly attention are far more concerned with the two bombs that the United States dropped on Japan on August 6 and 9, 1945, than with the sixty-seven bombs it detonated on Bikini and neighboring atoll Enewetak between 1946 and 1958.

The Marshallese are still living with the environmental and health effects of these detonations, but outside of the Pacific, the nuclear legacy of Bikini has become overdetermined by what in 1946 had seemed incidental: the image of actress Rita Hayworth in a strapless gown that had been tacked onto the nose of the bomb. This image of Hayworth is from the 1946 film *Gilda*, which, during the Bikini tests, had been showing in the Kwajalein theaters.[20] This film famously popularized the strapless dress—a feat of structural engineering that, thanks to "the technical skill involved in its design and construction," could exhibit a woman's buoyancy "without visible means of suspension." *Gilda* is thereby an unexpectedly fitting name for a new weapon of mass destruction, insofar as Hayworth's daring dress, like the bomb on which it appears, served to reassure the American public that these risky new technologies "need not threaten involuntary exposure."[21]

Emblazoned on a bomb named *Gilda*, Hayworth's strapless gown is significant in that its implicit punning of sexual exposure and nuclear exposure anticipates the introduction of an even more revealing garment. On July 5, just four days after the Bikini detonation, a showgirl named Micheline Bernardini debuted a new swimsuit designed by Louis Réard called "the Bikini" at a Paris poolside pageant. Réard's Bikini was different from the "two-piecers" that had begun appearing on American beaches in the 1930s. What distinguished this new style, moreover, was not the bra top, which would become more iconic in later years. The singular feature and spectacular scandal of Réard's creation resided "in the extreme gravity of the Bikini trunks." A 1947 article explains, "All 'Bikinis' show the navel; some are little more than G strings."[22]

Though a French national, Réard was clearly engaging fashion through the framework of American geopolitics. Not only did he name his swimsuit after the American nuclear tests, but his model Bernardini, after winning the pageant, had posed for cameras in "the stance of the celebrated Statue of Liberty."[23] In the United States, ironically, the Bikini bomb gained moral acceptance far more easily than the bikini swimsuit. Between 1946 and 1954, the bikini was an openly repressed presence in American society. Industry experts welcomed swimwear season every year by pronouncing that the offensive garment was on its way out. When discussed at all, the bikini was associated with the sordid rituals of the French Riviera (in particular, Saint-Tropez's aptly named Tahiti Beach). Bikinis that did appear in American fashion were often novelty items, not meant to be worn—for example, a mink bikini inspired by Davy Crockett or a chinchilla bikini with diamond brooches that cost $100,000.[24] Even as the fashion world renounced and lampooned the shocking swimsuit, designers attempted to capitalize on the atomic allure of the term *Bikini* (usually capitalized and/or in quotations) by applying it to things other than swimwear. Notably, American outlets paid little attention to Réard's new suit in July 1946 and instead opted to showcase a new line of hats called "Bikini Silhouettes."[25] The 1950s also brought Bikini earrings, sweaters, skirts, and frocks. A Bikini

hue appeared on mid-century color wheels. Referring initially to blues and later to nudes, the color Bikini could be found on shoes, sweaters, handbags, hosiery, and kitchen tiles.

As the signifier *Bikini* became rerouted within American fashion in the 1950s, the multiply displaced islanders who called Bikini home were struggling for another kind of legibility. The United States' disregard for the Bikinians and other Marshallese went hand in hand with its aggressive pursuit of a nuclear testing program on their islands. While the nuclear test of July 1946 had been a carefully orchestrated visual spectacle, subsequent bombs were exponentially more explosive yet significantly less seen. The most notorious test was *Bravo*, a hydrogen bomb detonated on Bikini on March 1, 1954. *Bravo* was one thousand times the force of the Hiroshima bomb. Because US personnel had neglected to evacuate nearby atolls, the detonation ended up exposing the Rongelapese to 175 rads (units of radiation) and the Utirikese to 14 rads.[26] Despite the severity of their exposure, these islanders had to wait three days before the US Navy removed them from their now radioactive homes—a delay believed to be deliberately engineered to secure human guinea pigs.[27] The eventual exposé of *Bravo*'s detrimental effects was enabled by the Japanese state, an entity more geopolitically powerful than any Marshallese governing body. And it is because of Japan's legibility as a viable claimant for atomic reparations that the first people to receive widespread recognition as "Bikini victims" were not the Bikinians, Rongelapese, Utirikese, or Enewetakese, but twenty-three Japanese fishermen who had come into the pathway of nuclear fallout. The antinuclear protests sparked by *Bravo* put a damper on glossy proclamations about the bomb's humanitarian ends.[28] But even as this global news story turned the tide against nuclear stockpiling, it also had the effect of further marginalizing Marshallese voices and perspectives.

The elision of Bikinians in a story about "Bikini victims" provides the context for the emergence of a new bikini suit designed by Tokyo chemist Choichi Tsukada. This bikini began making the rounds of American newspapers in April 1954. Like the mink bikini, Tsukada's bikini was mostly treated as comic relief in the American press ("Don't laugh, you'd look pretty funny too in a Bikini H-bomb suit").[29] And like the other knickknacks that appropriated the Bikini name, this design was not a swimsuit. Consisting of jacket, trousers, belt, gloves, and an elaborate headgear of lead-coated wire mesh and white cotton sheeting, Tsukada's bikini was more akin to a spacesuit. In this regard, this bikini suit was less an article of clothing than a protective wearable environment: the cotton sheeting served to deflect heat flash; the belt contained a device to purify the air; and the lead compound, patented by Tsukada in 1953, promised to reduce the effects of radioactivity.[30] In debuting his suit on the heels of the *Bravo* catastrophe, Tsukada shows the ease with which the bombing of Bikini became assimilated into Japan's own experience of American nuclear power. At the same time, Tsukada's suit made it newly possible, even in small ways,

for Americans to grasp the double meaning of the term *Bikini*. One observer, making a tongue-in-cheek reference to both the nuclear test site and the explosive swim brief, quipped that Tsukada's bikini is "the Pacific style, not the abbreviated Riviera beach costume."[31]

At first glance, the all-enclosing spacesuit and the all-exposing swimsuit seem functionally and aesthetically opposed. One journalist writes, "Where the earlier version of the bikini suit aimed to cover as little as possible, [Tsukada's] model is designed to conceal as much as possible."[32] Tsukada's invention is a comprehensive suite of coverings, something that is more inhabited than worn. Meanwhile, the bikini swimsuit tends to be associated with nakedness, and, according to Richard Martin and Harold Koda, "is not a 'suit' by any strict etymology." Martin and Koda go on to assert, though, that the term *suit* nonetheless remains appropriate, for the bikini is, in the final instance, a "complete assembly": it constitutes "the decisive limit of civilized clothing, the ne plus ultra of the wardrobe."[33] The Bikini arguably became a suit in 1954. Tsukada's invention notwithstanding, this was the year when the bikini suit and the Bikini site both made headlines, but never the same headline. This momentary doubling had an eclipse-like effect, whereby the island of Bikini faded from public view as bikini fashions gained prominence and, eventually, prosaicness.

The prosaic bikini was one that came to be dissociated from the socially exceptional "moments of revelation at the beach" and made its way into "the streets and communities and cities" where one finds the socially endorsed "definition for the proper."[34] In its capacity as a "proper" garment, the bikini swimsuit was not so different from the bikini spacesuit: both these garments aimed to protect the body through technological ingenuity. It is worth noting here that Réard, the bikini's inventor, had once been an automotive engineer and observed that "it did take some engineering to design a bikini that would stay on."[35] The bikini that could stay on and support the body—the bikini that could define the proper—borrowed technology and terminology from the foundationwear industry. Foundations such as corsets, girdles, and bras required designers to think about modesty alongside structural concerns—support, weight, balance, and pressure. These garments became a fashion necessity during World War II, when new workingwomen sought clothing that could help them meet the physical demands and long hours of booming wartime industries. According to one industry executive, foundationwear introduced an "utterly new principle of support," such that "the functional factor of the 'Foundation' is more and more added to the factor of fashion."[36]

What made support a reality for foundation designers was the invention of nylon, a high-performance fiber that boasted unprecedented shaping capabilities. Nylon was unveiled by the chemical company E. I. du Pont de Nemours and Company, better known as DuPont, on the eve of the United States' declaration of war against Japan. As hostilities intensified, an embargo halted American access to silk,

90 percent of which had been imported from Japan and three quarters of which were being used for women's stockings.[37] In this wartime scenario, DuPont nylon took on new meaning: to claim nylon's superiority to silk was to claim the United States' superiority to Japan.[38] It was even rumored that the word *nylon* was an acronym for "Now You Lousy Old Nipponese."[39] When the US government commissioned nylon for military use, Hollywood stars and housewives alike publicly donated their stockings to serve the war cause. Nylon's sensational success is featured far more prominently in DuPont's history books than the company's role in the Manhattan Project. Yet these stories are functionally inseparable. According to Pap A. Ndiaye, many of the DuPont engineers working on the plutonium bomb destined for Nagasaki had in fact come from the company's nylon division.[40] After World War II, nylon came to signify a different mode of warfare, one that crystallized a cold war politics of capitalist abundance. In 1951 David Riesman used the term "Nylon War" to describe the US government's "all-out bombing of the Soviet Union with consumer's goods."[41] But although DuPont and other chemical corporations made a concerted effort to shift their focus from military to civilian industries during these post–World War II years, the synthetics revolution nonetheless brought these industries together in startling ways. As Matthew Hersch shows, synthetic fibers revolutionized two kinds of "pressure suits," one among foundationwear makers and the other among aeronautical engineers. Astronaut Gus Grissom had reportedly worn a panty girdle when the Mercury-Redstone 4 was found to be lacking in stabilizing equipment.[42] And, not incidentally, it was an aeronautical engineer whom a film director summoned to design "a bra on the suspension principle" when an actress's "ample bosom" proved to be unmanageable.[43]

Second Skin: Natural Nakedness

What a foundational garment shares with a wearable environment is a preoccupation with infrastructural support at the most intimate level. In this shared preoccupation with infrastructure and intimacy, both the space industry and the underwear industry came to adopt the visual metaphor of "second skin." For example, second skin is frequently invoked by designer Ruben Torres, who, with DuPont's sponsorship, created various space-themed Lycra undergarments in the 1960s that could be worn as outerwear. In describing a lingerie line called "Moon Era," Torres says, "The emphasis here is on the natural shades . . . as the foundation is used increasingly as a second skin, rather than a distinctive item of clothing. I have chosen fabrics that are supple and lightweight, in keeping with the graceful femininity required of lingerie . . . yet powerful enough to fulfill their task as foundations."[44] Torres's designs offer a usefully hyperbolic version of how synthetics contributed to the ideology of foundationwear. His incorporation of outer space into inner wear dramatizes how second-skin garments came to be a kind of enclosure that holds out the promise of radical openness and perpetual change. A similar messaging appears in

far more ordinary contexts. In a 1957 article, *Vogue* writes that "all-in-one founda-tions" derive their special powers from nylon, among other synthetic fibers. A gar-ment spun of such fibers is "like a second skin: not a bone in its body."[45] By assuming the guise of skin, even the most delicate garments could "protect," "hug," "caress," and "liberate" a woman's most erogenous and most imperiled zones. Unlike the heavy boning of bygone corsets, which sought to discipline and control the body, second-skin foundations provided comfort and support, in the way of loving friends.

The prominence of the term *second skin* within the intimate wear industry offers an atomic age exemplification of what Anne Hollander calls "'natural' naked-ness." Hollander writes, "A sense of 'natural' nakedness in actual life is trained more by art than by knowledge. . . . The unclothed costume . . . will be worn, according to this mode, in correct period style—and consequently even nude snapshots will betray their date."[46] As a term that simultaneously connotes nakedness and suited-ness, second skin underscores both the fragile innocence and the frontier grit of the white American body in the age of nuclear deterrence. The attempt to substantiate the dangers of nuclear war through representations of the nuclear family is a running theme of atomic culture. In its most unambiguous form, this theme can be found in images of nuclear families holed up in nuclear shelters—shelters that replicated the synthetic interiors of suburban homes. We might think of intimate wear as a more quotidian version of these fallout shelters. The synthetic skins that both protected and liberated white women remind us of what is at stake in the American bid for nuclear dominance. That is, depictions of domesticity under threat served not only to secure a democratic free world but, more precisely, to ensure the social reproduc-tion of whiteness. Whiteness, then, as scholars have shown, is more than a matter of discrimination or exclusion; it is a project of possession with respect to both land and identity claims.[47]

In the context of the nuclear Pacific, possession has been authorized by the logics of militarism and normalized through the logistics of perception—through atomic stylizations of nature. The bikini offers an especially representative case of how the settler colonial impulse shared by the fashion industry and the war industry generated new representational paradigms for racialized gender by exploiting the rhetoric of a wholesome nature and, relatedly, the visual analogy between suit and skin. Indeed, the transformation of the erotic and exotic bikini into everyday wear—a transformation catalyzed by synthetic fabrics that imitated the natural look of skin—offers an instructive allegory of race and empire in the atomic age: the bikini's spectacle of natural nakedness, when assimilated into the visual domain of everyday domestic life, signals not only a desire to shield white womanhood from sexual expo-sure and nuclear exposure but also a willingness to sacrifice Indigenous lives, lands, and lifeways towards this putatively noble aim.

The domestication of the bikini into a proper garment was enabled by its reclassification as a form of demure innerwear. Up until the mid-1950s, most

American cities had restricted the use of bikini swimsuits to personal pools and balconies. When worn in public, bikinis were essentially three-piece suits, consisting of a bra, a brief, and a covering of some kind. In both these scenarios, the bikini was more akin to an inner garb—something worn either within a domestic setting or underneath an outer covering. The most widespread tactic for domesticating the bikini was the convertible style, which became known as the American bikini. These garments came with strings, straps, and buttons that allowed the bottom garment to be pulled high or worn low. In 1959 the underwear company Warner took the convertible suit to the logical extreme with a "pantie girdle" that could be "convert[ed] to a bikini for sunning."[48] Warner's suit, as both girdle and bikini, made the boundary between bedroom and beach exceptionally porous. No surprise, then, that during the years when the bikini was publicly shunned as a swimsuit, this same garment voraciously usurped the fashions that symbolized propriety—sleepwear, loungewear, and, most significantly, foundationwear. For example, in 1952 Olga introduced the "bikini garter girdle" in "nylon power lace," and Diane showcased the "Bikini pantie garter belt" equipped with "embroidered nylon sheer."[49] A 1958 DuPont nylon ad instructed women that the "very best way to enhance your spring wardrobe is with a 'foundation wardrobe,'" consisting of "girdles rang[ing] from swim-suit briefs to Bermuda beautifiers."[50] Such ads, in presenting the bikini as a style of girdles, combine the most seductive and the most pedestrian of fashions. Unlike the bikini-clad sirens of the beaches, the bikinis of the bedroom and the fitting room often took on a chaste bridal theme. The bikini-as-foundationwear trend came full circle in the 1960s when swimsuits, too—now called "slim suits," "skimmers," and "torso suits"—became associated with shaping and slimming rather than sexual display.

A 1964 *Vogue* article credits the bikini with establishing "the new sense of skin as a part of fashion, a reflection of glorious health." It would be more precise, though, to view this salubrious trend toward "more bareness"—toward synthetic cladding as a kind of wholesome exposure—as the byproduct of the collusion between the militarized culture of chemistry, the settler project of representational appropriation, and the racial ideology of whiteness.[51] Put another way, the bikini's inculcation of natural nakedness as "a part of fashion" depended on an updated visual idiom of scientific racism that made bare skin and synthetic skin virtually indistinguishable. This atomic era reconceptualization of nature and culture vis-à-vis skin adds a layer of historical nuance to scholarly discussions of racial surfaces. Critics such as Michelle Stephens, Shirley Tate, and Jennifer Biddle have contested characterizations of skin as a hardened container on which racial traits appear as immutable inscriptions.[52] Within this larger movement toward reimagining racialized skin as permeable, relational, inscrutable, and hybrid, the works of Sean Metzger and Anne Anlin Cheng are particularly relevant because of their focus on clothing. If we borrow Metzger's terminology, the skin made of synthetics also

constitutes "the skein of race." For Metzger, *skein* names a mode of racial interrogation that "emphasizes bodily forms and surfaces but without immediate recourse to residual biologisms."[53] Cheng's metaphorization of skin as *surface* rather than skein advances a similar line of inquiry, but with nudity rather than clothing as a starting point. Her analysis of "second skin" vis-à-vis Josephine Baker's stylizations of nakedness helps clarify the primitivist preoccupations of European modernism. For Cheng, "second skin" describes a dynamic interchange between organic and inorganic coverings—a phantasmic liveliness that troubles the "basic assumptions of a racial discourse that aligns skin with the corporeal and the intractable."[54] Both Metzger and Cheng survey the long twentieth century in theorizing racialized skin as less biological, less corporeal, and less natural than has been supposed. In these accounts, race is less a social construct than an inorganic one. In the context of US nuclearism, however, second skin has presented the opposite scenario: synthetic fabrics, as I have shown, tend to become less inert, less artificial, and less "plasticky" in their imitation of utopian nature. Because of this atomic return to nature, racial signifiers such as *bikini* have become abstracted almost beyond recognition. So, whereas European high modernism spearheaded a racially essentialist trend of "going native," American atomic culture can be described as using second skin to propagate an ostensibly more salutary aesthetic of "going natural."

The racial connotations of "going natural" are far more ambiguous than those of "going native." For example, although natural tones in atomic age underfashions generally meant a virtuous lily white, the embrace of bareness in swimwear during this same period was concomitant with an investment in tanning as a form of restorative skin care. What makes chaste white skin and healthy tanned skin equally viable touchstones for "going natural" is that both these skins blur the boundary between atomic facades and anatomical truths. When this blurring inheres in a sexually marked and racially attenuated cultural artifact such as the bikini, it reminds us that the atomic imitation of an edifying nature is also a projection of futurity on militaristic terms. The visualization of nature's future by way of synthetics, in other words, depends on the militarized logistics of racial and gender perception cultivated by American nuclearism. The synthetic bikini's foregrounding of white femininity moralizes the need for preemptive defense and risk management while transforming race, Indigeneity, and imperialism into a representational problem—into a visually manifest and historically forgettable incident.

The Bikini Incident

The preceding discussion helps explain how the peculiar reappearances of the bikini in Pearl S. Buck's *A Desert Incident* complicate the familiar lesson of cold war liberalism—which is that the housewife's route of "going natural" is more humane than the scientist's route of "going nuclear." Buck's moral stake in "going natural" is apparent from the start. In her play's opening scene, a scholarly gentleman named

Dr. Ashley pontificates about "primitive woman" during "the dawn of human life." Ashley's valorization of woman's "natural superiority" juxtaposes the primordial values of biology with the corrupt values of science. This gendered juxtaposition is brought to a head by the bikini-clad housewife. In leading the campaign to prevent the atomic tests, this sexually charged body secures a cozy domestic world hospitable to natural creation and prevents the atomic catastrophe augured by scientific creation. In such a rendering, the long-noted gendering of the split between the public sphere and the private sphere gains renewed authority through a homologous split between distant wars in the darker, underdeveloped world and placid domesticity on the American home front.

Buck's strident advocacy of nuclear domesticity over and against nuclear science means that despite the titular setting of the bleak desert, it is the "inviting house where arguments are contained" (fig. 3).[55] But does the inviting house really contain all the arguments? And is the house even a hermetic container? Even though the play's action never leaves the "inviting house," the glass walls of this house render the stark desert landscape ever present, if only as an incidental background that brings into relief the lushness of the living room. Buck's characters describe this "hideous jerry-built town in the desert" as if the US military and the corporate contractor Durand (a clear reference to DuPont) are its first inhabitants. But one can also think of the cartoonish cacti, looming outside yet nearby, as an injunction to read otherwise. As scholars have shown, Navajo country, once bursting with agricultural bounty, was made into a barren "wasteland" in the name of uranium mining.[56] The trope of the desert as a wasteland, akin to the trope of the uninhabited island, thus describes not an actual geography but a process of materializing the pollutability of an environment and the exploitability of its inhabitants. Like the hovering cacti, the play's myriad bikinis both announce and efface the boundary between an intimate interior and an ominous exterior. Beachwear may seem out of place in the living room and the desert. Yet, by placing the bikini blonde in a domestic enclosure, Buck establishes female sexuality and white reproductivity as moral goods sanctified by nature.

My investigation of this instability between inside and outside, skin and suit, has shown that explicit representations of white femininity can evidence not so much the traumatic erasure of race as the uncanny presence of race. Admittedly, this form of racial presencing offers limited redemptive value, and I certainly do not intend it as an alternative to the powerful historical correctives produced by Pacific artists, activists, scholars, and allies. In their efforts to engage the ongoing violence of US nuclearism, Hone Tūwhare, Teresia Teaiwa, Albert Wendt, Stewart Firth, Kathy Jetñil-Kijiner, and Aanchal Saraf are among those who have insisted upon Marshallese survivance, Pacific interconnection, Indigenous worldviews, and ethical witnessing. The question that I have grappled with is how to advocate for Pacific self-determination without appropriating it and how to clarify the

Figure 3. Living room scene in *A Desert Incident*. Billy Rose Theatre Division, The New York Public Library.

cultural logic of American empire without recentering whiteness. With these aims in mind, this essay has shown that the neat binaries of white and other and absence and presence are precisely what an atomic style disables. To account for the incidentality of racial signifiers, I have attempted to read for what cannot be contained in the living room and what cannot be erased by white representation. The focus of such a reading practice has been not an empirically given and fully present body, but this body's impressions and imprints—its embedment within, and fusion with, various synthetic coverings. By reframing the bikini as a site of maximal confusion between synthetic skin and bare skin, I have demonstrated that securing white femininity in its natural form has been possible only through a racialized regime of atomic experimentation. Race may remain visually incidental to popular

conceptions of the bikini, but this flagrantly incidental quality does not mean that race is inessential; it means that race is indelible. The incidence of the bikini's naming, then, is not an eccentricity lacking in historical necessity, but an altogether paradigmatic case of how racially motivated and geopolitically sanctioned forms of dispossession have enabled imperial security, settler innocence, and white life.

Sunny Xiang is associate professor of Asian/Pacific/American literature and culture in the English Department at Yale University. Her first book, *Tonal Intelligence: The Aesthetics of Asian Inscrutability during the Long Cold War*, was published in 2020. She is currently working on a project that explores how US-sponsored nuclear experiments revolutionized cosmetics, clothing, infrastructure, and other fashion genres.

Notes

1. Kerr, "Desert Incident."
2. Ross, "Pearl Buck Musical Making Bow."
3. Voyles, "Anatomic Bombs," 654, 664.
4. Teaiwa, "Bikinis and Other s/pacific n/oceans," 87.
5. McKittrick, "Mathematics Black Life," 25, 22. McKittrick is writing about the archive of slavery, but her call for an archival method that acknowledges but does not repeat the violence of Black erasure inspires my own efforts to give historical legibility and critical meaning to what passes as absence.
6. Kerr, "Our Stage in Caricature."
7. Buck, "Desert Incident."
8. "Better living through chemistry" and "Better Things for Better Living . . . Through Chemistry" were the coinages of chemical giant DuPont.
9. *Fortune*, "Plastics in 1940," 93.
10. Meikle, *American Plastic*, 64.
11. *Fortune*, "Plastics in 1940," 89.
12. Meikle uses this phrase to describe Barbarella's removal of a black synthetic spacesuit, a process that ends with "the heroine's head in an acrylic fishbowl, face and hair posed like those of Botticelli's *Venus*" (*American Plastic*, 220); Courrèges and Wether, "Is Fashion an Art?," 140.
13. Barthes, *Mythologies*, 98.
14. Barthes, *Mythologies*, 141.
15. Matsuda, *Empire of Love*. See also Margaret Jolly, "From Point Venus."
16. Shalett, "Plane's-Eye View." For surveys of how World War II affected islanders, see White and Lindstrom, *Pacific Theater*; White, *Remembering the Pacific War*.
17. Chow, *Age of the World Target*, 26–27, 32. The phrase "logistics of perception" comes from Virilio, *War and Cinema*.
18. Niedenthal, *For the Good of Mankind*, 3.
19. Hariman and Lucaites, "The Iconic Image of the Mushroom Cloud."
20. *New York Times*, "Test Bomb Named 'Gilda.'"
21. Milford-Cottam, *Fashion in the 1950s*, 33.
22. Chatoy, "Bikini Is Merchandise Now," 5; *Women's Wear Daily*, "Brevity and Femininity."
23. Alac, *Bikini Story*, 25. Earlier that same summer, Jacques Heim, who had allegedly brought the Tahitian pareo to France, introduced his own two-piece number called the

Atome. Patrik Alac recounts the early days of the Bikini and the Atome on pages 20–29. Voyles explores the American eroticization of nuclear power vis-à-vis white beauty queen "mascots" (mostly based in Las Vegas) in "Anatomic Bombs."

24. *Women's Wear Daily*, "Mink Bikini"; *Women's Wear Daily*, "Rome Letter."
25. *Women's Wear Daily*, "Paris Couture Quality Returns."
26. Johnson, "Nuclear Legacy," 58. Johnson writes, "In the absence of intensive medical care, upward of 400 rads can be a lethal dose" (58).
27. Firth, *Nuclear Playground*.
28. Anti-bomb protests were spearheaded by the Japanese left. These Japanese outcries against nuclear testing were amplified by global voices, including those in the United States. In May 1954 the Japanese government organized an expedition to the southern Pacific to study the effects of radiation on sea life. Drawing on samples from the radioactive fishing boat, Japanese scientists disclosed information about the novel H-bomb that the American government had hitherto kept secret (Lapp, *Voyage of the Lucky Dragon*). For more on the Japanese response to American atomic power in the wake of Hiroshima and Nagasaki, see, for instance, Yoneyama, *Hiroshima Traces*.
29. *Oakland Tribune*, "H-Bomb Bikini."
30. Murata, "Chemist Devises Protection." An early iteration of the suit was a collapsible enclosure made of lead-coated iron sheets. When expanded to a three-foot cube, it could—uncomfortably—fit one person.
31. *Oakland Tribune*, "H-Bomb Bikini"; *Rocky Mount Telegram*, "Japanese Designs New Bikini Suit."
32. *Quebec Chronicle-Telegraph*, "Atomic Era."
33. Martin and Koda, *Splash!*, 52.
34. Martin and Koda, *Splash!*, 54.
35. *Dispatch*, "Man Who Invented the Bikini."
36. Drayton, "Retail Executive."
37. Handley, *Nylon*, 34.
38. See for example Albee, "Nylon Goes Aloft."
39. Meikle, *American Plastic*, 138.
40. Ndiaye, *Nylon and Bombs*, 155.
41. Riesman, "Nylon War," 163.
42. Hersch, "High Fashion," 362–63.
43. Ewing, *Underwear*, 162.
44. *Women's Wear Daily*, "Inner Fashions Foundations," ellipses in original.
45. *Vogue*, "Slimming," 103.
46. Hollander, *Seeing through Clothes*, 87.
47. Moreton-Robinson, *The White Possessive*; Arvin, *Possessing Polynesians*.
48. *Women's Wear Daily*, "Novelty Bra and Pantie."
49. *Women's Wear Daily*, "Color Hits Lace Elastic Pantie Girdles"; *Women's Wear Daily*, "Siren Look."
50. DuPont Nylon, advertisement.
51. *Vogue*, "Upshot of Bareness," 141.
52. Stephens, *Skin Acts*; Tate, "'That Is My Star of David'"; Biddle, "Inscribing Identity."
53. Metzger, *Chinese Looks*, 13.
54. Cheng, *Second Skin*, 13.
55. Atkinson, "Desert Incident."
56. Voyles, *Wastelanding*.

References

Alac, Patrik. *Bikini Story*. New York: Parkstone, 2012.

Albee, George. "Nylon Goes Aloft." *DuPont Magazine* 37, no. 3 (1943): 2–5.

Arvin, Maile. *Possessing Polynesians: The Science of Settler Colonial Whiteness in Hawai'i and Oceania*. Durham, NC: Duke University Press, 2019.

Atkinson, Brooks. "'Desert Incident': Drama about Science, Sex, and Sand Opens." *New York Times*, March 25, 1959.

Barthes, Roland. *Mythologies*, translated by Jonathan Cape. New York: Noonday, 1972.

Biddle, Jennifer. "Inscribing Identity: Skin as Country in the Central Desert." In *Thinking through the Skin*, edited by Sara Ahmed and Jackie Stacey, 177–93. New York: Routledge, 2004.

Buck, Pearl S. "A Desert Incident." New York: Studio Duplicating Service, 1959.

Chatoy, Lillian. "Bikini Is Merchandise Now." *Women's Wear Daily*, January 19, 1959.

Cheng, Anne Anlin. *Second Skin: Josephine Baker and the Modern Surface*. New York: Oxford University Press, 2010.

Chow, Rey. *The Age of the World Target: Self-Referentiality in War, Theory, and Comparative Work*. Durham, NC: Duke University Press, 2006.

Courrèges, André, and Beth Wether. "Is Fashion an Art?" *Metropolitan Museum of Art Bulletin* 26, no. 3 (1967): 138–40.

The Dispatch. "Man Who Invented the Bikini Bares His Thoughts." November 7, 1974.

Drayton, Edward. "The Retail Executive: National Retail Advertising Digest." *Women's Wear Daily*, February 26, 1942.

DuPont Nylon. Advertisement. *Seventeen*, April 1958, 28.

Ewing, Elizabeth. *Underwear: A History*. New York: Theatre Arts Books, 1972.

Firth, Stewart. *Nuclear Playground*. Sydney: Allen & Unwin, 1987.

Fortune. "Plastics in 1940." *Fortune* 22, no. 4 (October 1940): 88–95.

Handley, Susannah. *Nylon: The Story of a Fashion Revolution*. Baltimore, MD: Johns Hopkins University Press, 1999.

Hariman, Robert, and John Louis Lucaites. "The Iconic Image of the Mushroom Cloud and the Cold War Nuclear Optic." In *Picturing Atrocity: Photography in Crisis*, edited by Geoffrey Batchen, M. Gidley, Nancy K. Miller, and Jay Prosser, 135–45. London: Reaktion Books, 2012.

Hersch, Matthew. "High Fashion: The Women's Undergarment Industry and the Foundations of American Spaceflight." *Fashion Theory* 13, no. 3 (2009): 345–70.

Hollander, Anne. *Seeing through Clothes*. New York: Penguin, 1988.

Johnson, Giff. "Nuclear Legacy: Islands Laid Waste." *Oceans* 13 (January–February 1980): 57–60.

Jolly, Margaret. "From Point Venus to Bali Ha'i: Eroticism and Exoticism in Representations of the Pacific." In *Sites of Desire/Economies of Pleasure: Sexualities in Asia and the Pacific*, edited by Lenore Manderson and Margaret Jolly, 99–122. Chicago: University of Chicago Press, 1997.

Kerr, Walter. "A Desert Incident." *New York Herald Tribune*, March 25, 1959.

Kerr, Walter. "Our Stage in Caricature as Pearl Buck Sees It: Reopening." *New York Herald Tribune*, April 12, 1959.

Lapp, Ralph Eugene. *The Voyage of the Lucky Dragon*. New York: Harper, 1958.

Martin, Richard, and Harold Koda. *Splash! A History of Swimwear*. New York: Rizzoli, 1990.

Matsuda, Matt. *Empire of Love: Histories of France and the Pacific*. New York: Oxford University Press, 2005.

McKittrick, Katherine. "Mathematics Black Life." *The Black Scholar* 44, no. 2 (2014): 16–28.

Meikle, Jeffrey. *American Plastic: A Cultural History*. New Brunswick, NJ: Rutgers University Press, 1995.

Metzger, Sean. *Chinese Looks: Fashion, Performance, Race*. Bloomington: Indiana University Press, 2014.

Milford-Cottam, Daniel. *Fashion in the 1950s*. London: Shire Publications, 2017.

Moreton-Robinson, Aileen. *The White Possessive: Property, Power, and Indigenous Sovereignty*. Minneapolis: University of Minnesota Press, 2015.

Murata, Kiyoaki. "Chemist Devises Protection against Atom Bomb Radiation." *Nippon Times*, October 11, 1953.

Ndiaye, Pap A. *Nylon and Bombs: DuPont and the March of Modern America*, translated by Elborg Forster. Baltimore, MD: Johns Hopkins University Press, 2007.

Niedenthal, Jack. *For the Good of Mankind: A History of the People of Bikini and Their Islands*. Majuro: Bravo, 2001.

New York Times. "Test Bomb Named 'Gilda,' Honoring Rita Hayworth." June 30, 1946, 3.

Oakland Tribune. "H-Bomb Bikini." April 17, 1954.

Quebec Chronicle-Telegraph. "Atomic Era Demands Practical Considerations." April 20, 1954.

Riesman, David. "The Nylon War." *Review of General Semantics* 8, no. 3 (1951): 163–70.

Rocky Mount Telegram. "Japanese Designs New Bikini Suit." April 16, 1954.

Ross, Don. "A Pearl Buck Musical Making Bow." *New York Herald Tribune*, April 24, 1960.

Shalett, Sidney. "Plane's-Eye View of the Pacific War." *New York Times*, January 14, 1945.

Stephens, Michelle Ann. *Skin Acts: Race, Psychoanalysis, and the Black Male Performer*. Durham, NC: Duke University Press, 2014.

Tate, Shirley. "'That Is My Star of David': Skin, Abjection, and Hybridity." In *Thinking through the Skin*, edited by Sara Ahmed and Jackie Stacey, 209–22. New York: Routledge, 2004.

Teaiwa, Teresia K. "Bikinis and Other s/pacific n/oceans." *Contemporary Pacific* 6, no. 1 (1994): 87–109.

Virilio, Paul. *War and Cinema: The Logistics of Perception*, translated by Patrick Camiller. New York: Verso, 1989.

Vogue. "Slimming—Not Swimming: New All-in-One Foundations." February 15, 1957, 102–3.

Vogue. "The Upshot of Bareness." November 15, 1964, 140–43.

Voyles, Traci Brynne. "Anatomic Bombs: The Sexual Life of Nuclearism, 1945–57." *American Quarterly* 72, no. 3 (2020): 651–73.

Voyles, Traci Brynne. *Wastelanding: Legacies of Uranium Mining in Navajo Country*. Minneapolis: University of Minnesota Press, 2015.

White, Geoffrey, ed. *Remembering the Pacific War*. Honolulu: Center for Pacific Island Studies, 1991.

White, Geoffrey, and Lamont Lindstrom, eds. *The Pacific Theater: Island Representations of World War II*. Honolulu: University of Hawai'i Press, 1989.

Women's Wear Daily. "Brevity and Femininity along the Riviera." September 4, 1947.

Women's Wear Daily. "Color Hits Lace Elastic Pantie Girdles." March 6, 1952.

Women's Wear Daily. "The Inner Fashions Foundations." October 14, 1965.

Women's Wear Daily. "Mink Bikini." August 4, 1955.

Women's Wear Daily. "Novelty Bra and Pantie." September 10, 1959.

Women's Wear Daily. "Paris Couture Quality Returns, Prices Increased." August 26, 1946.

Women's Wear Daily. "Rome Letter." March 23, 1956.

Women's Wear Daily. "The Siren Look of Black with Red in Corsets." October 2, 1952.

Yoneyama, Lisa. *Hiroshima Traces: Time, Space, and the Dialectics of Memory*. Berkeley: University of California Press, 1999.

A Bruise, a Neck, and a Little Finger

The Visual Archive of Ruth Ellis

Lynda Nead

In what ways can sex or sexual desire be said to be in the archive? What do we look for and what can be seen when we search for sex in the archive? Do we know in advance what signs and images we seek, or are we suddenly and unexpectedly struck by the visual traces of sex and sexuality? When contemporaries looked at the woman who is the subject of this article, they saw sex everywhere about her: they saw it in her lifestyle; in her clothes, voice, and manners; they saw it in her hair and in her makeup. How does the historian reconstitute these visual signs of sexuality? What is needed to recognize the visual remnants and prompts? In the photographic archive related to the last years of this woman's life, sex is explicit and implicit; it is both on the surface of the image and concealed in the spaces between what the photograph seems to show or is about. Sex is not always readily evident and must be conjured from the archive through acts of imagination and interpretation. The meaning of an image often exceeds the particularity of its subject; it is more than what is there and what is shown and is part of a wider set of historical discourses concerning, in this case, sexuality and gender, respectability and criminality. It is for the historian of visual culture to bring these components together and, in so doing, to make the images speak.

Ruth Ellis was the last woman to be hanged in Britain. She was twenty-eight years old. On April 10, 1955, and in front of several witnesses, she shot and killed her lover, David Blakely, outside a public house in north London (fig. 1). Ellis was

Radical History Review

Issue 142 (January 2022) DOI 10.1215/01636545-9397044

© 2022 by MARHO: The Radical Historians' Organization, Inc.

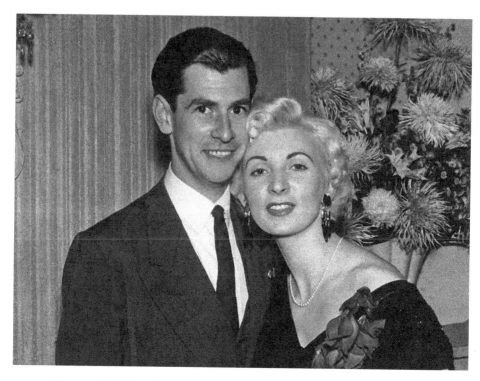

Figure 1. Photograph of Ruth Ellis and David Blakely, London, 1955. Mirrorpix.

immediately arrested and, following her committal, taken to Holloway Prison. Her trial in the Number One Court at the Old Bailey was a highly public affair; it was covered in the national and international press and sealed her reputation as a femme fatale. Her defense was weak and lackluster, and once her plea of man-slaughter on the grounds of provocation was rejected by the trial judge, the jury took just over twenty minutes to convict her of murder, for which the sentence was execution by hanging.

Ellis's relationship with Blakely was physically and psychologically abusive, and had she not met him, murdered him, and been hanged for her crime, her otherwise unremarkable life would likely be utterly forgotten. In so many ways, her twenty-eight years were like those of innumerable working-class women in postwar Britain; she has, however, achieved notoriety and has been the subject of films and television series, multiple biographies, histories of crime and jurisprudence, as well as feminist rereadings of her life and death.[1] Her life is also dispersed across the largest press photography archives in the world, where the images that were published on an almost daily basis after the murder can now be searched, researched, and licensed. There is an order that is imposed on the visual archive, an organization imposed by search terms that define and delimit the historical significance of the images they describe. There is more to these images, however, than search terms

can contain, and they reveal more about sex and desire in the 1950s than they appear to show. This article is an exploration of meaning in the visual archive—a practice in feminist visual analysis and historical interpretation that dis-orders the archive and breaks out of neat categories and simple narratives to discover new readings of the image of Ruth Ellis and of the lives of women in postwar Britain.

Ruth Ellis was described at the time of her trial as a "model" and as a "night-club hostess." A couple of years before her death, she had dyed her naturally auburn hair peroxide blonde; she was slim and stylish and always impeccably made-up. All the biographical studies include the anecdote that in the days before her trial she was granted a special request to have her hair re-dyed. In the weeks following her arrest, the darker roots of her natural hair color had begun to grow back, and she evidently wanted to look what she believed to be "her best" for her appearance at the Old Bailey. Her defense counsel was alarmed at her appearance, fearing that she looked too hard and glamorous and would give the jury the wrong impression and lose public sympathy. A member of the public later recalled that she seemed like "a typical West End tart"; a lazy insult that typified the dangerous compound of sexual attraction and aggression that characterized men's reactions to Ellis throughout her short adult life.[2]

This is the end of her story; it is better, however, to go back to the beginning, for we need to take the documented details of Ellis's life into the archive, in order to elicit what photography theorist Ariella Azoulay has described as "the possible within the concrete," to find, in other words, those traces of sex and those signs of abuse that can be conjured from the material signs in the photographs.[3]

Ruth Ellis was born in North Wales in 1926. Her father, Arthur Hornby, was a musician from Manchester; her mother, a Belgian refugee called Elisabertha Goe-thals, a twenty-year-old single mother working in domestic service. As the family grew, its condition deteriorated. Arthur started drinking and became extremely violent and abusive; in her biography of Ellis, Ruth's sister, Muriel Jakubait, claims that she was raped by her father, that she had a child by him, and that he also abused Ruth.[4] If these claims are true, then her father's sexual violence was only the beginning of Ellis's experience of male abuse; moreover, she was only one of many women in this period whose relationships and bodies were marked by the signs of male desire and rage. Ellis sought to better herself; she chose from the limited routes available to her and transformed her appearance to become the glamorous woman who took the dock at the Old Bailey in 1955. Ellis sought to "pass" as a professional, middle-class Englishwoman and to mix in social classes higher than her own. Blonde for Ellis was a sign of glamour and sophistication, a detail that will help make sense of the photographic archive.[5]

When war broke out in 1939, Ellis was thirteen years old. Like many other girls from working-class families, she left school in 1940, at the age of fourteen, with little or no qualifications and moved to London, where she lived and worked during

the war years. Despite the dangers of the blitz and subsequent German bombing campaigns, the capital was a logical move for a girl with her sights set beyond an impoverished home in Hampshire, where her family was living. Ellis moved through several occupations, from factory work and waitressing to nude photographic model and nightclub hostess. This was not an unusual trajectory for a good-looking, ambitious young woman in the mid-twentieth century. Her life maps out a familiar geography of London's commercialized leisure world and an inventory of jobs that enabled Ellis to explore the new forms of personal encounter and social mobility made possible by modern urban conditions.[6]

In her biography of Ellis, her sister writes: "She'd do anything to earn money: modelling, taking photographs; you name it, she did it."[7] Ellis had to earn money to give to her parents and to pay for the son she had with a Canadian soldier during the war, but she also clearly wanted more than the more mundane routes could offer. In the years immediately following the end of the war, a telephonist could earn around £3 a week, a junior clerk around £1 a week, and a skilled factory worker £4.[8] The basic weekly salary of a nightclub hostess at this time was £5, and in addition there was commission on the food and drink that she persuaded customers to purchase, along with free evening dresses, accommodation, and the patina of glamour.[9]

What did "modeling" mean in the context of postwar employment, gender, and sexuality? Like so much language in this period, "modeling" was frequently a euphemism and was loaded with sexual innuendo. Modeling was sexually and morally ambiguous; the running joke about the camera clubs at the time was that the men did not have film in their cameras but were simply there to ogle the girls. As cultural historian Gillian Swanson has commented, modeling brought together "the domain of sexualized and commodified consumption."[10] Modeling meant sex, and readers knew exactly what was implied when the headlines described Ellis as a "model."

From the camera club, Ellis moved on to the ersatz glamour of London's afternoon drinking bars and night clubs, and by 1946 she was, her sister writes, "well into club life."[11] Club hostesses were employed to socialize with patrons, to encourage them to spend lavishly on food and drink and also, occasionally, on sex. This was a new commercial environment for attractive, confident young women. While they were not prostitutes, in the sense that they were not "public" women on the streets, they might be sexually available and willing to exchange sex for money.[12]

In certain ways club life allowed Ellis to achieve some of her ambitions. She was earning good money, was mixing with wealthy men, and it was in the Court Club that she met George Ellis. George was seventeen years older than Ruth and had money; he was also a heavy drinker and violent. They married in November 1950 and moved to Southampton to enable him to take a job there. Married life was short-lived; George became increasingly violent, and, despite being pregnant again, Ruth returned to London, where she had her daughter, Georgina, in October 1951. With

the breakdown of her marriage, Ellis returned to hostessing and to the Court Club, which had been refurbished and renamed Carroll's, and moved into a flat on Oxford Street, owned by the racketeer Morris Conley.

Contemporaries saw sex in Ruth Ellis because it was everywhere around her; it defined her environment and saturated her body, her dress, and her appearance. It is from this period, around 1952–53, that Ellis dyes her hair platinum blonde and that her image becomes the subject of the photographic archive.[13] Blonde is a rich and polyvalent sign of femininity that expresses diverse forms of racial and sexual identity. In the early 1950s, when Marilyn Monroe was at the peak of her fame, blonde was an international sign of glamour. It was more than this, however, as film historian Richard Dyer states: "Blondeness, especially platinum (peroxide) blondeness, is the ultimate sign of whiteness. . . . And blondeness is racially unambiguous."[14] At a moment when the prewar British empire was on the point of collapse and the impact of migration from the colonies was most intense, blonde femininity was a complex sign of the white nation but also, at the same time, of sexuality and desirability.

The impact of "going blonde" should not be underestimated. Ellis had assumed the look of contemporary postwar glamour, defined by Hollywood stars and disseminated in films, magazines, and advertisements. Her sister describes the effort that Ellis invested in this physical transformation: "It didn't happen overnight. She learned about make-up, hairstyle, clothes and how to talk to well-off people. For somebody in the 1950s, without education, that change was enormous."[15]

According to Jakubait, going blonde worked its magic and transformed her sister: "From the time she started bleaching her hair her character changed. It was like two different people. Being blonde does that. It made her confident and more carefree. She looked beautiful . . . [like] Marilyn Monroe."[16] Ellis's peroxide curls frame her pale, perfectly made up face (fig. 1). With dark arched eyebrows and red parted lips, she is strikingly attractive and draws attention. Ellis needed to look vulnerable in court; she needed to look like a victim and not like a vindictive killer, but everything about the face reproduced in the newspapers in the weeks leading up to her trial spelled sex, transgression, and premeditation. The photographs we now examine in the archive have been the subject of moral and legal judgment; they are the vestiges of a woman's struggle and failure to achieve both glamour and respectability.

With her new look complete, Ellis was promoted by Conley, who made her the manager of the Little Club, a drinking club in Knightsbridge, where she met David Blakely. Blakely came from a wealthy upper-middle-class family. With an undistinguished school and military career behind him, he struggled to find a direction in his life until he discovered motor cars, took up racing, and began mixing with the motor racing circle on the tracks and in the London clubs. Blakely was a member of the Little Club, and within two weeks of their meeting, he moved into Ellis's flat

above the club. Analysis of Blakely's character and the details of his turbulent relationship with Ellis are described in all the publications about the murder, and it is unnecessary to rehearse them here; it is perhaps sufficient to say that he was charming, a heavy drinker, unstable, and violent.

What seems to have fascinated the press most about their relationship was their class difference. From the moment it was made public, when Ellis was arrested after the shooting, her humble background and unwarranted ambition were seen both as the problem within the relationship and the motivation for the murder. Ellis resented and coveted Blakely's class position, which, alongside his mercurial unreliability, might well have produced a tense, hyper performance of upper-class manners and a display of petit-bourgeois aspiration, rather than the easy internalization of class style that those who are confident of their social identity assume. There are signs of this tension in the photographic archive (fig. 2). An image, probably taken in 1955 and apparently in a drinking club, freezes at the moment that she lifts her drink to her mouth; she smiles at the camera, perhaps toasting the person taking the picture. She is well dressed in a lace-trimmed décolleté gown that shows off her slim, pale shoulders and neck; it was a style that was fashionable and that she would wear again. My eyes are drawn to the dainty watch on her wrist and to the wedding ring (still and always Mrs. Ellis); but the detail that strikes me most acutely is the little finger of the hand holding the glass. It is extended, pointed in a gesture of decorous respectability that is awkward, self-conscious, and painfully déclassé.[17] Acknowledging this gesture, the viewer feels the effort that she must constantly make to look acceptable in this context—to be other than herself or, rather, to be always her new self.

Working in this way, across discourses of postwar gender, class, and sexuality and the visual discourse of the photographic archive, enables a different way of seeing and feeling the image. Perhaps I have read the image wrongly; perhaps Ellis was relaxed and comfortable at the moment this photograph was taken, but by embedding the image in the social and sexual discourses of the moment in which it was made, tension and self-conscious aspiration are the preferred and imaginable conditions and meaning of this photograph, and, once seen, they permeate every detail of her body and face.

There is a prurience in the press reporting of Ellis's case: a fascination with her performance of femininity, the sexual nature of her crime, and the particular spectacle and pleasure of a woman hanged. The photographs in the press archives are searchable under her name and also through terms such as *British crime* and *murder*; they have short, generic captions such as, "Ruth Ellis, who was hanged at Holloway Prison on 13th July 1955 . . . "[18] This is what collects the images together as "an archive" and gives it meaning and Ellis her legacy and fame. Getty Images is a British-American photo library that supplies stock images and press photographs to commercial clients.[19] Over the years, it has acquired other photo agencies and

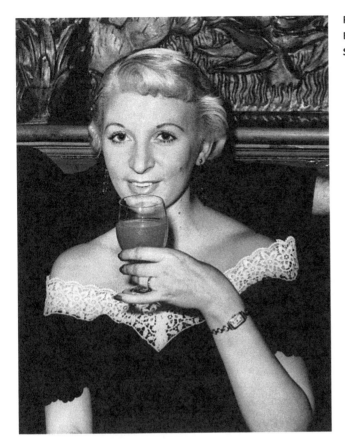

Figure 2. Photograph of Ruth Ellis, 1955. PA Images/Alamy Stock Photo.

archives, and, among hundreds of millions of images, it has a small and extraordinary collection of photographs of Ruth Ellis. Within this collection, there is a group of ten photographs, the archive's last and most recent acquisition; the photographs were taken in 1954, apparently during a single session in Ellis's flat above the Little Club (figs. 3–5). The archive caption identifies the photographer as "one Captain Ritchie," although no further information about him can be found.[20] Let us suppose that "Captain Ritchie" was one of the number of ex-servicemen who were members of the Little Club and a keen amateur photographer and that he suggested a private afternoon photo session with Ellis in her flat above the club. Ellis knew about posing; she had modeled at London camera clubs, and it would have been a relatively undemanding way of earning some extra money.

These are lazy, generic images, stock poses from a long history of soft porn. A raised leg as a suspender is undone, a smile, and a glance at the camera (fig. 3); or recumbent, on a sofa, with arms behind the head—a gesture frequently adopted to reveal the breasts, although here the blouse is retained (fig. 4). "Captain Ritchie's" photographs are artless in all senses of the term. Unsophisticated, candid, and

Figure 3. Photograph of Ruth Ellis:
"Poses in her underwear for one
Captain Ritchie, 1954."

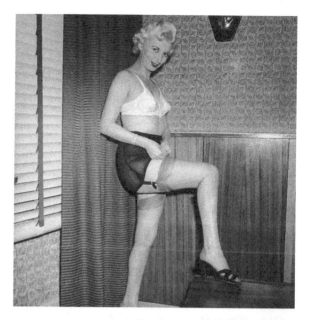

Figure 4. Photograph of Ruth Ellis:
"Poses in stockings and suspenders
for one Captain Ritchie, 1954."
Hulton Archive/Stringer/via Getty
Images.

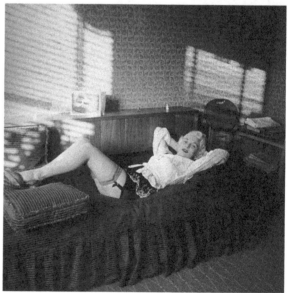

devoid of aesthetic qualities, they show no discernible interest in composition or framing, and the lighting is simply that offered by the closed blinds. What we have here are a talentless photographer and a model who assumes generic pin-up poses.

There is one more photograph in the series, which is slightly different from the others. In this image (fig. 5), Ellis has removed her top and now holds some leopard skin fabric to cover her breasts. She is closer to the picture surface, looking directly at the camera lens; the image is poorly framed, and her head and arm are

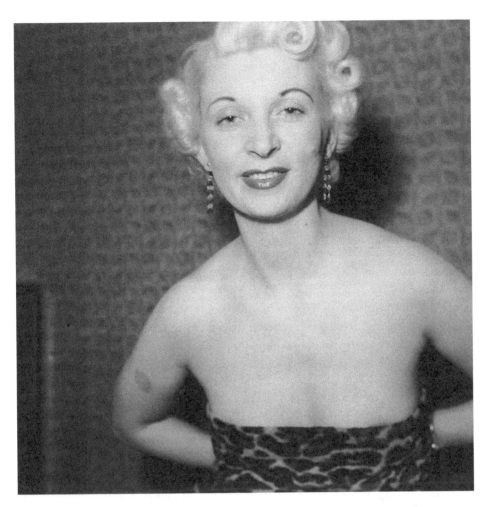

Figure 5. Photograph of Ruth Ellis: "Poses in leopard skin for one Captain Ritchie, 1954." Hulton Archive/Stringer/via Getty Images.

cut off by the edge of the photograph. In his classic study of photography, *Camera Lucida*, the French philosopher and critic Roland Barthes differentiates two modes of photographic meaning, the studium, which defines the more conventional, socially and culturally recognizable forms of signification, and the punctum, which escapes this symbolic system and which addresses the viewer directly and almost painfully. Barthes describes the punctum as "that accident which pricks me (but also bruises me, is poignant to me)"; it is a kind of physical and emotional violation.[21]

As Ellis removes her top, she reveals a fading bruise on her right upper arm. Violence weaves in and out of Ruth Ellis's life; from her early experiences in her family home, to her marriage to George Ellis and her relationship with David Blakely, men are violent toward her. All the press reports covered Blakely's physical

violence, and it was acknowledged and described in her trial. Indeed, there is a super-abundance of evidence in the print archives of a casual acknowledgment of beatings that resulted in bruises, injuries, and even a miscarriage. It is the most shocking aspect of what is throughout a harrowing and disturbing life. In some respects, I am reluctant to cite too many of these sources, but I also feel compelled to demonstrate just how habitual this physical violence was and how casually it was accepted by Ellis, postwar British society, and the judiciary.

Fights between Ellis and Blakely became a feature of life in the club during their relationship and eventually led to Ellis having to leave the flat. In her memoirs, published in the *Woman's Sunday Mirror* shortly before her execution, Ellis is reported as saying, "David often attacked me when he was drunk. . . . Even when other women were there he would smack my face and punch me. When we were alone it was worse."[22] Bruises—fresh and fading—were the constant visual signs of Blakely's abuse; her sister recalls, "My god, the bruises were black and green. . . . She'd casually say: 'Look at these marks on my body. I can't go out until they're gone.'"[23] A bruise is a visible trace of violence on the surface of the body, where the tissue is injured and blood is forced from the site of the blow, but the skin is not broken.[24] Bruising tells a history: the color of the mark changes from the time elapsed since it was inflicted, and it can be read as a narrative of abuse.

Perhaps most shocking of all is Ellis's own testimony during the trial. Giving evidence on her own behalf on the first day of the trial, Ellis was asked how Blakely's violence manifested itself. She replied, "He only used to hit me with his fist and his hands, but I bruise very easily, and I was full of bruises on many occasions."[25] That phrase, "I bruise very easily," has haunted me during my research on the visual archive of Ruth Ellis. I am aggravated by her acceptance of his violence, by her understatement and rationalization of the marks of abuse—her fault, not his. It returns to me as I look at the photograph of her posing with the leopard skin cover, and all I can now see is the fading bruise on her arm. Ellis was systematically abused and humiliated by Blakely, and the bruise is evidence of this. The photograph is testimony to social and sexual identity in postwar Britain, a memento of both male violence and the apathy of state institutions.

In the final days, over a long Easter weekend, as Blakely rejected Ellis and stayed with his racing friends, she stalked him, phoned him, and harassed him, and finally, with the help of her friend and former lover, Desmond Cussen, she shot and killed him.[26] In her statement at Hampstead Police Station, after her arrest, she said simply, "I am guilty. I am rather confused."[27]

There are no images, of course, of Ruth Ellis's execution. It is a visual absence, a tremendous gap, in the otherwise endlessly interrogated details of her life and her appearance. Until the middle of the nineteenth century, hanging had been a public event, but in 1868 the Capital Punishment Amendment Act removed hanging from public view, and thereafter executions took place behind prison walls. As hanging was removed from sight, so it became the subject of the imagination, fed

by reports in the popular press. Hanging is a primitive and brutal form of execution; with its rudimentary technology, it represents capital punishment at its most archaic and, as such, began to seem increasingly anachronistic and incompatible with the modernizing aspirations of postwar welfare Britain.[28] While British audiences were held captive by Ellis's story, therefore, there was also a powerful outcry against the barbarity of the sentence and the insensitivity of the British legal system.

There are no images of Ellis's execution, and yet the specter of her hanging has an inescapable presence that seems to haunt every image. The object of voyeuristic attention, her beauty seemed to make the public fantasy of her hanging more compelling; as Jacqueline Rose has observed, Ellis seemed "to release something of that peculiar pleasure which the idea of execution always seems to provoke."[29] Hanging is everywhere in the visual archive and nowhere to be seen; it is the term through which her image can be sought, yielding everything but the act itself.

There is a photograph that was reproduced in all the newspaper coverage (fig. 1); often cropped in different ways, it has become one of the most iconic images of Ellis. It is a photograph of a young, happy couple; they are smartly dressed and probably in a club. Ellis has a small, oval face with a long, slim neck that is emphasized by her pose and her off-the-shoulder top. Her peroxide blonde hair has been curled in the style made popular by Marilyn Monroe around 1953, her black arched eyebrows contrasting strikingly with her nearly white hair. She is undeniably good-looking—not as beautiful as Monroe but groomed and stylish. Blakely stands close to her, his cheek flattens the right-hand side of her hair, and it is difficult to avoid the impression that his face is a bit oafish and silly, his toothy grin contrasting with her practiced smile. It is a picture of two offenders and two victims, one shot, the other hanged.

When viewers saw this picture of Ellis in the papers, they knew that she had committed murder and that she would hang. When the judge pronounced the sentence at the end of the two-day trial, he delivered the words that were spoken in all capital punishment cases: "The sentence of the Court upon you is that you be taken hence to a lawful prison, and thence to a place of execution, and that you be hanged by the neck until you be dead."[30] Ruth Ellis's neck signifies this sentence; it represents the absolute authority of the state and its right to violence. Everything in the image seems to call attention to this meaning and to make Ellis's neck the focal point; hanging is the unbearable and inescapable connotation. There is an apocryphal story, recounted in Jakubait's biography, that their father, noting Ruth's "exceptionally long neck," used to say, "All the better for hanging with."[31] Perhaps in a society in which execution by hanging is a part of crime and punishment, this is not an unusual everyday quip; it is, nevertheless, chilling, both because of the identity of the speaker and its articulation of a terrible truth in the image.

Ellis's slender neck conveys the fragility of her body. Her daughter tells us that when Ruth was hanged, she weighed seven stone five pounds; she was a small woman by any standard, and there is, perhaps, something particularly shocking in

the mental image of this woman "being hanged by the neck."[32] Although her celebrity hangman, Albert Pierrepoint, wrote that "she died as brave as any man" and that death was instantaneous, this barely conceals the brutality and petty bureaucracy of the process: the standardization of the technology, the mathematical calculation of the drop, and the official record keeping.[33] Pierrepoint's account is countered by that of Evelyn Galilee, who was a prison warden at Holloway Prison and supervised Ellis during her last weeks in prison: "It was a vicious drop. Whatever the autopsy report said about it all being all right, clean break and everything—it wasn't all right. It was horrific. She was such a doll-like creature. I could see her as she was. Then I could see her broken body in my mind."[34]

Ellis's brother, Granville Neilson, was asked formally to identify her body and confirmed the damage that had been wrought by the execution and that had been partially disguised by prison officials who draped a scarf around her neck to hide the marks of the hangman's rope.[35]

Galilee's words, "I could see her as she was. Then I could see her broken body in my mind," evoke the structure of representation in the image of Ellis's neck; we see her as she is in the photograph, and, at the same time, we imagine her mutilated by the hanging. It is enormously difficult to avoid recreating a voyeuristic or salacious viewing position in writing about this photographic archive and, particularly, its resolution. Perhaps this is an inevitable consequence of seeking and finding sexuality and violence, which are present in every image.

.

I come away from the archive with a profound sense of sadness, not only for Ruth Ellis but also for all the other women in postwar Britain who longed for more and whose wishes were thwarted, or who loved and were humiliated and abused. A feminist encounter with the Ellis visual archive is a meeting not only with an individual woman but also, and as importantly, with 1950s sex, sexuality, class, and violence. The photographs show a woman's body as commodity and spectacle, a fetish object created through the perfection of surface appearance that could, at any moment, crack open to reveal the destructive powers of femininity and the retribution of patriarchal society. As Jacqueline Rose writes about Marilyn Monroe in her book *Women in Dark Times*, Monroe had to pay the price for her sexuality: "This is of course the classic role of the femme fatale who is always made to answer for the desire that she provokes."[36]

Sex is not deposited in the visual archive waiting for the diligent researcher to discover, but its traces can be apprehended from signs, absences, and feelings in images and texts. Working in the spaces between what the images seem to show reveals the vestiges of abuse and violence; marks of corporeal transformation; details of hair, makeup, and skin that speak of a life lived against the grain of a nation emerging from six years of war and rebuilding its society and economy. Ruth Ellis refused to remain within mainstream social structures; she was an indifferent

mother, and she was overtly sexual and transgressed respectable values in her work and in her life. This is a weight to bear—the cost of sexualized performance that inevitably forces itself onto the face and body, the strain and tension distilled into surface composure. As Azoulay writes, "Every additional documented detail allowed me to imagine more." We need to approach the archive through the imagination, intervening in the moment that the photograph was taken and imagining its conditions of production, "reading the possible within the concrete," drawing out the violence and sexuality, piecing together the moral and sexual judgments, the desire and the rejection.[37]

Lynda Nead is Pevsner Professor of History of Art at Birkbeck, University of London. She has published widely on a range of art historical subjects and particularly on the history of British visual culture in the nineteenth and twentieth centuries. She is a trustee of the Victoria and Albert Museum and is currently writing a book called *British Blonde: Women, Desire, and the Image in Post-War Britain*.

Notes

1.　For film and television, see, for example, *Dance with a Stranger* (dir. Mike Newell, 1985); *The Ruth Ellis Story*, ITV, 1977; *Ruth Ellis: A Life for a Life*, BBC1, 1999; and *The Ruth Ellis Files: A Very British Crime Story*, BBC4, 2018. Biographies and other publications will be cited throughout.

2.　See Marks and Van Den Bergh, *Ruth Ellis*, 134, 148; Ballinger, "Dead Woman Walking," 2; Ellis (with Rod Taylor), *Ruth Ellis, My Mother*, 178; Lee, *Fine Day for a Hanging*, 257.

3.　Azoulay, *Civil Imagination*, chap. 4.

4.　Jakubait, *Ruth Ellis*, 23. See also Lee, *Fine Day for a Hanging*, 38.

5.　There is an extensive literature on "blonde" femininities, much of which focuses on American women. My interest in my forthcoming book, *British Blonde: Women, Desire, and the Image in Post-War Britain*, is in the dissemination of American glamour in Britain and the meanings of blonde as they are absorbed into British postwar society and culture and express British notions of desire, sexuality, and the image. For a recent international study, see Vincendeau, "Blond Issue."

6.　On Ellis's wartime and postwar occupations, see Jakubait, *Ruth Ellis*, 51, and Lee, *Fine Day for a Hanging*, 43–44; on cultures of consumption and sexual behavior in twentieth-century urban life, see Swanson, *Drunk with the Glitter*.

7.　Jakubait, *Ruth Ellis*, 51.

8.　Salaries given in Jephcott, *Rising Twenty*, 119, 137.

9.　These are the terms and salary that Ellis received when she began working at the Court Club; see Ellis, "My Love and Hate by Ruth Ellis." See also Hancock, *Ruth Ellis*, 22.

10.　Swanson, *Drunk with the Glitter*, 162.

11.　Jakubait, *Ruth Ellis*, 55.

12.　For an excellent discussion of the commercial pleasure economy of postwar London and the figure of the "good time girl," see Mort, *Capital Affairs*. A number of the biographies state that Ellis had sex with men for money while she was a hostess; see, for example, Ellis, *Ruth Ellis*, 11, 31–32, and Hancock, *Ruth Ellis*, 1–2.

13.　Sources are inconsistent about the precise date that Ellis first dyed her hair, but it seems most likely that it was around 1953.

14. Dyer, *Heavenly Bodies*, 40; Dyer, *White*.

15. Jakubait, *Ruth Ellis*, 82.

16. Jakubait, *Ruth Ellis*, 114.

17. As a child, Ellis had rheumatic fever, which affected the joints of the little finger of her left hand. Jakubait stresses the resulting damage and gnarling of that hand as a crucial part of her argument that Ellis could not hold the revolver and did not shoot Blakely; see Jakubait, *Ruth Ellis*, 43–44, 179–80; this argument is rejected by Lee, *Fine Day for a Hanging*, 42, 396.

18. See, for example, PA Images search terms.

19. Much of my research on postwar visual culture has taken place at Getty Images, and I am immensely grateful to Matthew Butson, vice president at the Getty Images Hulton Archive, and Melanie Llewellyn, curator of the archive, for their support and interest in my work.

20. Inquiries have been made to the previous owner of the photographs; there is no further information, however, regarding either the provenance of the photos or the identity of "Captain Ritchie."

21. Barthes, *Camera Lucida*, 27.

22. Ellis, *Woman's Sunday Mirror*, 7. See also Ellis, "My Love and Hate," July 10, 1955, 1, in which a card that Blakely sent Ellis is reproduced with the caption, "a peace offering after he had given her a black eye, a sprained ankle and extensive bruises." Also, Ellis, "The Last Words of Ruth Ellis," July 17, 1955, 6, in which she mentions "the bruises on my arms" and the beating that results in the miscarriage, 7.

23. Jakubait, *Ruth Ellis*, 111–12. See also 285.

24. On bruising specifically in relation to forensic medicine, see Burney and Pemberton, "Bruised Witness."

25. From a partial transcription of the trial as reproduced in Goodman and Pringle, *Trial of Ruth Ellis*, 109. All national newspaper reporting on the trial recorded this statement.

26. Sources vary on the degree of Cussen's involvement with the murder of Blakely, but most agree that he gave her the gun and drove her to the pub where she shot him.

27. As cited in Lee, *Fine Day for a Hanging*, 201.

28. Seal, *Capital Punishment*, 8.

29. Rose, *Why War?*, 47.

30. From a partial transcription of the trial as reproduced in Goodman and Pringle, *Trial of Ruth Ellis*, 124–45.

31. Jakubait, *Ruth Ellis*, 89.

32. Ellis, *Ruth Ellis*, 44.

33. Pierrepoint came from a family of hangmen; as executioner in all the major murder cases of the mid-twentieth century, he assumed a kind of celebrity and later published his autobiography, *Executioner Pierrepoint*. On his claim that Ellis died instantly and the postmortem report, see Lee, *Fine Day for a Hanging*, 343, 345. On the standardization of hanging, see Seal, *Capital Punishment*, 17.

34. As cited in Jakubait, *Ruth Ellis*, 237.

35. On the formal identification of the body, see Jakubait, *Ruth Ellis*, 237; Lee, *Fine Day for a Hanging*, 346; Marks and Van Den Bergh, *Ruth Ellis*, 190.

36. Rose, *Women in Dark Times*, 124. On woman as fetish object, see Mulvey, *Fetishism and Curiosity*.

37. Azoulay, *Civil Imagination*, chap. 4.

References

Azoulay, Ariella. *Civil Imagination: A Political Ontology of Photography*, translated by Louise Bethlehem. London: Verso, 2015. Kindle.

Ballinger, Anette. "Dead Woman Walking: Executed Women in England and Wales 1900–1955." PhD diss., University of Sheffield, 1977.

Barthes, Roland. *Camera Lucida: Reflections on Photography*, translated by Richard Howard. London: Vintage, 2000.

Burney, Ian, and Neil Pemberton. "Bruised Witness: Bernard Spilsbury and the Performance of Early Twentieth-Century English Forensic Pathology." *Medical History* 55, no. 1 (2011): 41–60.

Dyer, Richard. *Heavenly Bodies: Film Stars and Society*. 2nd ed. New York: Routledge, 1986.

Dyer, Richard. *White*. London: Routledge, 1997.

Ellis, Ruth. "My Love and Hate by Ruth Ellis." *Woman's Sunday Mirror*, June 26, 1955.

Ellis, Ruth. "The Last Words of Ruth Ellis." *Woman's Sunday Mirror*, July 17, 1955.

Ellis, Georgie, with Rod Taylor. *Ruth Ellis, My Mother: A Daughter's Memoir of the Last Woman to Be Hanged*. London: Smith Gryphon, 1995.

Goodman, Jonathan, and Patrick Pringle, eds. *The Trial of Ruth Ellis*. Newton Abbott, UK: David & Charles, 1974.

Hancock, Robert. *Ruth Ellis: The Last Woman to Be Hanged*. London: George Weidenfeld and Nicolson, 1989.

Jakubait, Muriel. *Ruth Ellis: My Sister's Secret Life*. London: Constable and Robinson, 2005.

Jephcott, Pearl. *Rising Twenty: Notes on Some Ordinary Girls*. London: Faber and Faber, 1948.

Lee, Carol Ann. *A Fine Day for a Hanging: The Real Ruth Ellis Story*. Edinburgh: Mainstream, 2012.

Marks, Laurence, and Tony Van Den Bergh. *Ruth Ellis: A Case of Diminished Responsibility?* Harmondsworth, UK: Penguin, 1990.

Mort, Frank. *Capital Affairs: London and the Making of the Permissive Society*. New Haven, CT: Yale University Press, 2010.

Mulvey, Laura. *Fetishism and Curiosity: Cinema and the Mind's Eye*. 2nd ed. London: British Film Institute, 2013.

Pierrepoint, Albert. *Executioner Pierrepoint*. London: Harrap, 1974.

Rose, Jacqueline. *Why War?: Psychoanalysis, Politics, and the Return to Melanie Klein*. Oxford: Basil Blackwell, 1993.

Rose, Jacqueline. *Women in Dark Times*. London: Bloomsbury, 2014.

Seal, Lizzie. *Capital Punishment in Twentieth-Century Britain*. New York: Routledge, 2014.

Swanson, Gillian. *Drunk with the Glitter: Space, Consumption, and Sexual Instability in Modern Urban Culture*. New York: Routledge, 2007.

Vincendeau, Ginette, ed. "The Blond Issue." Special issue, *Celebrity Studies* 7, no. 1 (2016).

Running Mascara: The Hermeneutics of Trans Visual Archives in Late Franco-Era Spain

Javier Fernández Galeano

In 1972 the Madrid police department took two photographs of Daniela. In the first one, she wears a long, black wig, but in the second one the police had forced her to remove it, revealing her short-cropped blond hair. She wears a dark jacket, and her eyes are set beneath long eyelashes. Her mascara is smudged. Even though she is at the mercy of the police, she stares out and tightly closes her mouth.[1] In this article, I trace the capturing and preservation of visual archives of trans subjectivity in late Franco-era Spain, arguing that the definition of photographs as "material performances" leads us to reconsider recent debates about the "ethics of turning away" from police and forensic documents on trans experiences. Scholars such as Emmet H. Drager, Zeb Tortorici, and I have called attention to certain historical actors' stated refusal to be observed and classified by the clinical gaze of inquisition, police, and medical authorities. In these cases, silence, absence, and omission ought to be incorporated into historical writing not as impediments to be overcome but as fundamental strategies for forming and maintaining an autonomous self in the face of authorities' denial of one's very existence.[2] This perspective undoubtedly applies to the judicial cases against trans women arrested and prosecuted in Spain in the 1970s on account of their gender being legally classified as a "danger to society."

Radical History Review
Issue 142 (January 2022) DOI 10.1215/01636545-9397058
© 2022 by MARHO: The Radical Historians' Organization, Inc.

However, while the plethora of legal transcripts of depositions, forensic exams, and affidavits were clearly produced and archived against the will of these defendants, the personal photographs confiscated from them call for a slightly different approach. In this article, I focus on the stories of Daniela, Carla, and Romina.[3] Among a large sample of judicial files, I am focusing on their stories because they showcase the centrality of photographic performances and visual culture for trans communities living under the Franco regime.[4]

In the first section, I will thread together recent scholarship addressing the inseparability of visibility from trans materiality with a discussion on the historical particularities of the inscription of transphobic state violence in Spanish archives. In this way, this section centers the ethics of imposing the visual conventions of the clinical case on vernacular photography. In the second section, I relate the experiences of Daniela, who tried to get married with her fiancé in 1968 by adopting the legal identity of her sister. The transcripts of her arrests indicate state agents' uncertainties about Daniela's gender, and the strategies she used to protect her intimacy. Considering that there is no visual evidence from this first arrest, and the significant discrepancies between Daniela's portrayal of her physicality and the forensic report on her, in this section I will foreground Daniela's self-representation. During her later arrest in 1972, the visual aspects of Daniela's femininity were described and recorded by police officers who fixated on women's sexual emancipation. Following this trend, in the third section I look at the personal photographs confiscated from Carla, which were produced by a group of trans women who enjoyed posing in quiet settings and taking snapshots. Carla's story illustrates the disproportionate targeting of working-class trans women by police officers, as well as the centrality of the *paseo* (stroll) in Spanish trans women's quotidian practices of visibility. In 1975 Carla was arrested along with Romina on one of their strolls, leading Romina to shed tears that ruined her mascara, which comes to stand once again for state violence. Romina's file demonstrates the state's investment in curating trans visual culture; state agents photocopied her personal images and love poems to create photomontages with an implicit narrative that preserved the visual and textual semantics of intimacy from the original, confiscated materials.

Visibility and Ethics in Trans Scholarship

By focusing on the relationship between the state's curatorial practices, in the past and in the present, and trans visual archives as an index of trans women's physicality, relationality, and aesthetics, this article builds on and shifts an emerging field of inquiry. Since the early 2000s, there has been a significant effort to mend the historical neglect of the trans community in LGBTQ activism and scholarship.[5] As a result, there is increasing awareness that the Francoist legal codes—and the 1970 Law of Social Dangerousness and Rehabilitation, in particular—disproportionally targeted low-income trans people. Through a series of legal reforms, the fascist-rooted

Franco regime rebuilt its institutional framework in the mid- to late 1950s, which in the 1960s allowed it to consolidate a model of economic development based on mass tourism, cheap labor, and state repression. Catholicism remained the state official religion, and the clergy maintained its monopoly over education, censorship, and public morality.[6] In this context, the regime codified "homosexuality" as a danger to society when it revised the Vagrancy Law in 1954, thus asserting its authority and capacity to reconcile the agendas of socioeconomic modernization and Catholic-nationalist indoctrination. The targeted individuals were to be interned in "special institutions" (most often common prisons), displaced from their hometowns, and surveilled, totaling up to nine years of sentence.[7] Under a political system that enshrined masculinity as a duty to the nation, the Vagrancy Law, and subsequently the Law of Social Danger and Rehabilitation (passed in 1970), became instruments for enforcing gender normativity among the poor. The very archival classification of these files within the legal framework of "vagrancy" points to the state's focus on the sexuality of "nonproductive" social sectors, namely, domestic migrants who had been excluded from the expansion of the formal economy.[8] Moreover, as Geoffroy Huard emphasizes, trans people were classified by the Franco regime as "homosexuals" or "inverts."[9] Homosexuality was an umbrella category that included "any kind of sexual and gender deviation: prostitution, transgenderism, [and] effeminacy," despite many trans people's self-labeling as "transsexual" in the 1970s.[10]

Lucas Platero and Maria Rosón note that, given these sociopolitical trajectories, in Spain most of the relevant sources for tracing trans genealogies were produced in contexts of control and coercion.[11] In response, Platero has produced imaginative work that engages with the judicial file of a person (M. E.) arrested in Barcelona in the late 1960s for using male clothes while being officially classified as female.[12] By writing in the first person about his investment in this story, Platero helps the reader to imagine the quotidian life of M. E. in a way that subverts the logic of the extraordinary case.[13] Similarly, Raúl Solís Galván identifies "joy, irreverence, and naughtiness" as the traits that allowed trans women to carve their own spaces of survival.[14] Norma Mejía, in her ethnographic work on transgenderism and sex work in Barcelona, written from a first-person perspective, highlights that the "first generation" of transgender people to become visible in Spain expected that the democratic system installed at the end of the 1970s would protect them, but they were confronted instead with "marginalization, mockery, humiliations, and discrimination."[15] Mejía's work tempers any romanticization of trans experiences, as she cautions that transgender people's performance of joy should not detract attention from their extremely low life expectancy; she also argues that solidarity among trans people is "almost non-existent."[16] Finally, Rafael Mérida Jiménez describes trans women's experiences as commonly shaped by "an early self-recognition, rejection and fleeing, prostitution, hormones, drug-addiction, surgery, police raids, illness,

money, joy and loneliness."[17] These factors produced a shorter-than-average life expectancy in the trans community, which had particularly negative effects on the preservation of their historical memory. In addition, the decentralized network of public archives is lagging behind in the identification, acquisition, and cataloging of archival materials produced by trans people.[18] The fate of the personal belongings of the well-known performer Carmen de Mairena, found in a dumpster after her death, illustrates the consequences of this form of institutional neglect.[19]

In connection with the issue of historical preservation, the politics and ethics of visibility center much recent work by trans scholars and activists. Tatiana Sentamans argues that the ranges of the visible and the livable expand hand in hand and that "visibility means existence."[20] The transfeminist collective Post-Op describes its own interventions as "putting one's own body on the line to turn the invisible into desirable."[21] Likewise, Cyle Metzger and Kirstin Ringelberg define the visible not only in terms of "that which can be observed by the eye" but also as a "metaphorical tool" that points to "the inseparability of visibility from materiality in transgender existence."[22] This inseparability gives place to a relationship with visibility as a sort of double-edged sword. Invisibility blurs the past and makes the future impossible; while hypervisibility relates to the trope of monstrosity.[23] In "Known Unknowns," Reina Gossett, Eric A. Stanley, and Johanna Burton describe the "trap of the visual" as a primary path for trans people to access livable lives, and yet associated with rising levels of physical violence against them. These authors argue that individuals' agency in their own representation is key to resist the extractivist and instrumentalizing approaches to the "artwork and experiences of marginalized peoples."[24] This attention to agency becomes, if anything, more pressing when dealing with photography, which was historically constructed "as a privileged medium for situating the truth of deviance."[25] Hence, here I am interested in the agency of self-representation through photography.

Most of the images analyzed in this article were taken with the consent of and/or by trans women whose representational strategies centered joy, sisterhood, and intimacy as tenets of a livable life.[26] These photographs were—following Elizabeth Edwards's seminal work—material performances animated by actors' desire to leave their trace in history, aware as they were of photographs' potential as objects that matter and that open a space for the exploration of subjectivity.[27] Similarly, in her study of identification photos of Black diasporic subjects, Tina Campt invites us to listen to images that register "state management" and engage with them "as conduits of an unlikely interplay between the vernacular and the state."[28] The resulting method "reckons with the fissures, gaps, and interstices that emerge when we refuse to accept the 'truth' of images and archives the state seeks to proffer through its production of subjects."[29] In this line, here I listen to vernacular photos to unravel the tension between the representational strategies encrypted at their production and

in state curatorial practices. In these photographs, the models appear posing, hugging each other, smiling, exhibiting their legs, swimming, and sunbathing. As Campt points out, it is possible to recalibrate "vernacular photographs as quiet, quotidian practices that give us access to the affective registers through which these images enunciate alternate accounts of their subjects."[30] Originally, there was no obvious trace in these images of the intricate web of pathologizing and criminalizing mechanisms implemented by the Franco regime to ostracize trans people and prevent them from living their lives. Instead, these images glimpse at the imagination and production of sheltered spaces, where trans women could enjoy and be oblivious of the condemning gaze of the state, at least for a brief instant. Thus, I propose that visual materials created by trans women, even when archived as part of their prosecution, provide a means to reach beyond a forensic analysis and toward trans hermeneutics, namely, trans women's reading of their own self. [31]

At the same time, archival violence cannot be erased from the present. The Law for the Protection of Personal Data (Ley Orgánica de Protección de Datos de Carácter Personal), enacted by the Spanish government in 1999, contemplates the data from these judicial records as particularly "susceptible of affecting the security, honor, intimacy and image of people."[32] This clause does not refer to judicial records in general, just to those from the Francoist Vagrancy and Social Danger Courts, in charge of policing "antisocial" types such as the prostitute, the drug addict, the "homosexual," the vagrant, and the mentally disabled. In other words, the premise in the 1999 privacy law is that the data about people who were typified as a danger to society requires exceptional protection. Arguably, some of the people convicted as "homosexuals" agree with this premise. In the 1990s Antoni Ruiz discovered that the police still had access to his criminal background for charges of homosexuality recorded under the Franco regime in the 1970s. He pleaded to have access and then destroy his judicial file, for the sake of protecting his honor and privacy. The possibility of erasing the traces of the state persecution of sexual "minorities" remains controversial, as these traces also provide the documentary ground for keeping the state accountable for its historic crimes and building the collective memory of non-normative sexual communities.[33] In this context, the 1999 law aims at striking a delicate balance between public access and the right to privacy, mandating that "pertinent technical procedures" must be applied to "suppress" any personal data from the documentation if there are requests to access it.[34] The law is intentionally vague in stipulating how to suppress personal data, producing significant variation in archives' interpretation of this clause. In terms of the reproduction of photographs from the files, the agreement that I eventually reached with the archive of Barcelona was to follow a long-established convention of anonymization, by covering subjects' faces with a black bar. However, as T. Benjamin Singer points out, this convention perpetuates problematic, if not overtly violent, visual representations of trans subjecthood:

At first glance the bar would seem to indicate respect for the privacy of the person pictured. However, even as it ensures anonymity, it also creates the effect of scientific objectivity through de-sexualizing, defamiliarizing, and ultimately depersonalizing the represented figure. This visual strategy makes clear that these are medical photographs, rather than pornography, or snapshots for a family album.[35]

In the case at hand, to follow the law, I would be adding a black bar on photographs that were, in their origin, ordinary snapshots or charged with erotic and familiar meanings. In fact, their visual language included the elements that Singer and others identify as the opposite of the silence and passivity produced by medical representations: the subject looking directly at the camera, returning the gaze and resisting objectification; the snapshot amateur qualities that capture a "fleeting moment"; and social settings with people in the background, demonstrating subjects' participation in public spaces and social networks, and their own very existence in contexts other than "the clinic or the prison."[36] Singer emphasizes that photographs have "a profoundly ethical dimension" insofar as their visual language communicates how to relate to another person and properly regard their claims for recognition.[37]

Confronted with two options—either not reproducing the photographs or performing a "technical procedure" on them that depersonalizes the subjects and reinscribes the visual conventions of the medical or criminal case study—I have opted for the former.[38] The legal term *technical procedure* by itself is indicative of the kind of detached, clinical, and objectifying treatment of queer and trans subjects that scholar María Elena Martínez is so critical of; the implication is that archivists and historians can perform a kind of localized surgery on the visual traces of trans communities that extirpates the potential breach of privacy while preserving as much as possible the integrity of the living document.[39] Campt proposes to listen to photographs in which, in the absence of the face, individuality is transferred to other elements of the image.[40] However, in the case at hand, there is no way I can be sure whether Daniela, Carla, Romina, and others would prefer to appear "blindfolded" in their photos or just leave those photos in the archive. The second option, while imperfect, does not foreclose the possibility that, in a near or distant future, there might emerge a strategy of engagement with these photographs that is less constrained by laws that, in and of themselves, show that the wounds inflicted by state and social transphobia remain wide open. Hence, for now I am going to verbally describe my visual encounter with Romina, Carla, Daniela, and others. Since this approach relies on my subjective reading of photographs, I want to acknowledge that this is an exercise of "situated knowledge" and that I write from the position of a cisgender gay man who grew up in a mid-size town in Spain.[41] My reading is provisional, open to criticism and interpretation, and aims at critiquing the principles and

implementation of the Francoist legal regimes while staying close to the perspectives of the individuals targeted by them, such as Daniela.

Daniela: Intimacy and Aesthetics

The cover of Daniela's file announces it as a case of "Homosexualidad (Travestista)," a typology through which the authorities implied that she presented a variation of homosexuality characterized by cross-dressing.[42] At the time of her first arrest, she was traveling to Spain to get married to her French fiancé.[43] They stayed in a boarding house in Aranjuez until someone reported them to the Guardia Civil (Civil Guard) on account of her appearance. The visual evidence from this first arrest includes an ID photo of the fiancé, who was quite attractive, and a transcript of Daniela describing her own appearance. While this transcript is not visual evidence per se, it was meant to play the role of photographic evidence by painting and invoking an image of her before she was arrested: "When she was fourteen, she felt that she had the sensibility of a woman, even though she had male genitalia, but smaller than average and never having an erection. Her voice, her body shape from the wrist up, and her breasts were characteristic of a woman, and she used female underwear, both bra and panties."[44]

The authorities transcribed depositions by defendants using the third grammatical person, which produces a slippage between the male and female genders in the document. In Spanish, nouns and adjectives are gendered, and nouns are often implicit in the verb. The person typing the transcript used male nouns for Daniela. However, she inscribed her gender in official records by using female adjectives for herself (*documentada*, *enferma*).[45] Similarly, she was registered as living in a town in France, on a street she reported as being named "Desire." The fact that, when she was arrested again months later, she reported her address in France to be on a street named "Enjoy" (in English in the original) suggests that she might have been providing the authorities with an imaginary and eroticized street map and playing with their lack of language skills.

On a couple of occasions, the person transcribing Daniela's deposition "corrected" her grammatical gender by crossing out *la dicente* (deponent, female noun) and writing *el dicente* (male noun) on top of it. Thus judicial records capture both authorities' visual and linguistic strategies to erase trans subjectivities and, most importantly, the underlying presence of trans people's use of grammatical genders as it was originally transcribed.[46] Likewise, forensic doctors saw their own role as the "uncovering" of defendants' biological sex based on their observation and visual description of the defendants' secondary sex characteristics. The forensic report on Daniela reads: "This is a man of normal constitution, with perfectly shaped male genitalia, although his voice is slightly effeminate. Examining the thorax, we find a purely masculine thorax, without hair and with pigmented mammary areolas and protruding nipples. No gynecomastia (i.e., protruding breasts) has been observed."[47]

Forensic violence was exerted by means of these kinds of reports, which intended to deprive subjects of their right to give meaning to and represent their own bodies. Obviously, there were drastic discrepancies in the way in which the defendant and the forensic doctor described the former's body. The issue for historians regarding these discrepancies is not to resolve them; there are no photographs of Daniela's full body in the file, and—if there were—examining them would only perpetuate the kind of forensic violence facilitated by the Francoist authorities. In other words, the absence of visual evidence means, in this context, that different actors' visual descriptions of trans physicality remain contested. Hence, and given that bodily semantics are culturally constructed and subjective to a certain extent,[48] we can foreground Daniela's self-representation; her reported erotic experiences (i.e., her stated lack of "erection") and relationship with her body through intimate aesthetics ("bra and panties") constructed a physicality described by her fiancé and others as feminine.

The judge established in his sentence that Daniela was a danger to society: "He feigned to be a woman, using his sister's birth certificate for that purpose, married with [her partner], with whom he had an intimate life of the homosexual kind."[49] According to the sentence, Daniela was to spend from six months to three years in prison, one year of exile from Madrid, and three years of probation. After serving her time in prison in Segovia, she was arrested on probation while in the Basque country for dressing like a woman. The records produced at this time include a photograph of a middle-aged man, likely arrested for being with the defendant.[50] The subsequent arrest records, from 1972, showcase the effects of the application of the so-called security measures of prison, exile, and probation on defendants' personal and professional options. While at the time of her first arrest in 1968 Daniela worked at a factory and was planning to get married with her fiancé, by 1972 she was a sex worker in Madrid.[51] This is the moment when the booking photographs analyzed in this article's first lines were taken. The lines of running mascara on her face, her moving stare, and her disheveled wig are visual testimonies to the effects of state persecution. Using the pretext of a law supposedly aimed at protecting national mores and ruse of "rehabilitation," the authorities prevented the targeted subjects from living their lives—imprisoning, exiling, and surveilling them and forcing them into social ostracism—so that they would conform to the image of them that the law was intended to create.

However, I would suggest that the 1972 photographs also show that authorities were not able to subjugate the people they arrested as much as they wanted. To me, Daniela's expression—a disdainful and defiant look at the police officers—captures a feeling that there is nothing left to lose. In a similar vein, Jun Zubillaga-Pow describes how Singaporean trans women "put on a fierce facade to stare back," using "facial position and expression" to "convey a specific message, one that could be read as either arrogance or resignation."[52] I would situate Daniela's photo at that point when resignation meets and becomes arrogance. Her facial expression is

testimony to her resolve to carry on with her life despite being continually arrested. Amidst the pain that the running mascara on her face conveys, she looks directly at the police photographer, her eyelashes framing her stare. Her tensely pursed mouth tells the cameraman that she is immunized by years of continual police abuses. As Campt argues, quiet photographs like this one generate levels of intensity at the lower frequency of infrasound, which touches us, even though it is not audible.[53] Even though her mouth is sealed, we can perceive and feel Daniela's refusal to be fixed by the lenses of the state.

Still, relentless police harassment took a physical toll on her. As Nancy Scheper-Hughes would put it, violence became a daily lived experience for Daniela and shaped her "body-self."[54] Even though she was in her late twenties or early thirties in 1974, police officers described her as an "elderly miss" who was arrested when entering a boarding house with a young man.[55] During this last recorded arrest, police officers repeated the mortifying operation of taking her wig off her and paid striking attention to her looks, which they described as proper of a "modern girl" (*niña moderna*): "She exhibited a small pair of panties and stockings of the kind vulgarly called *pololos* or leotards. Her face and eyes were adorned with feminine makeup and she wore black suede boots of the kind that reaches up to the knee, with a short skirt showing off her thighs and with her breasts accentuated with a woman's bra."[56] Whoever wrote this report was well versed in women's latest fashions and used a very specific vocabulary for Daniela's clothing and fabrics. As the editors of *Trap Door* point out: "Fashion and imagery hold power, which is precisely why the state seeks to regulate and constrain such self-representations to this very day."[57] By fixating on the defendant's mini skirt as a core element of the "modern girl" phenomenon, the officer participated in the authorities' contemporary concerns about women's self-eroticization. Local district attorneys, for instance, advanced in their annual reports the hypothesis that there was a correlation among tourism, transactional sex, and modern fashion.[58] In view of these reports, police officers' vigilant observation and description of feminine aesthetics might respond to authorities' directives. The officers' zeal led them to violate the intimacy of people like Daniela, by observing and describing her taste in underwear.

Throughout her judicial file, Daniela's intimate life was as much recorded as shaped by Francoist policies. The file captures not only her emotional investments, erotic life, and aesthetics but also the ways in which the production of the file itself is imbricated in these intimate aspects of her life. In other words, the file indirectly suggests the potentialities of her physicality and her plans to get married by adopting her sister's identity, but also the ways in which these potentialities were curtailed by police arrests, forensic reports, and prison sentences. In brief, the file does not passively record her life trajectory; it actively shapes it by violent acts of intrusion that led her to an outcome—a recurrent cycle of imprisonments, release, sex work, and subsequent arrest reinitiating the cycle—that the file's inception had in

part predetermined for her. Yet Daniela's way of expressing herself and situated agency also resurface in the archival materials. She keeps a firm expression while posing for her identification photographs and refuses to adopt the physicality and gender that authorities and forensic doctors ascribe to her. What is more, the fact that she borrowed her sister's legal identity points to the centrality of sisterhood as a strategy of survival that unsettled the state taxonomic division between kinship and sexual "dangers," as the next section explores in more detail.

Carla and Romina: Posing and Togetherness

Photographs and intimate materials that were produced by trans women before their arrest provide a window into their representational practices. One file, initiated in 1974, includes several such photos confiscated from Carla. These are powerful images that shed light over how persecuted individuals carved their social spaces and decided how they wanted their femininity, sexuality, and eroticism to be captured by the camera. In these images, models pose for an unknown photographer. There are multiple photos of the same woman posing alone in different settings, with various clothes and postures: against a background of dense vegetation, while confidently smoking a cigarette, wearing a nice, short dress and exhibiting her shaved, long legs; lying barefoot on the grass in a park with one leg over the other; wearing bell-bottoms and a shirt in a field with her hands framing her hips; standing sideways against a backdrop of small bushes and trees while wearing a bra and a skirt; and looking frontally into the camera in an empty street, with her arms resting by her side. These portraits are key to understanding trans women's self-representation. As Gabriela Cano has noted: "Photographic portraits transformed visual body culture and made it possible for common people to fix their desired physical images in lasting prints. . . . Each time the portrait was viewed by oneself or someone else, the body image and the identity created by the photograph was confirmed."[59] In this line, the images from this file have in common their emphasis on naturalness and the focus on the model's legs as a metonymic attribute of her femininity. These visual codes correspond to the "logic of *sacar el cuerpo* (bring out the body)," which Marcia Ochoa describes as a series of "technologies to allow the feminine body to emerge," according to a "notion of nature as both inherent and in need of collaboration."[60] The pose and the background are the technologies used in these photographs to bring out the model's feminine body by foregrounding her beautiful legs and silhouettes in static, vegetal landscapes.

There are also confiscated photographs that reflect defendants' relationality. In a foreground image, a handsome young man with sideburns closes his eyes and kisses a woman on her chin while putting his arm around her. Her wide smile as well as the physical intimacy conveyed by their posturing suggest that they might have been emotionally and/or sexually involved in some way. The file also includes an image of two women playing with some props in a photo booth, and an image of a

blond woman with short hair wearing lipstick and a leather jacket, among many other visual traces of a sort of community or network formed by a group of people who enjoyed taking photographs of themselves to capture their bodily aesthetics and shared moments of joy and intimacy.

These photographs contradict the legal documents included in the files, which reduce and confine defendants' social roles. To begin with, the files are titled using the defendants' legally assigned names, which were not the names that they used in their daily life. Carla was first arrested when she was a minor of only sixteen—a fact that never appeared to be taken into consideration when adjudicating her sentence—and accused of prostituting herself in a street called Pasaje Domingo, which at that time was a known locale for transactional sex.[61] She explained that she had worked in different factories and in construction as well, but since she could not find a job for the last six months, she had dedicated herself to "homosexuality" (referring to prostitution).[62] She was arrested at a moment when the effects of the 1973 oil crisis rippled through the Spanish economy, causing high rates of unemployment and inflation, while the dying Franco regime tried to contain social unrest with increasingly repressive measures. This socioeconomic and political context shaped working-class trans women's experiences by adding multiple layers of vulnerability to their already precarious economic survival strategies.

The judge levied a harsh sentence, requiring that she pay a fine as well as cover the state's trial expenses, spend months in prison, be exiled for a year, and be surveilled after her release.[63] Exile sentences were particularly harmful and impractical for working-class families that relied on all their members' labor to earn the minimum income needed to sustain themselves. In this line, Carla's mother declared in 1975 that Carla had come back to their family's home so that she could help them financially.[64] However, constant police surveillance prevented her from carrying on with her life. Arrested for a second time, she was asked about her appearance and sexual practices and clarified that she dyed her hair and plucked her eyebrows because "she liked it," in much the same way that she had sex with men whom she liked without charging them.[65] Taste and aesthetics as a matter of choice resurfaced in the testimonies and photographs of trans women, even though official documents presented them as a question of "sexual inversion."

Most importantly, by looking at trans women's declarations and photographs together we can appreciate how sisterhood figured in their cultural and social practices. Carla and one of her friends, Romina, were arrested in May 1975 in one of the industrial suburbs of Barcelona. According to the arrest report, the two of them were taking a stroll when neighbors started to crowd around them to discuss whether they were male or female, until the Guardia Civil intervened and arrested them.[66] Carla declared that "[she] did not have carnal knowledge of her friend [Romina]. The affection she felt for her was proper of a sister."[67] As Franco lived his last days, trans women vocally and visually asserted themselves by taking to the

streets and demonstrating the role of affect in building alternative forms of kinship.[68] Strolling (*pasear*) has multiple connotations in Spanish that here suggest the defendants' determination to be part of the public sphere. *Pasear* is the quintessential form of community sociability in Spanish towns; after work, people take to the streets and squares, sit on benches, greet other passersby, exchange news and rumors, tell jokes and play music, share information about their relatives and neighbors, and discuss sporting and political events.[69] To participate in the daily stroll or *paseo* for these women meant to reclaim their right to belong, to leisure time in the public sphere, to see and be seen. In this sense, *pasear* as a quotidian practice was inscribed "in the struggle to create possibility within the constraints of everyday life" by using a "strategy of affirmation and a confrontational practice of visibility," as Campt puts it.[70]

This desire to be seen drives my engagement with this visual archive. In the Francoist authorities' view, the confiscation, filing, and archiving of these portraits neutralized the potential "danger to society" of the models and other people looking at these objects in a way that confirmed models' body image and identity, per Cano's analysis. In this sense, the incorporation of the photographs in the judicial file was a hermeneutic practice, a "taxonomic tool" meant to insert these images into a transphobic narrative. Their preservation was aimed at retaining for posterity the moment of exposure of gender nonconformity, of inscribing the stigmatization of trans subjectivities both in institutional archives and on the bodies of the violators. Yet, as Edwards points out, the archive remains unstable: "The very fact of public access, present and future, threatened to destabilize preferred readings . . . as archives were subject to small acts of re-ordering, re-captioning, and re-interpretation, fostering 'myriad of random encounters with objects of knowledge rather than singular linear narratives.'"[71] In this line, one of the ways of unsetting the reading of trans bodies by Francoist curators is to fully engage in a random encounter with the images that trans women took of themselves to preserve their desired body image.

Along with their *paseos*, the photographs suggest that they also spent their spare time in photo booths, parks, beaches, and natural spaces. In other words, their presence was not exclusively confined to those areas that the authorities associated with homosexuality or transactional sex. At the same time, while they certainly frequented public areas; natural backgrounds stood for a sort of shelter where they could fully show their bodies without being afraid of the social and legal consequences. The opposite of these women's self-representation was the image imposed on them by police officers during their arrest. A face streaked with running mascara epitomizes the consequences of police violence, both in Carla's and Daniela's files. Carla's friend Romina declared that, while the police officer was making a phone call to report them, she had ducked into a public bathroom "and took the mascara off her face, because she had been crying a little bit."[72] There are two possibilities here. She

might have taken off the mascara so that it would not be used as evidence against her (by means of photographing her with makeup). However, this possibility is unlikely, since she admitted that she was wearing mascara anyway. Most likely, she did cry when arrested for the simple act of strolling with her friend, and perhaps she cleaned her face so as to not give police officers the satisfaction of seeing and photographing her spoiled makeup. The police report on Romina's arrest pays striking attention to aesthetics: "She had makeup on her face, with lipstick and a mole next to the lower lip, wearing red pants and a red sweater without sleeves and showing her cleavage. She also wore women's shoes, four rings on her hands, and a lady's wristwatch on her left wrist."[73]

When opening Romina's file, one encounters a photocopy of all the photographs and intimate materials that were confiscated from Carla and kept in her file. Francoist officers created surrogate records by carefully arranging the personal photographs and letters confiscated from Carla into derivative montages, in a curatorial practice that goes beyond the logic of destruction and erasure. If we concretize the definition of *photocopy* as the creation of new but unoriginal images "by the action of light . . . on an electrically charged surface,"[74] we see that state agents superimposed the personal photographs that these trans women had taken of themselves to an electrically charged surface so that light could form new images. Thus, far from erasing the confiscated photographs, light circulated through them to form a sequential series of vignettes with their own implicit narrative, but as joyful and enticing as the original images. The visual narrativization of trans experiences is even more evident on the next page in the file, in which the state agent who selected, produced, and arranged the photocopies apparently had decided to visually connect intimate materials to depict and narrate an intimate relationship. At the top of this page there are two images taken in a photo booth, which in their side-by-side contraposition suggest either a coupling between the models, apparently a man and a woman, or, alternatively, that these photographs show a trans woman before and after her transition. Underneath these images, the curator had included a love poem and an address, maybe to imply that one of the two individuals in the photographs had sent the poem to the other one:

Por qué no vuelves a mi lado
sí me consumo de ansiedad
es que tal vez me has olvidado
mas no lo quiero ni pensar
echo de menos tus caricias
la soledad de nuestro amor
echo de menos tu sonrisa
y el eco dulce de tu voz
esperaré que vuelvas
nuevamente lo mismo

qué otras veces espere
qué importa que yo sufra
intensamente
te quiero más que ayer
más cada vez
y si no vuelves a mi lado
de tu recuerdo viviré
triste recuerdo de un
pasado que nunca
más ha de volver

Why don't you come back to my side?
I am anxiously consuming myself
[thinking] that maybe you forgot me
but I don't even want to think about it
I miss your caresses
the loneliness of our love
I miss your smile
and the sweet echo of your voice
I'll wait for you to come back
Once again, the same
that other times I waited
no matter whether I suffer
Intensely
I love you more than yesterday
more and more
And if you don't come back to my side
On your memory I will live
sad memory of a
past that never
more shall come back

 While this poem is worth citing as a vital literary text that connects us with the affective life of trans women under Franco, our reading is in itself a result of police officers' violent intrusion into their intimacy. At this point, there is no escaping the realization that historicizing the experiences of marginalized individuals entails an act of voyeurism. The envelope that the curator had included in the photocopy next to the poem was addressed to Romina, using her female name and her legal last names. The curator seemed to indicate in this way that Romina had received this poem from a lover, who might have been the male person whose ID photo appeared on top of the poem in the photocopy. The poem itself highlights certain significant aspects of a relationship that apparently involved Romina. First, the poem characterized love as lonely. This oxymoron, especially in the Spanish

original, "la soledad de nuestro amor," conveys that the bond between two lovers is stronger when it forces them into social ostracism. The theme of a mutual attraction that becomes more intensely consuming by virtue of being forbidden is a common trope. Yet, in this particular iteration, it becomes a forceful language through which trans women claim intimacy as a mode of belonging. The semantic field of the poem (caresses, smile, voice) alludes to the performance and production of intimacy in the photographs from the same file. According to transgender studies scholar Cole Rizki, the "unassuming generic conventions" of snapshots include elements that are "universally recognizable" as a performance of intimacy, such as the "frontal pose, centered subject [and] affectionate gestures like arms around shoulders and broad smiles," all of which appear in the photos from this file. This visual language, with its focus on quotidian affects, counteracted the media spectacle of news and images that sensationalized trans people's life and death.[75] In addition, when we count on both photographic and written documents from trans communities, following Singer, this should be seized as an opportunity to temper what he calls the "tyranny of the visual" by incorporating subjects' own written statements, an approach that in this case contributes to highlight how the language of intimacy traverses both registers.[76]

Conclusion

Taking into account the long trajectory of deployment of judicial evidence to subjugate and erase trans people, in this article I focus on how their confiscated personal photographs can be read in a way that turns the concept of "evidence" against itself. The visual archive foregrounded in this piece points to trans women's ideas of intimacy, beauty, and kinship—sisterhood, in particular, appeared to be a central value and survival strategy for these women, as I have traced through the relationship between Carla and Romina, and between Daniela and her sister. Thus these images center a different narrative than the one presented by depositions and legal documents, which generally revolve around public shaming, forensic violence, and police harassment. Through the photographs that trans women took in (semi)public and naturalized spaces, and through their participation in social rituals and affective relationships, we can trace the genealogy of their experiments with freedom and transitioning, just as Spain was preparing to embark on its own post-Franco transition.[77]

Javier Fernández Galeano is a historian of Modern Latin America and Iberia. His research traces the erotic lives and legal battles of Argentine and Spanish gender-nonconforming people in the twentieth century. Javier received his PhD in history from Brown University and is currently a Juan de la Cierva Fellow at the University of Valencia. He has published in the *Journal of the History of Sexuality*, the *Latin American Research Review*, and *Encrucijadas*, among others.

Notes

This research was conducted with the support of the Andrew W. Mellon Postdoctoral Research Fellowship (at Wesleyan University), the Juan de la Cierva fellowship, and the research teams "El problema de la alteridad en el mundo actual" (HUM536), "La clínica de la subjetividad: Historia, teoría y práctica de la psicopatología estructural" (PID2020-113356GB-I00) and "Memorias de las masculinidades disidentes en España e Hispanoamérica" (PID2019-106083GB-I00). I want to acknowledge the Arxiu Central dels Jutjats de la Ciutat de la Justícia and the Archivo General de la Administración for their assistance in accessing the sources. Finally, I want to thank the editors of this special issue and my colleagues Cole Rizki and Justin Pérez for their valuable comments, which profoundly shaped my reading of the sources and methodological discussions.

1. File 279/1968. Legajo 1465. Vagrancy Court of Madrid. Archivo General de la Administración. Alcalá de Henares, Spain (hereafer, File 279/1968).

2. Drager, "Looking after Mrs. G"; Fernández-Galeano, "Performing Queer Archives"; Tortorici, "Decolonial Archival Imaginaries."

3. These are the pseudonyms that I use for them in accordance with Spanish privacy protection laws, which also forbid the publication of any information that may allow for the identification of defendants.

4. To trace the effects of the Vagrancy and Social Dangerousness and Rehabilitation Laws on trans and queer communities, I am collecting a database of judicial case files from the courts that operated in different Spanish cities during the Franco era. At the moment, this database includes more than one thousand entries from the courts of Madrid, Barcelona, Sevilla, Málaga, Las Palmas de Gran Canarias, and Bilbao.

5. Chamouleau, *Tiran al maricón;* Ramírez Pérez, *Peligrosas y revolucionarias*; Mora Gaspar, "Construcción de la identidad." Documentaries such as *Nosotrxs Somos* (dir. César Vallejo, 2018) and *Rosario Miranda* (dir. David Baute, 2002) also contribute to this trend.

6. Casanova and Gil Andrés, *Twentieth-Century Spain*, 239–62.

7. Ley de 15 de Julio de 1954.

8. Chamouleau, *Tiran al maricón*, 164–78.

9. Huard, *Los invertidos*, 8.

10. Huard, *Los invertidos*, 13.

11. Platero and Rosón, "Una genealogía trans°," 135.

12. Platero, *Por un chato de vino*.

13. Platero, "'Su gran placer es usar calzoncillos y calcetines.'"

14. Solís adds that trans women have been historically neglected by institutions and activist groups in Spain, owing to the fact that most of them were poor. Solís Galván, *La doble transición*, 20–22.

15. Mejía, *Transgenerismos*, 16.

16. Mejía, *Transgenerismos*, 21–22.

17. Mérida Jiménez also argues that in the 1970s most trans women employed in show business in Barcelona came from a working-class background. The police targeted these visible, poor trans women—labeled *mariconas*—and spared well-off trans women. Mérida Jiménez, *Transbarcelonas*, 68–69, 79.

18. There are also institutions and organizations that are committed to the preservation and accessibility of trans and queer archives, including the Museo Nacional Centro de Arte Reina Sofía (n.d.) and the Casal Lambda (n.d.).

19. Imedio, "Los recuerdos de Carmen de Mairena."
20. Sentamans, "Redes transfeministas," 36–37.
21. Post-Op, "De placeres y monstruos," 198.
22. Metzger and Ringelberg, "Prismatic Views," 162.
23. Platero, "Críticas al capacitismo heteronormativo," 220.
24. Gossett, Stanley, and Burton, "Known Unknowns," xvi.
25. Singer, "From the Medical Gaze," 601.
26. This aligns with the insistence "on pleasure, self-care, beauty, fantasy, and dreaming as elements key to sustained radical change." Gossett, Stanley, and Burton, "Known Unknowns," xxiv.
27. Edwards, "Photography," 130–36.
28. Campt, *Listening to Images*, 1–5.
29. Campt, *Listening to Images*, 8.
30. Campt, *Listening to Images*, 5.
31. I borrow the definition of cameras as hermeneutic devices from Edwards, who argues that "the camera, photographs, and archive, and the spaces between them, become sites where things are made readable." Hence, following Edwards, we ought to focus our attention on how "material practices make photographs adequate to the historical desires that enmesh them." Edwards, "Photography," 137.
32. Ley Orgánica 15/1999.
33. Terrasa Mateu, "Control, represión y reeducación," 512–16.
34. Ley Orgánica 15/1999.
35. Singer, "From the Medical Gaze," 602.
36. Singer, "From the Medical Gaze," 604–6, 611.
37. Singer, "From the Medical Gaze," 602.
38. I am indebted to transgender studies scholar Cole Rizki for pointing out the intricacies of this ethical choice and providing me with resources to critically think about it.
39. Martínez, "Archives, Bodies, and Imagination."
40. Campt, *Listening to Images*, 20.
41. On situated knowledge, see Figari, "Conocimiento situado y técnicas amorosas de la ciencia"; Valentine, *Imagining Transgender*, 21–22.
42. File 279/1968.
43. According to Mérida Jiménez, trans people imprisoned and interviewed by psychiatrists and other medical experts described their transitioning as a fundamental step to escape repressive mechanisms and be able to formalize their relationships with their partners. Mérida Jiménez, *Transbarcelonas*, 91.
44. "A los catorce años sintió que su sensibilidad era la de una mujer, a pesar de tener sus órganos genitales masculinos, si bien mas pequeños que los normales, sin que se haya erreccionado nunca; que la voz, la forma del cuerpo de cintura para arriba y los senos, eran los característicos de una mujer, usando las ropas interiores de la misma, tanto de sujetador como de bragas." Deposition of Daniela in front of the court of first instance on April 5, 1968. File 279/1968. Translations are mine.
45. Report by the Guardia Civil of Aranjuez on April 5, 1968. File 279/1968.
46. Rizki presents a similar analysis of the crossing out of *heterosexual* from reports on HIV by the Buenos Aires police. Rizki, "'No State Apparatus,'" 89.
47. "Se trata de un varón de constitución normal, con un aparato genital masculino perfectamente conformado, si bien la voz es ligeramente afeminada. Examinado el tórax, nos encontramos con un tórax netamente masculino, sin vello y las areolas mamarias

pigmentadas y pezones salientes. No observa ginecomastia, es decir abultamiento de las mamas." Forensic report on April 8, 1968. File 279/1968.

48. Stryker, *Transgender History*.

49. "Aparentando ser mujer, a cuyo efecto usaba la partida de nacimiento de una hermana suya y que estaba casado con [su pareja], con el que hacía vida íntima de tipo homosexual." Sentence issued on May 24, 1968. File 279/1968.

50. Report by the police of San Sebastian on October 7, 1968. File 192/1968 from the Vagrancy Court of Bilbao. Included in File 279/1968.

51. Police report on May 6, 1972. File 279/1968.

52. Zubillaga-Pow, "'In the Raw,'" 447–49.

53. Campt, *Listening to Images*, 6.

54. Scheper-Hughes, *Death without Weeping*, 135.

55. Police report on April 6, 1974. File 279/1968.

56. "Exhibió una pequeña braga con medias de las vulgarmente llamadas pololos o leotardos. Que así mismo se hace constar que su cara la llevaba pintada con masajes y sus ojos adornados con maquillajes propios de mujer y calzada con botas negras de 'ante' de las que llegan hasta la rodilla, con falda corta exhibiendo sus muslos y sus pechos apoyados con un sostén propio de mujer." Police report on April 6, 1974. File 279/1968.

57. Gossett, Stanley, and Burton, "Known Unknowns," xvi.

58. For instance, in 1968 the district attorney of Valencia shared his concern about young men prostituting themselves to access a consumer culture centered on fashion trends, in a description of "jumbled gatherings of long-haired Yé-yé, hippie, and beatnik [individuals] wearing all kinds of extravagant clothing, in oppressively narrow alleyways." Cited in Ramírez Pérez, "Franquismo y disidencia sexual," 158.

59. Cano, "Unconcealable Realities of Desire," 38.

60. Ochoa, *Queen for a Day*, 157–58, 161.

61. Arrest report on June 20, 1974. File 416/1974. Juzgado Especial de Vagos y Maleantes de Barcelona, Arxiu Central dels Jutjats de la Ciutat de la Justícia, Hospitalet de Llobregat, Spain (hereafter, ACJCJ).

62. Deposition in front of the judge on June 20, 1974. File 416/1974.

63. Sentence issued on October 16, 1974. File 416/1974.

64. Deposition by Carla's mother on February 21, 1975. File 416/1974.

65. Police report on March 19, 1975. File 416/1974.

66. Report by the Guardia Civil of Sabadell on May 23, 1975. File 416/1974.

67. "No ha tenido contacto carnal con su amiga [name/nombre] y que su afecto es de hermana." File 416/1974.

68. Huard, *Los invertidos*, 89.

69. The personal photos and experiences of Carla and Romina may fit within the frame developed by media scholar Andre Cavalcante, who focuses on "transgender individuals' struggle for the ordinary, or the constant and deliberate work devoted to achieving the uneventful and common inclusions and affordances of everyday, associative life." Cavalcante, *Struggling for Ordinary*, 24. Barely anything could better represent "uneventful and common inclusions" in 1970s Spain than the daily *paseo*. In this line, Mérida Jiménez argues that trans women's daily struggles for public presence in 1970s Barcelona were related to their "intimate liberation." Mérida Jiménez, *Transbarcelonas*, 92.

70. As Campt highlights, the "seeming insignificance" of these everyday practices of visibility obscures the fact that the trivial and mundane are essential in the lives of the dispossessed. Campt, *Listening to Images*, 4, 7–8.

71. Edwards, "Photography," 148.
72. Report by the Guardia Civil of Sabadell on May 23, 1975. File 416/1974.
73. "El que tenia la cara pintada, con lunar junto al labio inferior y estos pintados, vistiendo pantalón rojo, suéter rojo sin mangas y escotado y calzando zapatos de mujer y cuatros anillos en las manos y reloj de pulsera de señora en la muñeca izquierda." Report by the Guardia Civil of Sabadell on June 23, 1974. File 442/1974. Juzgado Especial de Vagos y Maleantes de Barcelona, ACJCJ.
74. *Merriam-Webster's Collegiate Dictionary*, s.v. "photocopy." www.merriam-webster.com /dictionary/photocopy.
75. Rizki, "Familiar Grammars," 201.
76. Singer, "From the Medical Gaze," 607.
77. During the democratic transition in the 1970s, *travestis* were among the most visible participants in the public protests against the legal legacies of the Franco regime's persecution of queer and trans people. Platero and Rosón, "Una genealogía trans°," 139.

References

Campt, Tina M. *Listening to Images*. Durham, NC: Duke University Press, 2017.

Cano, Gabriela. "Unconcealable Realities of Desire: Amelio Robles's (Transgender) Masculinity in the Mexican Revolution." In *Sex in Revolution: Gender, Politics, and Power in Modern Mexico*, edited by Jocelyn Olcott, Mary K. Vaughan, and Gabriela Cano, 35–56. Durham, NC: Duke University Press, 2006.

Casal Lambda. n.d. https://lambda.cat/centre-documentacio-armand-de-fluvia/ (accessed August 8, 2021).

Casanova, Julián, and Carlos Gil Andrés. *Twentieth-Century Spain: A History*. Cambridge: Cambridge University Press, 2014.

Cavalcante, Andre. *Struggling for Ordinary: Media and Transgender Belonging in Everyday Life*. New York: New York University Press, 2018.

Chamouleau, Brice. *Tiran al maricón: Los fantasmas "queer" de la democracia (1970–1988), una interpretación de las subjetividades gais ante el Estado español*. Madrid: Ediciones Akal, 2017.

Drager, Emmett Harsin. "Looking after Mrs. G: Approaches and Methods for Reading Transsexual Clinical Case Files." In *Turning Archival: The Life of the Historical in Queer Studies*, edited by Zeb Tortorici and Daniel Marshall. Durham, NC: Duke University Press, forthcoming.

Edwards, Elizabeth. "Photography and the Material Performance of the Past." *History and Theory* 48, no. 4 (2009): 130–50.

Fernández-Galeano, Javier. "Performing Queer Archives: Argentine and Spanish Policing Files for Unintended Audiences (1950s–1970s)." In *Turning Archival: The Life of the Historical in Queer Studies*, edited by Zeb Tortorici and Daniel Marshall. Durham, NC: Duke University Press, forthcoming.

Figari, Carlos. "Conocimiento situado y técnicas amorosas de la ciencia: Tópicos de epistemología crítica." *Cinta de moebio, revista de epistemología de ciencias sociales* (n.d.): 1–12.

Gossett, Reina, Eric A. Stanley, and Johanna Burton. "Known Unknowns: An Introduction to Trap Door." In *Trap Door: Trans Cultural Production and the Politics of Visibility*, edited by Reina Gossett, Eric A. Stanley, and Johanna Burton, xv-xvi. Cambridge, MA: MIT Press, 2017.

Huard, Geoffroy. *Los invertidos: Verdad, justicia y reparación para gais y transexuales bajo la dictadura franquista*. Barcelona: Icaria, 2021.

Imedio, Ferran. "Los recuerdos de Carmen de Mairena, junto a un contenedor." *El periódico*, January 29, 2016.

Ley de 15 de Julio de 1954 por la que se modifican los artículos 2° y 6° de la Ley de Vagos y Maleantes, de 4 de agosto de 1933. *Boletín oficial del estado*, July 17, 1954.

Ley Orgánica 15/1999, de 13 de diciembre, de Protección de Datos de Carácter Personal. *Boletín oficial del estado*, núm. 298.

Martínez, María Elena. "Archives, Bodies, and Imagination: The Case of Juana Aguilar and Queer Approaches to History, Sexuality, and Politics." *Radical History Review*, no. 120 (2014): 159–82.

Mejía, Norma. *Transgenerismos: Una experiencia transexual desde la perspectiva antropológica.* Barcelona: Bellaterra, 2006.

Mérida Jiménez, Rafael Manuel. *Transbarcelonas: Cultura, género y sexualidad en la España del siglo XX.* Barcelona: Bellaterra, 2016.

Metzger, Cyle, and Kirstin Ringelberg. "Prismatic Views: A Look at the Growing Field of Transgender Art and Visual Culture Studies." *Journal of Visual Culture* 19, no. 2 (2020): 159–70.

Mora Gaspar, Víctor. "Construcción de la identidad en contextos de resistencia. Subalternidad sexual en los discursos del tardofranquismo y la transición española (1970–1979)." PhD diss., Universidad Autónoma de Madrid, 2018.

Museo Nacional Centro de Arte Reina Sofía. n.d. ¿Archivo queer? www.museoreinasofia.es /exposiciones/archivo-queer (accessed August 8, 2021).

Ochoa, Marcia. *Queen for a Day: Transformistas, Beauty Queens, and the Performance of Femininity in Venezuela.* Durham, NC: Duke University Press, 2014.

Platero, R. Lucas. "Críticas al capacitismo heteronormativo: Queer crips." In *Transfeminismos: Epistemes, fricciones y flujos*, edited by Miriam Solà and Elena Urko, 211–24. Tafalla: Txalaparta, 2013.

Platero, R. Lucas. *Por un chato de vino: Historias de travestismo y masculinidad femenina.* Barcelona: Bellaterra, 2015.

Platero, R. Lucas. "'Su gran placer es usar calzoncillos y calcetines': La represión de la masculinidad femenina bajo la dictadura." In *Mujeres bajo sospecha: Memoria y sexualidad, 1930–1980*, edited by Raquel Osborne, 193–210. Madrid: Editorial Fundamentos, 2015.

Platero, R. Lucas, and María Rosón. "Una genealogía trans°: Siglo XX." In *Trans°: Diversidad de identidades y roles de género*, edited by Niurka Gibaja Yábar and Andrés Gutiérrez Usillos, 134–41. Spain: Ministerio de Educación, Cultura y Deporte, 2017.

Post-Op. "De placeres y monstruos: Interrogantes en torno al postporno." In *Transfeminismos: Epistemes, fricciones y flujos*, edited by Miriam Solà and Elena Urko, 193–210. Tafalla: Txalaparta, 2013.

Ramírez Pérez, Víctor M. "Franquismo y disidencia sexual: La visión del Ministerio Fiscal de la época." *Aposta: Revista de ciencias sociales* 77 (2018): 132–76.

Ramírez Pérez, Víctor M. *Peligrosas y revolucionarias: Las disidencias sexuales en Canarias durante el franquismo y la transición.* Las Palmas de Gran Canaria: Fundación Canaria Tamaimos, 2019.

Rizki, Cole. "Familiar Grammars of Loss and Belonging: Curating Trans Kinship in Post-dictatorship Argentina." *Journal of Visual Culture* 19, no. 2 (2020): 197–211.

Rizki, Cole. "'No State Apparatus Goes to Bed Genocidal Then Wakes Up Democratic': Fascist Ideology and Transgender Politics in Post-dictatorship Argentina." *Radical History Review*, no. 138 (2020): 82–107.

Scheper-Hughes, Nancy. *Death without Weeping: The Violence of Everyday Life in Brazil.* Berkeley: University of California Press, 1993.

Sentamans, Tatiana. "Redes transfeministas y nuevas políticas de representación sexual (I): Diagramas de flujos." In *Transfeminismos: Epistemes, fricciones y flujos*, edited by Miriam Solà and Elena Urko, 31–44. Tafalla: Txalaparta, 2013.

Singer, T. Benjamin. "From the Medical Gaze to Sublime Mutations: The Ethics of (Re)Viewing Non-normative Body Images." In *The Transgender Studies Reader*, edited by Susan Stryker and Stephen Whittle, 601–20. London: Routledge, 2013.

Solís Galván, Raúl. *La doble transición*. Madrid: Libros.com, 2019.

Stryker, Susan. *Transgender History*. Berkeley, CA: Seal, 2008.

Terrasa Mateu, Jordi. "Control, represión y reeducación de los homosexuales durante el franquismo y el inicio de la transición." PhD diss., Universitat de Barcelona, 2016.

Tortorici, Zeb. "Decolonial Archival Imaginaries: On Losing, Performing, and Finding Juana Aguilar." In *Turning Archival: The Life of the Historical in Queer Studies*, edited by Zeb Tortorici and Daniel Marshall. Durham, NC: Duke University Press, forthcoming.

Valentine, David. *Imagining Transgender: An Ethnography of a Category*. Durham, NC: Duke University Press, 2007.

Zubillaga-Pow, Jun. "'In the Raw': Posing, Photography, and Trans°Aesthetics." *TSQ* 5, no. 3 (2018): 443–55.

Homemade Pornography and the Proliferation of Queer Pleasure in East Germany

Kyle Frackman

East Berlin in the 1970s. Men meet for sex, pose for erotic snapshots commemorating the occasion, and share these and other images with each other. These black-and-white photos show a variety of naked men: thin, muscular, blond, dark-haired. Their reactions to the camera vary as well: some sheepishly or reluctantly gaze at the camera, while others confidently pose and show off their erections. Scattered among these photos are homemade reproductions of commercial pornography: photos of magazine pages or of other photos, with some betraying the context in which they were produced (with part of a newspaper in the frame), and others revealing the methods used (overexposure or an awkward flash).[1] These images, produced by unknown amateur photographers and circulated among friends, acquaintances, and erotic enthusiasts, are evidence of a clandestine yet joyful sexual culture in East Berlin of the 1970s. They are also illustrations of a complex moment in the history and culture of East Germany (GDR, German Democratic Republic)—a time when male homosexuality had been recently decriminalized and amateur photography and visual culture were changing, as supplies and equipment for photography became more available and the images they produced more ubiquitous.

Beyond their extraordinariness, the images raise questions about their context and production. They lead one to ask, for example, what they have meant and for

Radical History Review
Issue 142 (January 2022) DOI 10.1215/01636545-9397072
© 2022 by MARHO: The Radical Historians' Organization, Inc.

whom. Turning to the "what," these images have been creative expression, memento, social tool, and pornography, while also standing as a critique and, importantly, a record of existence. In terms of the "who" of the photos, they create a web of individuals, including the photographers, the subjects, the viewers (or "consumers"), and now the scholars. There are other important questions about what the images do, at both the time of their creation and of their interpretation. Writing about the "truth-telling" powers of photographs, John Roberts argues that within them there does exist "empirical evidence . . . of appearances" as well as "evidence of the social determination of these appearances."[2] In these photos, one sees the display of a past time and place, which help establish an interpretation of what effect they might have on the viewer.

This article examines some of these photographs to answer questions about the work they are doing and how one can interpret them, considering their historical and cultural context. There are two main components to my argument. First, these images are indirect products of the East German state, but they also are evidence of actions or expressions by individuals and groups within this society. Official support for amateur photography enabled its use for sexual pleasure and connection, while censorship and import embargoes made illicit art production and reproduction more likely. In other words, although the state encouraged certain leisure activities, it was the initiative of anonymous individuals that sparked the creation of these materials. Second, I argue that the images form an archive of queer pleasure, presentation, and critique. The archive I discuss comes from a private collection of shared pornographic and erotic images, including photos that documented sexual encounters among men (including at least one of the photographers) and photographic reproductions of commercially available pornography.[3] I have selected four from among the scores of images for their ability to speak to widely relevant themes of cultural production, creative expression, and desire in the GDR. The images, which circulated among like-minded connoisseurs, not only testify to the existence of the desire they document, but they also pose a challenge to acceptable public discourses in the GDR in their very composition, like the existence of same-sex desire and its role in the creation of visual records. As Thomas Yingling has argued, "For gay male culture, pornography has historically served as a means to self-ratification through self-gratification (or at least through the acknowledgment if not the enactment of homoerotic desire)."[4] It is worth stating that it is impossible and undesirable to classify any "identity" on the part of the men creating or posing in the images I discuss. Instead, my argument centers on the kinds of pleasures they may activate.

To the extent that the state played a role, individuals' ability to express themselves, especially in ways that exhibited vulnerable, controversial, and potentially dangerous desires, is necessarily important.[5] Cultural production in the GDR was not completely controlled by the state and therefore free of criticism and dissidence

in the way that triumphalist narratives described the society.[6] Andrew Port has observed that "power relations were far more complex than the simple 'state vs. society'—'regime vs. masses'— 'rulers vs. ruled' dichotomies have suggested."[7] In his innovative study of plastics and East German consumer culture, Eli Rubin argues that the GDR was "a unique culture, something purely East German, a combination of state and society but representing the power of neither over the other."[8] Even if one understands the GDR context to be one in which there was no total domination of citizens by the state, there were still manifest dangers for members of marginalized groups to engage in forms of self-expression and dissidence. Imagery, as well as creative expression in photography, "provide," according to Jennifer Evans, "visualizations of power, agency, and resistance well below the level of official media representations."[9] Photographic images can have great effect on our understanding of what was privately queer in a society with a disputed level of privacy.

The period of these images' creation in the GDR was also one of changing notions of privacy. Reforms and legal changes that took place in the 1970s altered the orientation of public life and with it the shape of what was private. Paul Betts has demonstrated that "the state's overbearing presence" in public life "made a relatively private home life all the more necessary and valued among its citizens."[10] Some of the reckoning with conceptions of public and private in the GDR arose from depictions of a "niche society," as Günter Gaus described it, in which private life held enormous importance for the small joys of life like gardening and celebrations of holidays with family.[11] Dagmar Herzog has argued that "sex eventually became a crucial free space in this otherwise profoundly unfree society."[12] Although Herzog is writing here primarily about heterosexuality and conditions affecting abortion, marriage, and divorce, the observation rings true for queer sexualities and their position in the GDR.

Eastern Bloc regimes sought to manage citizens' leisure time, so that it could be productive for the state's goals. The 1960s and 1970s were a time of increased demands by GDR citizens that the state offer them the cultural opportunities they desired, which many expressed by showing up at events that were most meaningful to them and adapting them.[13] One means of expanding cultural opportunities for the population was the encouragement of hobbies, including amateur photography. Following post-Stalinist reforms, hobbies channeled citizens' creative energies and could be at least partly monitored, while also praised and recognized, in amateur competitions.[14] Amateur photography could serve both public and private objectives: "as an instrument of power, cultural commodity, [and] the repository of individual communications."[15] By the 1970s, with increased availability of television, the censorship of photographic images persisted, but artists were given greater flexibility.[16] Amateur photography delivered "exalted symbols of the private," illustrating how private life could be structured in relation—but as a contrast—to public life.[17] As a means of encouraging appropriate "socialist leisure activity" and to capture

attention, the GDR regime went to great lengths to give its populace what it wanted. This included introducing nude images into the mainstream and using these as an exported commodity to be sold for the country's financial gain.[18] Such actions contradicted the ideological position that sexuality was for reproduction, rather than for pleasure.[19] Although it was probably not the state's intention, there was a lively exchange of professional and amateur photos, including nudes and erotic images, regardless of any official prohibition or avenues for sanctioned erotic content (like in the periodical *Das Magazin*).[20] The plentiful work in the published collection *Die nackte Republik* (*The Naked Republic*) shows how fond many amateur photographers were of creating their own nude material—ranging from imitations of naturalist nudism to shots that emulated Western pornography.[21] Officially permissible hobbies could also be used for forbidden goals. Prior scholarship on erotic and pornographic materials within the GDR has concentrated mostly on heterosexually oriented texts and images. One reason for this is the disproportionate number of available objects to analyze on the hetero-oriented side.[22] At least partly because of their illicit or unmentionable nature, queer or homo-oriented erotica and pornography have received less attention.[23]

In the mid- to late 1960s and the early 1970s, several events occurred that illustrate contradictory cultural impulses in GDR society and politics. Reforms under leader Walter Ulbricht, which critics said were succumbing to East Germans' irrational consumerist desires, led to a backlash. The cultural developments the ruling party hardliners attacked included what they saw as increasing criticism of the socialist state and cultural works (film, television, literature) that supposedly encouraged immoral behavior found in the imperialist, capitalist West—although the "immoral" artists were usually targeted for their critiques of life in the GDR.[24] As if to contribute to moralistic concerns, male homosexuality was decriminalized in 1968, owing to the assessment by a behind-the-scenes legal reform commission that homosexuality was a "biological problem" concerning a "vanishing percentage of the population" who "have no control over their drives."[25] The queer images to which I now will turn arose in this context, one of competing impulses of liberalization and prohibition as well as the otherwise contradictory surface and actual messages in a quasi-totalitarian society.

Unlike many of the kinds of images already mentioned, the photos I analyze are illicit. Publicly available nudes displayed almost exclusively women and usually in a manner associated with nature (e.g., lying on a beach), evoking past nude photography, especially of the 1920s. Privately produced photographs could take more chances, portraying more explicit imagery and a wider range of subjects, like breaking the near taboo of displaying naked men as well as showing sex acts. Private photos also allowed the creators to transgress the social boundaries determined by heterosexism.

The circumstances of such photos' production could vary widely, but there tended to be some commonalities. It is not surprising that the photos were usually

produced by people who had the equipment, materials, and skills necessary for the process, or had access to these in some form. This could mean that friends could provide these services, or undeveloped film could be removed from the country for processing in the West. The individuals producing these photos had a range of motivations, including the creation of sexual community (often with reciprocal sharing), personal enjoyment and mementos, artistic expression, or commercial gain through the sale of the images.[26]

Individuals involved in the production of these images put themselves in a compromising position. Usually, such photos were taken by amateur photographers who also had the skills and materials to develop the film. It is beyond the scope of this article to discuss the full range of creative energy that these photos illustrate, but one can see from the selected examples that these images could be controversial in at least two ways. First, they were legally dangerous because they violated the law against the distribution of pornographic material.[27] Although this prohibition was selectively enforced, there is evidence that the police and the Ministry for State Security, or Stasi, actively looked for and confiscated offending material.[28] Second, and perhaps more important, the photos ran afoul of the official views of sexuality, both for their non-procreative focus and for their homoeroticism, as men were the objects of other men's sexual desires.

The first two photos come from a series of images created in a space with a couch and an identifiable curtain, which allow them to be categorized by this one location. These first two images show a naked man posing in front of a curtain. In one photo (fig. 1), the man sits on a couch, leaning backward, his arms behind him propping himself up, his body stretched diagonally and thinly across the frame, while he gazes down at his semi-erect penis. Excerpts of magazines, including at least one cover and a few other pages, are affixed to the curtain.

In another image (fig. 2), the same man stands directly facing the camera, holding his penis with his right hand, his left hand perched just below his hip. His head is cocked slightly to his left; instead of looking at the camera, his eyes look diagonally toward the ceiling, almost like an eyeroll, as what seems to be the beginning of a smirk graces his lips. The expression has a playful effect, which adds to the critique these photos deliver. In both images, the curtain before which the man poses is adorned with covers and pages taken from GDR magazines. One of the covers, seen in both figures 1 and 2, comes from the July 7, 1971, issue of *Filmspiegel* (*Film Mirror*), featuring a cover portrait of actress Monika Woytowicz as the character Peggy in Konrad Petzold's 1971 film *Osceola*. A cover of *Neue Berliner Illustrierte* (*NBI*) from September 1971, showing an action shot of Olympic gold medalist swimmer Roland Matthes, is also visible. Other pages show a range of photographs: one shows a sports team; another two-page spread seems to show the evolution of vehicles from horse-drawn carriages to trains and automobiles. The two identifiable magazines come from the GDR's mass media environment and must be viewed within the context of the overall publishing structure within the GDR itself and in the Eastern

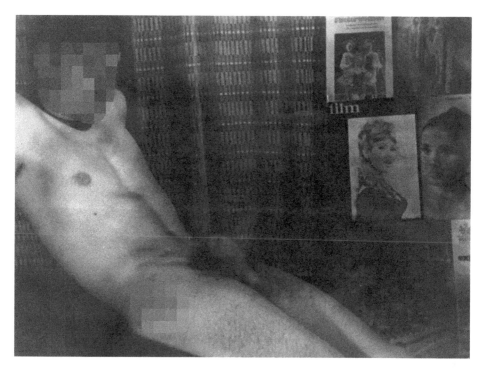

Figure 1. The background collage provides an audience as the man puts himself on display, early to mid-1970s.

Bloc. These magazines, like other state-controlled media, had limited ability to comment on actual "news" and often played a role of "public relations," if not overtly relaying the state's messages, then attempting to satisfy East Germans' demand for media, leisure, and consumer culture often inspired by their West German counterparts.[29]

It is possible that there are pages from other periodicals displayed in the collage, but the choices of at least *Filmspiegel* and *NBI* are not coincidental. These magazines were two of the most popular periodicals published in the GDR, both meant to appeal to the desire for entertaining and slightly consumerist media. *NBI* especially, with copious photographs (as of the early 1970s only recently printed in color owing to limited resources), had thematic and tonal similarities to the ruling party's newspaper *Neues Deutschland* (*New Germany*) but was not as dense and had far more illustration. *Filmspiegel*, which began publishing in 1954, was one of the appearances of mass media following the uprisings of 1953, an effort to appease (or distract) the East German people. The magazine "understood itself as representing the views and reflecting the tastes of the GDR's cinema-going public."[30]

These two photos with related compositions evince different attitudes in their presentation of the posing man and his environment. Figure 1 leans distinctly

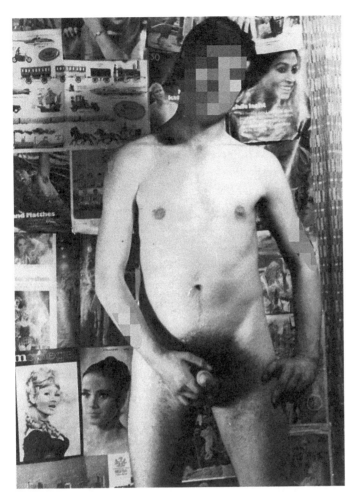

Figure 2. The collage is a backdrop, as the composition posits the man as worthy of his own cover image, early to mid-1970s.

more toward the erotic, although the pose and only semi-erect penis give a nod toward more artistic nudes.[31] In this display of the background collage, two of the magazine pages are avatars of (heterosexual) voyeuristic desire, as Woytowicz's photo seems to delight in the erotic event, while the adjacent close-up photo portrait of a woman gazes at the man's penis. The composition draws the eye toward the near center of the photo—the man's penis—toward which the posing subject, the women of the magazine photos, and the photographer are looking. Although the two magazine covers add another aspect—a playful voyeurism—to the image, the magazines are more incidental to the overall impact of the photo, which is more erotic, again emphasizing the man's sexual arousal while also putting the rest of his body on display. Both figures 1 and 2 deploy the magazine covers' (and women's) gaze, making the desire that the images evoke and provoke more multi-perspectival and pansexual. Part of a series of photos that document queer sexual encounters, these images

display the photographer's object of desire, which the women on the covers admire. These photos make desire itself the subject, also reminding one that complementary sexual interests can benefit from the same object of admiration. Figure 2, however, makes full use of the collage of magazine pages. Here, the composition places the subject amid the covers, positing him as worthy of a pinup. This man does not resemble models in the physique and bodybuilding magazines of the 1950s and 1960s, but the juxtaposition of nudity, eroticism, and media both criticizes the types of mainstream media available in the GDR and reminds one of the importance of such publications for community and self-identification.[32] Beyond this meta-level deployment of queer media history, these photos' (queer) use of the magazines has a more literal interpretation in its artifactual function: testifying to the existence of queer desire in contrast to the mainstream visual vocabulary of the era. These photos illustrate a queer use of desire, as the man's body—especially in figure 1's evocation of more "artful" nudes—channels the photographer's desire as well as that of the pinups.

The original amateur photos are especially intriguing, but another category of image is also available among the homemade, privately shared objects: reproductions of commercially produced pornography. These images have evidentiary value, but particularly for their attestation to the underground stream of sexual visual culture. Figures 3 and 4 reveal other considerations facing the would-be pornographer: the technical requirements and difficulties of photo processing and development. The next image divulges more about the processing of these photos. Figure 3 is a photo of a standing blond man with a moustache, smiling, his hands held behind his head. He wears a small yellow T-shirt and nothing else, revealing an erection. His hairstyle and the shirt place the photo in the 1970s. The lower corners of the image contain more marks that are remnants of the handling and development process. The most striking characteristic of the photo, however, is that it has a faded, foggy quality and presents a pink hue, which is often the result of expired film. This photo is one of a series of attempts to produce a copy of commercially available material; other versions (not reproduced here because of space limitations) reveal greater development problems (deeper pink color, occlusion of the underlying image, and distortion caused by the processing liquid). An interpretation of these images as somehow technically flawed is by no means certain, since one cannot be sure of the photographer's intent. As these photos are found with a series of other reproductions of commercially available pornography, combined with the oral history surrounding such images, one could reasonably surmise that the goal was to create suitable bootleg reproductions to be shared or distributed and possibly sold.

Many photos betray the illicit, duplicative nature of their production: blurry focus, overexposures, the glare of flashes obscuring some of the photos, the wooden tables on which the photos were resting. Figure 4 is an example of the operation to reproduce images for wider distribution. In portrait orientation, the photo shows a woman's legs spread as she sits on a man's lap and seems to guide the man's penis.

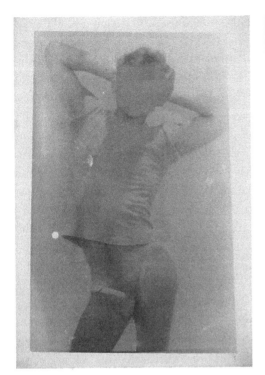

Figure 3. This image is one of several showing inconsistencies in the processing of photographic copies that could be caused by expired film stock or processing liquid.

Figure 4. The copied image on the pornographer's workspace, with glare (left) and newsprint (top) visible.

More interesting than the image itself (which is another example of a queer use of imagery, appealing to multiple desires) are the other details that such images reveal. There is printed German text above the image, from either a magazine or newspaper. Between text and the central image, there is either another image or one sees the table. At the bottom of the image, one sees evidence of another photo, perhaps one of a series waiting to be rephotographed. Such details conjure a vignette of a pornographer's workshop, an assembly line of smuggled pornographic images waiting to be reproduced and then either cherished or perhaps sold. The images are instructive, as I have argued, for their illustration of the conditions of visual production, in terms of both the availability of necessities like cameras, photographic print paper, and developing tools, and the amateur hobbyist photographic culture that fostered such production.[33] In addition to what they reveal about their creation, the images also remind one of other aspects: scopophilic desire, erotic arousal, and yearning for sexual community.

The photos are evidence of the encounters and activities they document, but they also attest to the reality of circulation, distribution, and the community to which

the images contributed. One component is the social and sexual gatherings (I counted at least thirteen men displayed) that inspired the original amateur images' creation. These photos provide documentation of sexual encounters, and they also offered a space for discussion, usually of the reproduced images. Some photos have comments in pencil on the reverse, offering remarks on the bodies of the men displayed.[34] Were these comments meant as guidance for the aspiring bodybuilder among the recipients of the shared images? Were they a means of categorizing or ranking the men's bodies? The answers to these questions are not apparent; nor is a determination of whether the comments were notes purely for the images' creator.

Thinking about the images' circulation, it is powerful to consider the unique mobility of these and other queer images. As Evans has written, "All images are mobile, but queer erotic photographs are particularly frenetic, trafficked from place to place, circulating in tourist and fine art networks, on the boundary between high and low, and . . . along twilight subcultural pathways."[35] The photos illustrate a network of desire and contacts, independent of how many people were involved in their creation or circulation. Extending beyond any discernible meanings, the work that these images do is manifold: the contemporaneous erotic inspiration, community, and circulation; the archival significance that inspired their maintenance in a personal collection; and now the scholarly and historical significance for an assessment of queer experiences in the GDR. Each of these complex series of events creates different kinds of meanings and reactions to those meanings. Evans has argued that one can approach photographic images as "agents of meaning in their own right," activating and reactivating emotional responses associated with their creation.[36] The affective and desirous orientations of these photos provoke questions about the subjects, objects, and audiences implicated in these displays. Annette Kuhn writes, "Meanings do not reside in images, then: they are circulated between representation, spectator, and social formation."[37] The feverish creation, transit, and existence of these images collectively tell more about queer and queer visual experience in the GDR of this period than one could glean from an individual image.

These images are extraordinary sexual artifacts, which are important in at least two ways. First, the photos have archival significance (i.e., the documentation they provide) and emotional content (i.e., what seems to inhere in the image itself and what the image can evoke in the viewer). As already mentioned, depictions of queer life—in this case, images that capture and evoke queer desire—are rare. Beyond the research already cited, other engagements with homosexual or queer experience in the GDR have focused on, for example, autobiographical nonfiction (and "transcript literature"), political activism in the late 1970s and early 1980s, or film.[38] It is likely that more images like this exist in private collections, but precisely for that reason—the privacy surrounding the images and the practices themselves—scholars have not had much opportunity to talk about the desires that such images evoke and provoke.

A second way these images are significant is their potential for delivering emotional content. Writing about photographs and their role in public life and documentation of work, Kevin Coleman, Daniel James, and Jayeeta Sharma posit that "photographs are a unique kind of artifact, at once a historical document, a site of affective investment, and an aesthetic object."[39] One has a great opportunity when "viewing erotic photography as history," as Evans writes, "especially when we consider the emotional work of images in creating historical subjectivity in the changing places and spaces of viewing and display."[40] Related to these interpretations, Ann Cvetkovich's work in *An Archive of Feelings* is instructive for thinking about how "grappling with the psychic consequences of historical events"—part of Cvetkovich's definition of trauma—is a process behind the objects analyzed here.[41] Cvetkovich observes that, for underrepresented and traumatized populations, "memory becomes a valuable historical resource, and ephemeral and personal collections of objects stand alongside the documents of the dominant culture in order to offer alternative modes of knowledge."[42] Forms of expression thus become "repositories of feelings and emotions, which are encoded not only in the content of the texts themselves but in the practices that surround their production and reception."[43]

While many engagements with such archives of feeling tend to focus on traumatic, melancholic, or otherwise negatively coded emotions, as Tim Dean has observed, positive-leaning interpretations are also possible.[44] Dean's work is illuminating because it shows that pornography, too, "preserves evidence of something that is otherwise transient and ephemeral," in line with what Cvetkovich theorized as archives of feeling.[45] Recalling Yingling's quote above, Dean argues that the archives—emotional, physical, transient, and otherwise—serve the crucial function of "cultural memory" for members of non-majority sexualities.[46] These images serve multiple purposes of memory, testimony or evidence, and form a communal rallying point for the underrepresented and persecuted who appear in them.

Regardless of the audience, the photos and associated commentary represent an articulation of desire and pleasure, one that created—or found its place in—a mode of visuality that had remained unrepresented in public GDR culture. Even if these images remained highly localized among a small audience, their existence was also transgressive in a national context of compulsory heterosexuality, as the GDR was a nation of petty bourgeois moralistic beliefs about sexuality. Turning again to Evans's argument that images' "intervention" can be just as if not more important than "inherent meaning," one can discern that such images could go far beyond titillation, "bringing to the surface a range of emotions and reactions that reflect the sentiments, fears, hopes, and aspirations of the time."[47] Operating beneath the surface of East German public life, both the series of sexual encounters documented in the original photos and the counterfeit production of pornography provide evidence of versions of private life in the GDR. One sees the variety of

erotic inspiration that could be found in materials ranging from artistic depictions of the male body to beefcake and physique photos to hardcore hetero- and homo-oriented pornography.

The photos I have analyzed here, both originals and reproductions, reshape our historical understanding of queer experiences in the GDR. Although this collection of images emphasizes men's self-presentation and affective engagement, the images nonetheless still tell us about the persistence of queer life, desire, and pleasure in the GDR more broadly. Amid a proliferation of visual representations in GDR life, public and private, encouraged by official state policies and challenging the primacy of the regime's goals, the photos I have analyzed capture the existence of a hidden queer life. Thanks at least in part to the support of the GDR state, these erotically oriented photographers were able to take advantage of the circumstances to engage in activities that the state would likely not want to support, even despite the easing of legal restrictions. The subversive quality of the images is not only for how one could interpret their possible meaning around the time of their creation; it is also vital for historical and cultural assessments of the realities of queer life in the GDR. As an archive of queer existence, the photos are evidence of both the existence of queer desire and its potential for affective resistance against majoritarian and oppressive actions.

Kyle Frackman is associate professor of German and Scandinavian studies and graduate chair in Germanic studies at the University of British Columbia. His research is situated in queer studies and engages with literature, film, and other media from the nineteenth to the twenty-first centuries.

Notes

This article draws on research supported by the Social Sciences and Humanities Research Council of Canada. I am grateful for research assistance from Steve Commichau. For their input, I thank Peter Rausch and Michael Eggert, as well as the article's anonymous reviewers.

1. Finding a workable definition of *pornography* is difficult. Definitions range from, for example, John B. McConahay's—"any sexually explicit verbal (written/oral) or visual material (including films, plays, and other performances) created with the intention of producing sexual arousal" (italics removed)—to Wayne Batten's rather poetic definition: "some form of explicit, unsimulated sexual prowess soliciting awe and envy but concluding in satiety," and many varieties in between. See McConahay, "Pornography," 37; Batten, "Strange Bedfellows," 86.

2. Roberts, *Photography*, 1–2.

3. Although these images were taken with the consent of the individuals portrayed and the images were shared and distributed among contacts in the GDR, I have blurred the subjects' faces and any identifying marks to protect their privacy. The images came to my attention, as with many historical discoveries, through happenstance. The owner of the private collection, who also told me about them as we talked about other aspects of queer life in the GDR, was at least the third person to possess the images, as they had been shared among a series of acquaintances, mostly gay men. Multiple gay men I spoke with were familiar with the practice of sharing photos. According to the oral history attached

to the photos that the collector communicated, many of the photos documented an amateur photographer's sexual encounters with men from both the East and the West. For more on images as private archive as well as record of sexual encounters, see Spring, *Secret Historian*; and Moddelmog and Ponce, *Samuel Steward*.

4. Yingling, "How the Eye Is Caste," 6.
5. See, for example, Grieder, "In Defence of Totalitarianism Theory." Unless otherwise indicated, all translations from the German are my own.
6. Ross, *East German Dictatorship*, and Epstein, "East Germany and Its History," detail the research that arrived prior to and shortly after the collapse of the GDR. More recent examples include Silverberg, "Between Dissonance and Dissidence," and Kelly and Wlodarski, *Art outside the Lines*.
7. Port, "Introduction," 5.
8. Rubin, *Synthetic Socialism*, 9.
9. Evans, "Introduction," 9–10.
10. Betts, *Within Walls*, 6.
11. Gaus, *Wo Deutschland liegt*, 156.
12. Herzog, *Sex after Fascism*, 188.
13. Richthofen, *Bringing Culture*, 173–77.
14. Crowley, "Socialist Recreation?," 97–98. For more on official GDR photography, see Wolle, "Smiling Face of Dictatorship."
15. Cuevas-Wolf, "Making the Past Present," 33, 52.
16. Kuehn, *Caught*, 108.
17. Degot, "Copy Is the Crime," 113; Cuevas-Wolf, "Making the Past Present," 34. For more on GDR photography in the 1970s, see Immisch, "Appearance and Being."
18. McLellan, "Even under Socialism," 221, 226; McLellan, "Visual Dangers," 170.
19. McLellan, "Even under Socialism," 230.
20. Backmann, "Als die Bilderwelten zusammenstürzten"; McLellan, "Even under Socialism," 226.
21. Honnef, *Die nackte Republik*; McLellan, "Even under Socialism," 226. On the promotion of amateur photography, see Goodrum, "Problem of the Missing Museum," 37–88.
22. More research has focused on literary representations of erotic, sexual, or romantic content. Examples include Linklater, "Unbeschreiblich köstlich"; Poiger, *Jazz, Rock, and Rebels*; and Urang, *Legal Tender*.
23. Exceptions include Bryant, "Locating the Lesbian Socialist Subject"; Evans, "Seeing Subjectivity"; McLellan, "Visual Dangers"; McLellan, "Even under Socialism"; and McLellan, "From Private Photography."
24. Richthofen, *Bringing Culture*, 163–64; see also McLellan, "Even under Socialism," 234–35n18.
25. Grau, "Liberalisierung," 332. Although the GDR regime had moved to differentiate itself from the Nazi dictatorship, it nonetheless sought to prevent public displays of homosexuality. The criminal reform took place amid legal arguments about whether individual criminal acts had great meaning for the overall class struggle and socialist cause. Alleged crimes against a person were no longer considered attacks against the social structure itself. Grau, "Liberalisierung," 325–31.
26. The friendly, communal distribution of erotic or pornographic images is a precursor to the now common phenomenon of sharing explicit selfies and sexts, including through hookup and dating apps. On contemporary practices, see, for example, Paasonen, Light, and Jarrett, "The Dick Pic"; Oswald et al., "I'll Show You Mine."

27. The law in question was §125 against "distribution of pornographic texts," which explicitly mentions "sketches, reproductions, films or representations." The punishments could include public rebuke, fines, or imprisonment.

28. Examples of confiscated material in the Stasi Archive (Bundesbeauftragte für die Unterlagen des Staatssicherheitsdienstes der ehemaligen Deutschen Demokratischen Republik, or BStU) include the collection of photos in BStU MfS HA II 48523 and MfS HA XX/Fo/1367.

29. Fiedler and Meyen, "Steering of the Press," 450–51.

30. Wedel, "Traces of Dissent," 4.

31. The man's poses have a long tradition in nude portraiture and studies, including in nude photography. See, for example, Ellenzweig, *Homoerotic Photograph*; and Borhan, *Man to Man*.

32. For more on the history of the pinup and physique image, see Dyer, "Don't Look Now." On the history of homophile and gay media, especially magazines, see, for example, Rehberg and Boovy, "Schwule Medien nach 1945"; and Johnson, *Buying Gay*.

33. For more on the conditions for GDR photographers, see Schiermeyer, *Greif zur Kamera*.

34. One such comment: "Good biceps. Shoulder is well defined, but otherwise still much to do."

35. Evans, "Seeing Subjectivity," 198–99.

36. Evans, "Seeing Subjectivity," 183.

37. Kuhn, *Power of the Image*, 6.

38. Transcript literature (*Protokolliteratur*) refers to a genre of narratives popular starting in the 1970s, often based on interviews and usually compiled by an editor, who sculpts them into something resembling a combination of oral history, autobiography, and history. On political activism, see Grumbach, *Die Linke und das Laster*; McLellan, *Love*; McLellan, "Glad to Be Gay"; Marbach and Weiß, *Konformitäten und Konfrontationen*. For examples of "transcript literature" (*Protokollliteratur*), see Lemke, *Ganz normal anders*; translated as Lemke, *Gay Voices from East Germany*; and Karstädt and Zitzewitz, *Viel zuviel verschwiegen*. For more on the latter text and archives of feelings, see Bühner, "How to Remember Invisibility." On film and queer experiences in the GDR, see, for example, Dennis, "*Coming Out* into Socialism"; Frackman, "East German Film *Coming Out*"; Frackman, "Shame and Love"; Frackman and Stewart, *Gender and Sexuality*.

39. Coleman, James, and Sharma, "Photography and Work," 1.

40. Evans, "Seeing Subjectivity," 198.

41. Cvetkovich, *Archive of Feelings*, 18.

42. Cvetkovich, *Archive of Feelings*, 8.

43. Cvetkovich, *Archive of Feelings*, 7.

44. Dean, "Introduction," 10.

45. Dean, "Introduction," 9.

46. Dean, "Introduction," 10.

47. Evans, "Introduction," 2.

References

Backmann, Ulrich. "Als die Bilderwelten zusammenstürzten." In Honnef, *Die nackte Republik*, n.p.

Batten, Wayne. "Strange Bedfellows: Tragedy and Pornography." *Canadian Journal of Film Studies* 27, no. 2 (2018): 85–103.

Betts, Paul. *Within Walls: Private Life in the German Democratic Republic*. Oxford: Oxford University Press, 2010.

Borhan, Pierre. *Man to Man: A History of Gay Photography*, translated by Patricia Clancy. New York: Vendome, 2007.

Bryant, Dara Kaye. "Locating the Lesbian Socialist Subject: Absence and Presence in East German Fiction, Sex Discourse, and Personal Narratives." PhD diss., Michigan State University, 2005.

Bühner, Maria. "How to Remember Invisibility: Documentary Projects on Lesbians in the German Democratic Republic as Archives of Feelings." In *Sexual Culture in Germany in the 1970s: A Golden Age for Queers?*, edited by Janin Afken and Benedikt Wolf, 241–65. Genders and Sexualities in History. Cham: Palgrave Macmillan, 2019.

Coleman, Kevin, Daniel James, and Jayeeta Sharma. "Photography and Work." *Radical History Review*, no. 132 (2018): 1–22.

Crowley, David. "Socialist Recreation? Amateur Film and Photography in the People's Republics of Poland and East Germany." In *The Sovietization of Eastern Europe: New Perspectives on the Postwar Period*, edited by Balázs Apor, Peter Apor, and E. A. Rees, 93–114. Washington, DC: New Academia, 2008.

Cuevas-Wolf, Cristina. "Making the Past Present: GDR Photo Albums and Amateur Photographs." *Visual Resources* 30, no. 1 (2014): 33–56.

Cvetkovich, Ann. *An Archive of Feelings: Trauma, Sexuality, and Lesbian Public Cultures*. Durham, NC: Duke University Press, 2003.

Dean, Tim. "Introduction: Pornography, Technology, Archive." In *Porn Archives*, edited by Tim Dean, Steven Ruszczycky, and David Squires, 1–26. Durham, NC: Duke University Press, 2014.

Degot, Ekaterina. "The Copy Is the Crime: Unofficial Art and the Appropriation of Official Photography." In *Beyond Memory: Soviet Non-conformist Photography and Photo-Related Works of Art*, 103–17. New Brunswick, NJ: Rutgers University Press, 2004.

Dennis, David Brandon. "*Coming Out* into Socialism: Heiner Carow's Third Way." In *A Companion to German Cinema*, edited by Terri Ginsberg and Andrea Mensch, 55–81. Malden, MA: Blackwell, 2012.

Dyer, Richard. "Don't Look Now: The Male Pin-Up." In *The Sexual Subject: A Screen Reader in Sexuality*, edited by *Screen*, 265–75. New York: Routledge, 1992.

Ellenzweig, Allen. *The Homoerotic Photograph: Male Images from Durieu/Delacroix to Mapplethorpe*. Between Men—Between Women. New York: Columbia University Press, 1992.

Evans, Jennifer. "Introduction: Photography as an Ethics of Seeing." In *The Ethics of Seeing: Photography and Twentieth-Century German History*, edited by Jennifer Evans, Paul Betts, and Stefan-Ludwig Hoffmann, 1–19. New York: Berghahn Books, 2018.

Evans, Jennifer. "Seeing Subjectivity: Erotic Photography and the Optics of Desire." In *The Ethics of Seeing: Photography and Twentieth-Century German History*, edited by Jennifer Evans, Paul Betts, and Stefan-Ludwig Hoffmann, 182–204. New York: Berghahn Books, 2018.

Fiedler, Anke, and Michael Meyen. "The Steering of the Press in the Socialist States of Eastern Europe: The German Democratic Republic (GDR) as a Case Study." *Cold War History* 15, no. 4 (2015): 449–70.

Frackman, Kyle. "The East German Film *Coming Out* (1989) as Melancholic Reflection and Hopeful Projection." *German Life and Letters* 71, no. 4 (2018): 452–72.

Frackman, Kyle. "Shame and Love: East German Homosexuality Goes to the Movies." In *Gender and Sexuality in East German Film: Intimacy and Alienation*, edited by Kyle Frackman and Faye Stewart, 225–48. Rochester, NY: Camden House, 2018.

Frackman, Kyle, and Faye Stewart, eds. *Gender and Sexuality in East German Film: Intimacy and Alienation*. Rochester, NY: Camden House, 2018.

Gaus, Günter. *Wo Deutschland liegt: Eine Ortsbestimmung*. Hamburg: Hoffmann und Campe, 1983.

Goodrum, Sarah. "The Problem of the Missing Museum: The Construction of Photographic Culture in the GDR." PhD diss., University of Southern California, 2015.

Grau, Günter. "Liberalisierung und Repression: Zur Strafrechtsdiskussion zum §175 in der DDR." *Zeitschrift für Sexualforschung*, no. 15 (2002): 323–40.

Grieder, Peter. "In Defence of Totalitarianism Theory as a Tool of Historical Scholarship." *Totalitarian Movements and Political Religions* 8, nos. 3–4 (2007): 563–89.

Grumbach, Detlef, ed. *Die Linke und das Laster: Schwule Emanzipation und linke Vorurteile*. Hamburg: MännerschwarmSkript Verlag, 1995.

Herzog, Dagmar. *Sex after Fascism: Memory and Morality in Twentieth-Century Germany*. Princeton, NJ: Princeton University Press, 2005.

Honnef, Klaus, ed. *Die nackte Republik: Aktfotografien von Amateuren aus 40 Jahren Alltag im Osten*. Berlin: Das Magazin Verlagsgesellschaft, 1993.

Immisch, T. O. "Appearance and Being: GDR Photography of the 1970s and 1980s." In *Do Not Refreeze: Photography behind the Berlin Wall*, edited by Nicola Freeman and Matthew Shaul, 24–27. London: Cornerhouse, 2008.

Johnson, David K. *Buying Gay: How Physique Entrepreneurs Sparked a Movement*. New York: Columbia University Press, 2019.

Karstädt, Christina, and Anette von Zitzewitz. *Viel zuviel verschwiegen: Eine Dokumentation von Lebensgeschichten lesbischer Frauen aus der Deutschen Demokratischen Republik*. Berlin: Hoho, 1996.

Kelly, Elaine, and Amy Wlodarski, eds. *Art Outside the Lines: New Perspectives on GDR Art Culture*. Amsterdam: Rodopi, 2011.

Kuehn, Karl Gernot. *Caught: The Art of Photography in the German Democratic Republic*. Berkeley: University of California Press, 1997.

Kuhn, Annette. *The Power of the Image: Essays on Representation and Sexuality*. London: Routledge, 1985.

Lemke, Jürgen. *Ganz normal anders: Auskünfte schwuler Männer*. Berlin: Aufbau-Verlag, 1989.

Lemke, Jürgen. *Gay Voices from East Germany*, edited by John Borneman. Bloomington: Indiana University Press, 1991.

Linklater, Beth. "'Unbeschreiblich köstlich wie die Liebe selber': Food and Sex in the Work of Irmtraud Morgner." *Modern Language Review* 93, no. 4 (1998): 1045–57.

Marbach, Rainer, and Volker Weiß, eds. *Konformitäten und Konfrontationen: Homosexuelle in der DDR*. Hamburg: Männerschwarm Verlag, 2017.

McConahay, John B. "Pornography: The Symbolic Politics of Fantasy." *Law and Contemporary Problems* 51, no. 1 (1988): 31–69.

McLellan, Josie. "'Even under Socialism, We Don't Want to Do without Love': East German Erotica." In *Pleasures in Socialism: Leisure and Luxury in the Eastern Bloc*, edited by David Crowley and Susan E. Reid, 219–37. Evanston, IL: Northwestern University Press, 2010.

McLellan, Josie. "From Private Photography to Mass Circulation: The Queering of East German Visual Culture, 1968–1989." *Central European History* 48, no. 3 (2015): 405–23.

McLellan, Josie. "Glad to Be Gay behind the Wall: Gay and Lesbian Activism in 1970s East Germany." *History Workshop Journal* 74, no. 1 (2012): 105–30.

McLellan, Josie. *Love in the Time of Communism: Intimacy and Sexuality in the GDR.* Cambridge: Cambridge University Press, 2011.

McLellan, Josie. "Visual Dangers and Delights: Nude Photography in East Germany." *Past and Present*, no. 205 (2009): 143–74.

Moddelmog, Debra, and Martin Joseph Ponce, eds. *Samuel Steward and the Pursuit of the Erotic: Sexuality, Literature, Archives.* Columbus: Ohio State University Press, 2017.

Oswald, Flora, Alex Lopes, Kaylee Skoda, Cassandra L. Hesse, and Cory L. Pedersen. "I'll Show You Mine So You'll Show Me Yours: Motivations and Personality Variables in Photographic Exhibitionism." *Journal of Sex Research* 57, no. 5 (2020): 597–609.

Paasonen, Susanna, Ben Light, and Kylie Jarrett. "The Dick Pic: Harassment, Curation, and Desire." *Social Media + Society* 5, no. 2 (2019): 1–10.

Poiger, Uta G. *Jazz, Rock, and Rebels: Cold War Politics and American Culture in a Divided Germany.* Berkeley: University of California Press, 2000.

Port, Andrew I. "Introduction: The Banalities of East German Historiography." In *Becoming East German: Socialist Structures and Sensibilities after Hitler*, edited by Mary Fulbrook and Andrew I. Port, 1–30. New York: Berghahn Books, 2013.

Rehberg, Peter, and Bradley Boovy. "Schwule Medien nach 1945." In *Was ist Homosexualität? Forschungsgeschichte, gesellschaftliche Entwicklungen und Perspektiven*, edited by Florian Mildenberger, Jennifer Evans, Rüdiger Lautmann, and Jakob Pastötter, 529–56. Hamburg: Männerschwarm Verlag, 2014.

Richthofen, Esther von. *Bringing Culture to the Masses: Control, Compromise, and Participation in the GDR.* New York: Berghahn Books, 2009.

Roberts, John. *Photography and Its Violations.* New York: Columbia University Press, 2014.

Rubin, Eli. *Synthetic Socialism: Plastics and Dictatorship in the German Democratic Republic.* Chapel Hill: University of North Carolina Press, 2008.

Schiermeyer, Regine. *Greif zur Kamera, Kumpel! Die Geschichte der Betriebsfotogruppen in der DDR.* Berlin: Ch. Links Verlag, 2015.

Silverberg, Laura. "Between Dissonance and Dissidence: Socialist Modernism in the German Democratic Republic." *Journal of Musicology* 26, no. 1 (2009): 44–84.

Spring, Justin. *Secret Historian: The Life and Times of Samuel Steward, Professor, Tattoo Artist, and Sexual Renegade.* New York: Farrar, Straus and Giroux, 2010.

Urang, John Griffith. *Legal Tender: Love and Legitimacy in the East German Cultural Imagination.* Ithaca, NY: Cornell University Press, 2010.

Wedel, Michael. "Traces of Dissent: The Journal *Filmspiegel* and Readership Responses to the Ban of Frank Beyer's DEFA Film *Spur der Steine* (1965/66)." *Historical Journal of Film, Radio and Television* 41, no. 1 (2020): 98–113.

Wolle, Stefan. "The Smiling Face of Dictatorship: On the Political Iconography of the GDR." In *German Photography 1870–1970: Power of a Medium*, edited by Klaus Honnef, Rolf Sachsse, and Karin Thomas, translated by Pauline Cumbers and Ishbel Flett, 127–38. Cologne: DuMont, 1997.

Yingling, Thomas. "How the Eye Is Caste: Robert Mapplethorpe and the Limits of Controversy." *Discourse* 12, no. 2 (1990): 3–28.

An Interview with Topher Campbell

rukus! Archive

Conor McGrady

The rukus! archive was founded in 2005 by photographer Ajamu X and filmmaker and theatre director Topher Campbell. It is the first archive in Europe dedicated to collecting, preserving and making available artistic, social, and cultural histories related to Black LGBTQ+ communities in the United Kingdom. Its intellectual origins reside in the work of Stuart Hall and British cultural studies, and the critical dialogue it establishes with both mainstream heritage practices and dominant Black and queer identity discourses. The archive covers the period between 1976 and 2012 and is housed at the London Metropolitan Archives. The archive received the London Metropolitan Archives Landmark Archives Award in 2007. The editors discussed the rukus! archive with Topher Campbell for this special issue of *Radical History Review*.

Conor McGrady: *Tell us about rukus! What prompted—and enabled—the foundation of the archive?*

Topher Campbell: Rukus! Federation is part of the evolution of a friendship that became a creative partnership now in its third decade. Ajamu X and I came to maturity in the 1990s, at a time when there were essentialist ideas about sexuality, race, and Black masculinity. The bandwidth for Black men was very narrow and existed mainly in a view of us being hypersexual, thuggish, criminal, or a respectable magical negro in service of white-centered ideas of us. Ajamu and I saw the way white

Radical History Review
Issue 142 (January 2022) DOI 10.1215/01636545-9397086
© 2022 by MARHO: The Radical Historians' Organization, Inc.

mainstream straight and LGBTQ+ culture actively invisibilized Black Queer communities in the UK. There was also an essentialist idea of a right kind of Blackness, coupled with respectability politics that dominated Black mainstream culture. Black LGBTQ+ culture wasn't seen as the right kind nor valued in any way, to the point of even questioning its existence. A prevalent view that still persists today was that Black LGBTQ+ people are part of a white conspiracy to keep Black people down. It wasn't a case of where are all the Black LGBTQ+ people in the 1990s, but do they even exist? The conspiracy of silence about Black LGBTQ+ people in Black UK communities and in Black mainstream culture forced homophobic and internalized racist ideas of our existence into wide acceptance.

With rukus! we wanted to speak to the way our existence was either problematized through basic racism or pigeonholed as being in crisis because of the HIV and AIDS epidemic. But more than any of this, rukus! was born out of a frustration and anger, a desire for playfulness, mischievousness, and wanting to put sex back into sexuality. We were living vibrant lives, connecting and growing with Black Queers nationally and internationally, and we saw none of this narrative anywhere. The UK Black LGBTQ+ story was obscured by North American histories and culture. We wanted to give witness to our stories.

Rukus! Federation was named because the word *rukus* is part of Jamaican culture. To "cause a rukus" means "to mek up noise," to disturb the peace, and rukus!, one of Ajamu's favorite porn stars who boasts a ten-inch dick. The use of *Federation* is inspired by the cultural movements of the twentieth century, including the Futurist, Vorticist, and Bloomsbury set. I thought if they can declare themselves an art movement, why can't we? We also borrowed the name from the Star Trek Federation because I am a Trekkie. This notion of multiple and simultaneous playful naming reflects our lived experience as Black Queer men as perceptions of us switch between the entangled identities acted upon us, while at the same time, our actions are framed by them (fig. 1).

CM: *Re: political context: Why did you initiate this archive of Black LGBTQ+ subjects in Britain and why 2005?*

TC: There was no intention of creating an archive at first. There was an intention of answering the question: Is there Black Queer Culture in the UK and if so where is it? We were living it, so we knew it was there and yet we were constantly being told it wasn't or that we were too small a community to be important. There were no public conversations about our existence, no place where we could point to and say we exist and in this way, on our own terms. We wanted to create a space that enabled us to see ourselves. We decided to do an exhibition of Black LGBTQ+ life and culture. We started with the people we know. We sent out invitations asking people to give us

Figure 1. rukus! Federation logo. Courtesy of rukus! Federation.

their memorabilia. There was no response. The legacy of silence combined with an absence of belief within the community that there is value in our lived experience, meant that people didn't understand what we were doing. The way racism, homophobia, and transphobia work is that people learn not to value themselves. There were, and still are, systemic things that inhibit Black people from talking about their place in history and culture.

Eventually we went to people's houses, sat with them, and talked about how things like flyers, letters, leaflets, badges, and so on were part of our heritage. They gave us so much stuff. I had loads of club flyers I collected as fetish objects linked to my sexual and physical development as a Black Queer man. Each night represented a way of searching for sex and forming friendships and growing up, but they also represented the scale and breadth of Black Gay club culture in the late 1990s and 2000s. Ajamu had love letters, photographs, and original flyers from exhibitions, so we started from our own obsessions and interests too. We were angry and sad. Angry at the misrepresentation and bullshit from all sides about who we were and sad for the passing of so many of our friends through HIV/AIDS and depression, yet to be celebrated.

We wanted to celebrate, consolidate, and instigate while also making an imprint, a timepiece, about our time. This was a way of saying you can't erase and . . . you can all fuck off! What became the rukus! archive was in essence an art project.

At the end of this process, we managed to gather huge amounts of material, which after the exhibitions had been taken down, sat in Ajamu's basement. While there they were vulnerable to floods or fire and we recognized they needed a permanent home. We are not archivists, or at least our archive practice is bound up in our artistic practice, but what the materials needed were professional archivists. The rukus! archive was born from this process. Over thirty volunteers enabled the archiving process to take place. Some amazing Black LGBTQ+ artists, writers, activists, and archivists from around the world came into the London Metropolitan Archive and made this happen. They are also an essential part of the story and speak to the

other aspect of rukus!, which is that it is as much about community and the act of gathering together as it is about anything else.

A lot of Black LGBTQ+ work is locked into a rights-based narrative, an oppression-based narrative, a deficit narrative. No one was doing work around aspiration, celebration, and what we wanted to produce. The archive came from wanting to have a different kind of conversation. Linked to that, Black social and cultural history rarely includes Black LGBTQ experience, and the wider LGBTQ community rarely includes a Black experience.

By 2005, we were still experiencing a conspiracy of silence about us in UK society. The disconnect between our lived experience was overwhelming. We had to do something to change the narrative.

CM: *What do you think is the significance of visual materials to Black LGBTQ+ communities, and their histories, in the United Kingdom?*

TC: The rukus! archive is part of a permanent collection of archives at LMA (London Metropolitan Archives), so in this sense we are pleased that nobody can deny the existence of Black British LGBTQ+ histories and culture any longer. In this way it sits in addition to, and sometimes in opposition to, narratives about Black and Black LGBTQ+ histories and culture that come from the United States, which have typically dominated the narrative about the Black diaspora experience.

There are direct mental health benefits from seeing your face and likeness represented in images and ideas of how to live. I remember seeing a Black gay couple on an advert for Barclays Bank in 2016. It was jarring to see a Black same-sex couple positioned like that. I had to search for the ad and replay it over and over again to deconstruct how mainstream culture had found a way to insert the couple's presence. It was such an uncommon sight that I wondered if it was fabricated and if the couple really existed. My response speaks to the way in which our programming about what we expect to see is so ingrained that when we see two Black men in love appear "out of context," it is received with suspicion even by those of us who desire more of such images.

So, for me it's not just about image making but also about on what terms are the images made? Who are the images for, and who, by, and how do they sit within the way images of Black LGBTQ+ lives have been depicted?

For example, one of the most prolific photographers on the London Black gay scene was white. His images haven't been seen outside various gay publications, but they are a valid part of Black LGBTQ+ legacy. However, they are very different to the images created, say, by a group of Black Lesbians on holiday or the chronicling of a nonbinary Black Queer person by themselves on Instagram.

There is also the question of appropriation and amplification. Who is profiling the images and materials? Who is seeing them and how are they being

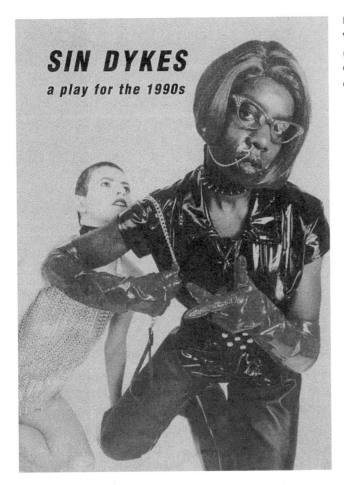

Figure 2. *Sin Dykes* program. Writer/director Dr. Valerie (Vimalasara) Mason-John. Oval House Theatre, 1998. Courtesy of rukus! Federation.

platformed? These considerations speak to power and a legacy of misrepresentation, fetishization, and sexualization by the mainstream that leads to problematizing our existence. There is undoubtedly a need for images and stories of Black British LGBTQ+ histories and culture, but there is also a need for relationship building and curating images. When it comes to working with Black LGBTQ+ peoples, the mainstream needs to respond with humility to a demand made by the trans movement: "Nothing about us without us." (fig. 2)

CM: *What critical dialogue do you hope rukus! establishes with mainstream heritage practices and dominant Black and Queer identity discourses (or other . . .)? Can you tell us about an example?*

TC: Although it is important to have a critical dialogue with the mainstream, the main focus for me is the dialogue, as Black Queers, we have with each other. We can see that dominant cultures are not interested in our lives in the way we are.

Figure 3. The Black Perverts Network. Late 1990s. Location Brixton. Courtesy of rukus! Federation.

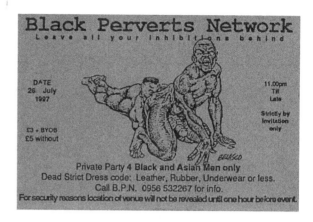

Mainstream culture, by definition, sees us as a minority, and minorities are marginal. Rukus! is about centering Blackness and essentially radical Black Queer Blackness. When it comes to measuring social indicators of equality, Black people and Black Queer people are at the sharp end of all statistics. Whether it be the social justice system, health, housing, education, wealth, or employment, we get the worst deal. Rukus! is about our complex intersectional existence and doesn't subscribe to box ticking and positive imagery. Instead, our "discourse" is about sitting within the multidimensional realities that we inhabit. In this way we must talk to ourselves first and foremost because our manifestation in the mainstream is always about being a problem to be solved.

Also, the mainstream is not interested in conversations that include sex. Instead, it prefers LGBTQ+ people to be neutered and sexless because their funding agreements, sponsors, and perceived audiences are prone to offense. Understanding and reflecting on sex and desire in Black Queer histories and culture are vital when it comes to discovering how we have managed to build our lives regardless of the hostile environment we have to live in. Witness how, even today, the twin pillars of homophobia and racism are so overwhelming that even the act of social intimacy between two Black, same-gender loving people can be seen as radical.

In a collaboration with the Museum of London in 2010, the exhibition *Outside Edge,* curated by Ajamu, did not allow for the display of flyers from the Black Perverts Network, a 1990s private sex club (fig 3.). The idea that our archive should be censored by a mainstream organization is a reflection of the way our presence is policed by cultural institutions and subsequently how we are silenced. Therefore, the dialogue by the mainstream is as live and contentious as it is collaborative. We displayed the images on a study day as part of the exhibition. In doing so we demonstrated the need to be subversive because Black men fucking each other in the arse for pleasure will never be respectable. However, this is our history, and whole lives are built around the pleasure we consent to share and explore with each other, or not.

CM: *In "Love and Lubrication in the Archives," you quote Stuart Hall saying that "archives are not inert historical collections." How has the work of Stuart Hall and British cultural studies more generally shaped rukus!?*

TC: Stuart always had a good relationship with the evolution of rukus! As far as I know we were the only Black Queer arts company, charity, and collective that Stuart engaged with. My relationship with Stuart began when he agreed to narrate my first film, *The Homecoming*. There were no other major Black public intellectuals or any mainstream institutions engaging with us as artists at the time. Stuart's words, "Those people who are in Western Civilisation who have grown up in it but yet are not completely part of it, have a unique insight . . . and something special to contribute," are quoted at the beginning of *The Homecoming*, which can also be characterized as mine and Ajamu's first artistic collaboration. I was immersed in, and inspired by, Stuart's radical positioning of Blackness when I first encountered it. Props to Stuart in every way. He could see what we were doing. He gave us the tagline "Making Difference Work."

However, the notion of a living archive was understood by our lived experience and the interplay of social and political forces and our emerging ideas of transgression and sex. Being artists who created public work but who were also actively creating a space for Black queerness to thrive, we were as much invested in the ideas of cruising, fucking, and forming relationships as we were with the politics of representation, image making, and community building, while also creating a space for histories, memory, and legacy. I have learned that an archive is not something "out there" in a museum or a building fossilized for introspection. Instead, it exists in the way we gather together, in our desires and in our passions. The question is how do we capture that? How do we tell the story of the embodied archive? The fact that our lips, nipples, arses, cocks, and vaginas are also our archive in a world where notions of archive exist in a respectability paradigm, can't be overstated. In this way the very energy of rukus! disturbs the peace and is in itself a way of archiving our existence.

The rukus! archive is porous and shape-shifting. And although there is a physical archive, now, it is not finished, as Ajamu and I are in our separate ways still curating our legacies, as are so many other incredible artists, activists, and ordinary Black LGBTQ+ people in the UK.

My feeling is that Stuart took inspiration from us as much as we did from him, which is why he was so awesome.

CM: *What are your hopes for the future of rukus!?*

TC: Rukus! Federation was formally created on June 23, 2000, which means it's twenty-one years old this year. I remember that the age of consent for same-sex male partners in the UK was twenty-one. So some of my early sex life as a young adult

made me a criminal growing up. Being twenty-one meant that I could shag lads without any threat of getting a criminal record. It was liberating. Rukus! is also about liberation.

I would like to work with organizations to enable rukus! to digitize the current contents of the archive. I can also see a future where the next generations of Black LGBTQ+ artists are commissioned to contribute to the archive in imaginative and creative ways. If there is anyone out there open to collaboration, please get in touch. I'm also looking forward to an exciting collaboration with the Horse Hospital in 2021. Now more than ever, in an age of restrictive laws and surveillance encroaching on our daily lives, we need to find ways of amplifying voices that challenge the status quo. It's all about shifting away from the single story for Black LGBTQ+ people in the UK. It's all about liberation.

Topher Campbell's twenty-plus-year output spans broadcasting, theatre, performance, writing, experimental film, and site-specific work. His focus has been on sexuality, masculinity, race, human rights, memoir, and climate change. In 2005 he was awarded the Jerwood Directors Award and was nominated for the 2011 What's On Stage Theatre Event of the Year Award. In 2017 he was longlisted for the inaugural Spread the Word Life Writing Prize for his forthcoming memoir *Battyman*. His films have appeared in festivals worldwide, including his first film, *The Homecoming*, a meditation on art, masculinity, and sexuality featuring commentary by Stuart Hall. His latest film, *Fetish*, a collaboration with 2014 Mercury Music Prize Winners Young Fathers, is shot on the streets of New York and premiered at the Barbican Centre, London. In 2017 he was awarded an honorary doctorate by the University of Sussex, Brighton, England. His next film, *Encounters*, is a meditation on HIV stigma and desire, for VisualAIDS and the Whitney Museum, New York.

Conor McGrady is an artist and Dean of Academic Affairs at Burren College of Art. He has exhibited internationally, with one-person exhibitions in New York, Miami, Atlanta, Chicago, Split and Zagreb, Croatia. Group exhibitions include the 2002 Whitney Biennial in New York, The Jerusalem Show VII: Fractures (Qalandiya International Biennale), Biennale of Contemporary Art, D-0 Ark Underground, Sarajevo-Konjic, Bosnia and Herzegovina. His writing has appeared in *Ruminations on Violence* (2007), *State of Emergence* (2011), *State in Time* (2012) and *The Design of Frontier Spaces* (2015). He lives and works in the Burren, Ireland.

CURATED SPACES provides a focus on visual culture in relation to social, historical or political subject matter.

Virgin Territories

A Conversation with Roland Betancourt

David Serlin

It has been just over four decades since the publication of John Boswell's *Christianity, Social Tolerance, and Homosexuality: Gay People in Western Europe from the Beginning of the Christian Era to the Fourteenth Century* (1980) threw the equivalent of a bomb through the stained-glass window of medieval history. An avowed believer in the idea of an essential "gay" person across time and culture, Boswell took the then-controversial position against social constructionist theories of sexuality—as popularized by books like Michel Foucault's *History of Sexuality, Volume 1* (1978)—to argue that the early Christian church's attitude toward gay and lesbian people was far more accepting, and far less punitive, than canonical histories had portrayed.

One could draw a direct genealogical line from Boswell's work in the 1980s to that of Roland Betancourt, a self-described "queer Latinx medievalist" and a professor of art history and visual studies at University of California, Irvine. In his most recent book, *Byzantine Intersectionality: Sexuality, Gender, and Race in the Middle Ages* (2020), Betancourt analyzes and contextualizes numerous early Christian texts, many featuring often confounding visual representations of sexual acts or gendered behavior. His book draws on rare manuscripts from collections as diverse as those of the Vatican Library, the Bibliothèque nationale de France, and St. Catherine's Monastery in Sinai, Egypt, which has been in continuous use since the mid-sixth century AD.

Radical History Review
Issue 142 (January 2022) DOI 10.1215/01636545-9397101
© 2022 by MARHO: The Radical Historians' Organization, Inc.

Like Boswell, Betancourt argues that authors and artists during the Byzantine era were far more open to experimenting with complex sexual narratives than many medievalists (and, importantly, non-medievalists) have been trained to see. Betancourt believes that seeing various forms of queerness in the medieval archive has less to do with projecting contemporary academic values backward and more to do with disorienting and disabling the normative filters—both methodological and ideological—through which many historians have tended to view representations of gender and sexuality in the past.

David Serlin spoke with Betancourt via Zoom in January 2021. A bibliography of selected texts for further reading, "Queering the (Long) Middle Ages," follows their conversation.

David Serlin: *Your book,* Byzantine Intersectionality, *offers the reader textual and visual evidence of attitudes toward sexuality that are more than a little surprising for the modern historian: for instance, you use a Byzantine depiction of Mary's Annunciation to think through and historicize ideas about consent. What concepts around sex and power were you working with when you began to research your book, and had you been thinking about them for a long time?*

Roland Betancourt: It all began with a homily by Photius, the ninth-century Patriarch of Constantinople, which I discussed at length in my first book. At the time I mentioned it only in passing, but Photius uses the word *consent,* which originally derived from the Greek meaning "assent"—more in the sense of agreeing to something, but also conceiving of something. It is this metaphorical language of consent as mental but also physical that interested me.

Biblical texts tell us that Mary agreed to conceive the Christ child. And we know how the story ends. With Photius's homily, though, there is a focus on what happens in the middle of the story that biblical texts might have glanced over. Photius asks: When, precisely, does Mary conceive? When, exactly, do these events happen? The focus becomes on conception happening after consent.

DS: *Walk me through what you see going on in this image (see fig. 1). How, for you, does this image do particular kinds of rhetorical work with regard to thinking about consent and power?*

RB: This image comes from an icon, a free-standing panel painting from St. Catherine's Monastery in Sinai, Egypt. Mary is on the right side, Gabriel the Angel is on the left, and the Holy Spirit is descending on Mary from above to enact conception. You can even see the way in which the Holy Spirit is in a little bubble in the center of a dove, which almost looks like a glowing orb. You can barely make out the bird in the center. But the image also illustrates ways of looking that Byzantine viewers were

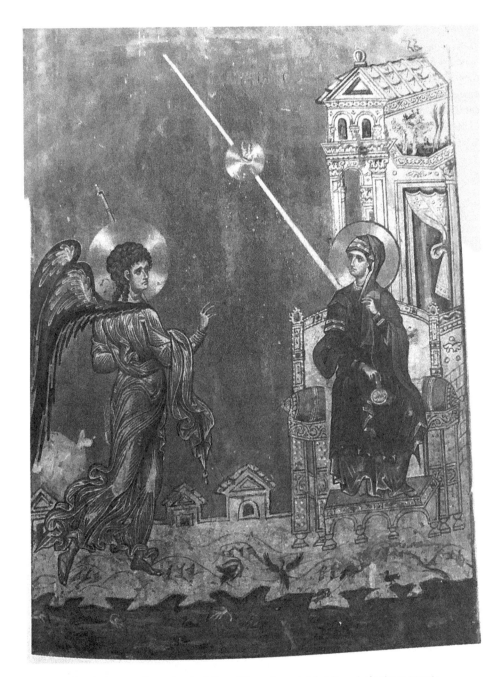

Figure 1. The Sinai Icon, a Byzantine depiction of the archangel Gabriel's arrival prior to Mary's Annunciation, ca. twelfth century CE. Saint Catherine's Monastery, Sinai. Image courtesy of Saint Catherine's Monastery, Sinai.

Figure 2. **Barely perceptible close-up of Christ in utero on the Sinai Icon, a Byzantine depiction of the archangel Gabriel's arrival prior to Mary's Annunciation, ca. twelfth century CE. Saint Catherine's Monastery, Sinai. Image courtesy of Saint Catherine's Monastery, Sinai.**

very much trained to do. Viewers see Gabriel approaching the Virgin and know that the icon is asking them to contemplate: Has the angel just arrived? Has Mary "agreed" yet? Are we somewhere in the middle of a dialogue?

The West's iconography depicts a Mary who is demure. But in the Byzantine sources, Mary is fiery and combative. That is what distinguishes her from Eve. There are textual examples where Mary says to Gabriel, "What are you doing? Get out of my house!" These are wonderful aggressions—I say "wonderful" in the sense that they're surprising to see when they come up—that are fascinating for thinking about how the authors of these texts are refracting attitudes about sexual violence.

For me, this icon is also important because it's an image of the Annunciation made famous by art historians. If you're taking a survey of art history, this is probably one of the two or three images of Byzantine art that you can count on being there. Because of this, it's a wonderfully non-exceptional image that makes it generative for asking tough questions about depictions of sexuality. I mean, other than the ghostly image of the Christ child in utero, there is nothing iconographically unique about this depiction of the Annunciation (see fig. 2). So I thought it would be productive to reevaluate it as an art object and also in terms of the theological conversations around Mary's role in the Annunciation that were taking place in this period. These Byzantine homilies expand on the basic narrative by asking: What is important here? Why is it that Mary consents? And why is consent important? They will often bring up the example of Eve, who hastily consented to what the serpent was saying and fell for its conspiracy theories.

DS: *Sort of like the second-wave feminist charge "Eve was framed"?*

RB: Yes, exactly. It's basically that. I adore a later fourteenth-century homily by Nicholas Cabasilas that says Eve was a problem because she was the product of rape. God knocked Adam unconscious and forcefully created Eve without any acknowledgment. This is what I love about medieval theology; it is not hampered by conventional preconceptions that say, "Don't ask questions, just believe." That simply does not happen at all during the first millennium of Christianity. The Church fathers are often found saying, "This makes no sense. Let's reason it out."

One of the interesting things about Byzantine homilies is that, when they narrated an event, they described it in the present. Even though you know how the story ends and you know how it begins, you still need to understand that these moments have a beginning, middle, and end. There's a sense here that we're celebrating the Annunciation right now. So the compositional logic that we see in the homily is reflected in the compositional logic that we see in the icon. You look at Gabriel on the left and you can see the way that he is approaching Mary. It almost seems from the position of his right foot that he's just landed. His cloak is billowing in the background just above his foot. His wings are arched back. He is doing this right now. And she's presented as if she's cross-examining the angel. There's a clear sense that Mary is not just going to consent because someone walked in and said, "Hey, you're gonna be the mother of God."

Viewers can see compositionally the importance of Mary agreeing in this moment. There's a trope in many of these narratives that Mary is, in some ways, attracted to the angel. That there's a sexual tension in the room. In fact, what makes that narrative of consent so intriguing is that it's a visual language of consent that fits into pagan narratives and even some Old Testament narratives as well. Because there is no penetration, no sexual deed, reproductive consent is abstract. And yet, she's scared because Gabriel sounds like a suitor. In an eighth-century homily by Patriarch Germanus, she notes the youthful beauty of Gabriel, commenting: "I am rapidly beginning to suspect that you have come to lead me astray." What's critical here in anchoring this to a conversation about sexual consent is seeing this icon as a hybrid of attraction and courtship rather than marriage per se.

DS: *How would you respond to someone who argues that consent as we understand it—especially through the work of feminist legal historians such as Pamela Haag, Ishita Pande, Catherine MacKinnon, or Carol Pateman—is a modern legal category and moral imperative that simply did not exist a thousand years ago?*

RB: I would rather show how ideas about consent were articulated in the past than make a disclaimer that consent didn't exist. This was methodologically very important for me, especially because I was so confident in the fact that I was working from the sources outward. My conclusions emerged directly from the Byzantine

sources themselves. So, in some ways, I don't think there's anything provocative in this book. I just read the sources.

Unlike many of my colleagues who get caught up with identity categories and who argue that trans and queer people did not exist, I take it for granted now, because I've learned that respectability politics doesn't save anyone. So I'm not going to draw a line and say, "We can't use the word *trans* because it's a modern term," because that attitude provides fodder for those who would say that queer people didn't exist in the past or that consent is a modern invention. I don't want any work that I do to be co-opted by the Right, whether by transphobes or white supremacists. We've seen a lot of responses like that in Byzantine studies in recent years, and with medieval studies as well.

In addition, it's been very important for me to stress how forgotten this world and its contributions have been. Without these sources, it becomes hard to connect Byzantium to the wonderful work around gender and sexuality being done in the early modern period because Byzantium is so frequently left out of that conversation. This is true of other aspects of Byzantine studies. For instance, currents in contemporary global politics are expanding the field: how, for instance, do we understand spaces that are "on the cusp" of Byzantium, such as Syria, Ethiopia, the Balkans, and the Slavic world in general, where Moscow is thought about as a "third Rome"?

DS: *If I were to go to St. Catherine's Monastery today to see this icon, how small or large is it? Is it on a wall, or is it in a frame? Is it next to other icons?*

RB: For the sake of visualizing, let's say it's about twice the size of a large MacBook Pro. In the Byzantine period, icons like this one would have been set up within the barrier between the altar and the viewer. The idea is that, in the Byzantine liturgy, you stand—there are no pews. People would go and kiss the icons and greet them. The intimacy of connection is always present. This is particularly true of the image of the Christ child in utero, who only appears to you once you get close to the icon (see fig. 2). There's even a temporal understanding embedded in the work itself: you see the angel approaching Mary at the same time that you are approaching Mary. And as you go to kiss Mary, suddenly Christ reveals himself to you.

Byzantine art is so good at playing with these dynamics. That's one of the frustrating things about seeing icons that are so removed from their original context. In the space of the Byzantine ritual, they are still so wonderfully alive. I think that's one of the strengths about studying Byzantium: their iconography is so carefully calibrated that even very slight differences mean a lot to viewers. Of course, there are different strategies for depicting affect, and so forth, which should not be

overlooked and decontextualized. Generally speaking, though, the scrutiny of looking is accepted and encouraged, whereas in the modern West there's more of an overarching and totalizing approach to an image, and that really alters how we understand the composition.

DS: *Icons like this one, and illuminated manuscripts as source materials, seem to have found a champion in the digital era. Most of the major library collections have spent extraordinary amounts of money and labor digitizing and photographing archival objects, a process that has made them infinitely more accessible while also, at the same time, diluting the physical experience of encountering these objects in the first place. Do you find that to be the case for the Byzantine objects you study?*

RB: It's complicated. I've had moments where I'm looking at a PDF of a Byzantine manuscript and I think, "Oh my God, this is so high-res. I could never see these details with the naked eye." With digitization, you are forced to think more about coffee stains and how they smudge texts, and how that must be understood as part of the reading experience, rather than understanding only what is actually behind the smudge. The flip side of encountering a text digitally is being in the conservation studio at the Vatican Library looking at a physical manuscript under the microscope, which for the art historian is and will always be like holding the holy grail. There are so many other forms of knowledge that emerge in that moment that are not just forensic.

One of the more profound experiences I had while researching this book took place when I was at the Vatican Library looking at a manuscript illustrating another version of the Annunciation (see figs. 3 and 4). It was late in the day, and I was running out of time, so I kept flipping the pages forward. I saw the same images of Gabriel and Mary in a long repetitive sequence. I kept thinking, "Why am I seeing the Annunciation over and over again?" The images were not exactly the same, but the artist was depicting variations of the exact same moment to emphasize that time had somehow stopped.

It was a moment when the archive was totally arresting—not only because of the sheer beauty and materiality of the art but also because of a confrontation with boredom and repetition and the realities of being in an archive with a limited amount of time. I'd been thinking so much about temporality in Byzantine manuscripts, and here was I confronting temporality in the manuscript while viewing the manuscript. My experience of that sequence mirrored exactly what I was experiencing in the archive. It was a mind-blowing moment.

DS: *What you're describing is a version of the Annunciation as the film* Groundhog Day.

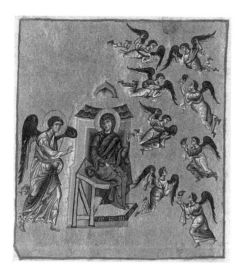 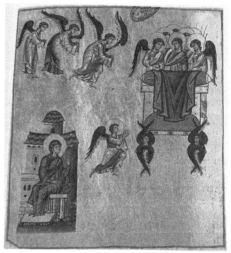

Figures 3–4. (left to right) Scenes from a sequence of illustrations in a Byzantine manuscript (Vat. gr. 1162) depicting Mary's Annunciation as a frozen moment in time and space, ca. twelfth century CE. Reproduced by permission of Biblioteca Apostolica Vaticana, with all rights reserved.

RB: Yes! All the captions are signaling to the reader that there's been a very slight change; yet I had never seen a medieval artist literally repeat the exact same scene back-to-back. It's almost as if someone was cutting and pasting the same image over and over again.

To have dead space in a manuscript is not unique, even one that is lavishly illuminated. But it is frankly shocking to see a medieval artist wasting parchment space, paint, and gold to depict the exact same image repeatedly when there are thousands of Byzantine manuscripts that may feature a single image—an image of an evangelist within a gospel text that they composed—but have no other images. For me, all of these Annunciation images were playing with slight variations of pictorial space to freeze time as a way of visually dramatizing ideas about sex and consent.

DS: *What you're saying about dramatizing sex and consent seems to tie in with another image from your book: an illustration of Susanna (see fig. 5), one of the figures from the Book of Daniel, in the margins of a manuscript. It decorates a section of the text where Susanna is nearly gang-raped while she is bathing. There's so much going on here.*

RB: This image of Susanna comes from a ninth-century collection of biblical and homiletic texts for the moral instruction of the reader.

The image of Susanna suggests a moment when someone was reflecting on a story about an imminent rape and translates that rape into the margins of the manuscript.

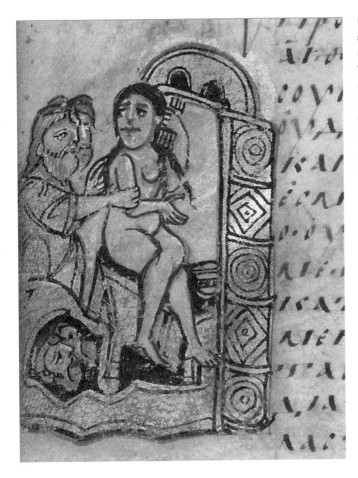

DS: *So who would have seen an image like this one of Susanna, and what would have been the context in which they're seeing it?*

RB: What makes the Susanna image so interesting is that it would have been seen only by an erudite reader of theology who also would have been quite skilled at looking. Susanna here might have been seen by an elite reader—perhaps someone involved in the composition of sermons or homilies. There was an elite intellectual culture in Byzantium, and these were among the most elite images of all because they would have been restricted to the most selective audience.

For me the starting point for analyzing an image like this is less about its popularity or circulation, which is really hard to quantify, and more about understanding how images like this contour the experience of spoken texts. Manuscript illumination in Byzantium is, in some ways, the grounding of the field historiographically; it's how Byzantium has been championed, particularly in a US context that hews to the "decline and fall of the Roman empire" narrative. So a text that might have been

limited in its synchronous viewership, but which now exists in a national archival collection, has now had centuries of viewership. Plus, these texts are critical tools for those people who are in the business of guiding others to understand images. If you go into Hagia Sophia, for instance, there are a very limited number of images, but none of these are narrative. There are no mosaics of the Annunciation. So homilies are very important for understanding how authors guide you through images and show you how to interpret them.

DS: *An elite, patriarchal group with access to illustrated scenes of sexual activity involving vulnerable women that they circulate among themselves? That sounds like a group of eighteenth-century French aristocrats sharing pornography with each other.*

RB: That may be true. This image of Susanna is certainly an index of a kind of porosity of secrecy, in which secrecy is defined by an elite text with a limited viewership. And what's even more interesting about this image is the fact that it comes in a manuscript that's filled with many other images, but there is no explicit emphasis on sexuality in this manuscript. It is a holistic commentary on the biblical text and earlier typologies for the biblical texts. So this image of Susanna is a blip on the radar of this much broader program of illuminations.

In the last chapter of my book, I ask: how did artists struggle with the challenge of depicting a scene, like the near rape of Susanna, when they didn't have many comparable examples? This isn't the situation with the Annunciation, in which there are endless examples on which to draw. So what types of iconographies of sexual violence, or even broader concepts like "evil," did those artists think they were using to compose this scene? In answering those questions, I think it says a lot about how they understood these narratives. I'm very interested in the allure of secrecy, and the intimacies that secrecy creates in these types of privileged circles that circulate texts that seem outrageous to us.

DS: *What you're saying about this margin illustration of Susanna, of course, is the exact opposite of the Annunciation icon at St. Catherine's Monastery (see fig. 1), which was and remains an object that was always seen by the public.*

RB: Well, manuscripts were produced by and for a literate elite, whereas icons were not only meant to be seen but to be touched. At the same time, there's always this tension where you're deliberately touching the object in lieu of not touching the figures who are depicted in them. I love the ways that touching and prohibitions against touch engender a desire to touch more. The desire to touch is heightened by one's inability to touch the divine.

These aspects show that Byzantium is very much the medieval Roman empire, and as such it sustains many of those traditions for at least a millennium

or longer. For instance, the Church fathers were very explicit in describing how devotion has a language of eroticism attached to it. For them, there was less of a divide between *agape*—chaste love—and *eros*. This is something that is perceived as antithetical to modern instantiations of Christianity, where the blurring of devotion and eroticism is simply foreign to the modern reader, and not at all what we associate with contemporary Christianity, in which violations of *agape* have led to a serious moral crisis.

DS: *I'm glad you are mentioning this, because I thought that, throughout your book, one of your goals was to show that many aspects of Byzantine Christianity were closer to the queerness of earlier pagan or even polytheistic conventions than the chaste, unruffled interpretations of modern Christianity that are more or less artifacts of the Victorian era.*

RB: One of the things I've worked hard to do is to strip away the modern Christianity that we have so often just assumed and projected onto a period that is, in every capacity, decentered from those assumptions. Byzantine theologians and philosophers were asking questions about personhood and identity as articulated through processes of conception, mental visualization, and perception that we might recognize today. The anachronism, from my perspective, comes when we approach Byzantium through the eyes of modern Christianity, which is a serious distortion and does not allow us to see Byzantium on its own terms.

This is also true in terms of how we look at Byzantine art. St. Catherine's is, in many ways, the best Byzantine archive that we have, in the sense that the icons that exist there have had an unbroken connection to the location where they are found. And yet, we know almost nothing about them. We don't know what their dates are, or anything about their production. So it is also a diachronic archive of objects that exist transcendentally across time rather than the synchronous archive of all the contexts that you could find. For all these reasons, I thought that this was a good way to enter into a broader conversation about Byzantine visual culture. Plus, I think one of the strengths about Byzantium is that they had such a calibrated iconography that even very slight differences mean a lot to viewers who are trained to look. There's the scrutiny of close looking, whereas in the West there's more of an overarching thesis to an image, and that really alters the composition.

DS: *So would you say that your book is a strategic intervention into methodology—a queering of archival practice in general as much as an interpretive intervention into the field of Byzantine visual culture?*

RB: This book was an opportunity for me to try to imagine a future for my field. For the most part, I hate how we teach methods in art history, which is not dissimilar

from how we teach methods in many disciplines: "Here's the week on gender; here's the week on race." If we truly want to rethink the canon, we cannot limit these investigations to certain sessions, but find ways to incorporate new methodological or critical approaches in every week.

Also, I think too many historians in my field have disregarded certain manuscripts and texts precisely because of this idea that nobody reads them. They were often just regarded as satire or too elite. We have to look at these things that oftentimes are not taken seriously because that's where our lives are preserved. There's a reason why a lot of queer historians work on materials at the fringes. No one is going to preserve my life in a saint's text, but they will preserve it when they need to attack me, or someone like me. So I think queer histories cannot be told without taking these things seriously.

When I told people that I was writing a book about sexuality, gender, and race in the Middle Ages, they would say, "Well, you're just applying modern terms to the past." And my response was, "Well, yes, I'm using our critical vocabulary to understand the past methodologically." As a medievalist, this is very important. But it works in the other direction as well: every time that I hear someone invoke Byzantium to describe a political situation—the January 6 insurrection at the US Capitol as "a byzantine plot to overthrow the government," for but one example—I think I should catalog every time the word *Byzantine* is used to describe the modern condition.

Roland Betancourt is professor of art history and Chancellor's Fellow at the University of California, Irvine. Previously, he was the Elizabeth and J. Richardson Dilworth Fellow at the Institute for Advanced Study in Princeton. His published books include *Sight, Touch, and Imagination in Byzantium* (2018), *Byzantine Intersectionality: Sexuality, Gender, and Race in the Middle Ages* (2020), and *Performing the Gospels: Sight, Sound, and Space in the Divine Liturgy* (2021). His ongoing work focuses on Byzantine temporality and simulacral spaces, past and present.

David Serlin is associate professor of communication and science studies at University of California, San Diego, and affiliated faculty at the Center for the Study of Social Difference at Columbia University. His books include *Replaceable You: Engineering the Body in Postwar America* (2004), *The Routledge History of American Sexuality*, coedited with Kevin Murphy and Jason Ruiz (2020), and *Window Shopping with Helen Keller: Architecture and Disability in Modern Culture* (forthcoming). He was awarded the 2020–21 Rome Prize in Architecture from the American Academy in Rome, where he became an avowed Byzantinist.

Queering the (Long) Middle Ages: A Selected Bibliography

Blud, Victoria. *The Unspeakable: Gender and Sexuality in Medieval Literature, 1000–1400.* Cambridge: D. S. Brewer, 2017.

Boswell, John. *Christianity, Social Tolerance, and Homosexuality: Gay People in Western Europe from the Beginning of the Christian Era to the Fourteenth Century.* Chicago: University of Chicago Press, 1980.

Boyd, David Lorenzo, and Ruth Maze Karras. "The Interrogation of a Male Transvestite Prostitute in Fourteenth-Century London." *GLQ* 1, no. 4 (1995): 459–65.

Bullough, Vern L., and James A. Brundage, eds. *The Handbook of Medieval Sexuality.* New York: Garland, 1996.

Burger, Glenn. *Chaucer's Queer Nation.* Minneapolis: University of Minnesota Press, 2003.

Burger, Glenn, and Steven F. Kruger. *Queering the Middle Ages.* Minneapolis: University of Minnesota Press, 2001.

Burgwinkle, William. *Sodomy, Masculinity, and Law in Medieval Literature: France and England, 1050–1230.* New York: Cambridge University Press, 2004.

Burns, E. Jane. *Bodytalk: When Women Speak in Old French Literature.* Philadelphia: University of Pennsylvania Press, 1993.

Cadden, Joan. *Nothing Natural Is Shameful: Sodomy and Science in Late Medieval Europe.* Philadelphia: University of Pennsylvania Press, 2013.

Dinshaw, Carolyn. *Getting Medieval: Sexualities and Communities, Pre- and Postmodern.* Durham, NC: Duke University Press, 1999.

Dinshaw, Carolyn. *How Soon Is Now? Medieval Texts, Amateur Readers, and the Queerness of Time.* Durham, NC: Duke University Press, 2012.

Foka, Anna. "Beyond Deviant: Theodora as the Other in Byzantine Imperial Historiography." In *Deviant Woman: Cultural, Linguistic, and Literary Approaches to Femininity*, edited by Tiina Mäntymäki, Marinella Rodi-Risberg, and Anna Foka, 29–48. New York: Peter Lang, 2015.

Fradenburg, Louise, and Carla Freccero, eds. *Premodern Sexualities.* New York: Routledge. 1996.

Galatariotou, Catia. "*Eros* and *Thanatos*: A Byzantine Hermit's Conception of Sexuality." *Byzantine and Modern Greek Studies* 13, no. 1 (1989): 95–138.

Giffney, Noreen, Michelle M. Sauer, and Diane Watt, eds. *The Lesbian Premodern.* New York: Palgrave Macmillan, 2011.

Gutt, Blake. "Transgender Genealogy in *Tristan de Nanteuil.*" *Exemplaria* 30, no. 2 (2018): 129–46.

Heng, Geraldine. *Empire of Magic: Medieval Romance and the Politics of Cultural Fantasy.* New York: Columbia University Press, 2003.

James, Liz, ed. *Women, Men, and Eunuchs: Gender in Byzantium.* New York: Routledge, 1997.

Karras, Ruth Maze. *Sexuality in Medieval Europe.* 2nd ed. New York: Routledge, 2012.

Lochrie, Karma. *Heterosyncrasies: Female Sexuality When Normal Wasn't.* Minneapolis: University of Minnesota Press, 2005.

Lochrie, Karma, Peggy McCracken, and James A. Schultz, eds. *Constructing Medieval Sexuality.* Minneapolis: University of Minnesota Press, 1997.

McClanan, Anne. *Representations of Early Byzantine Empresses: Image and Empire.* New York: Palgrave Macmillan, 2002.

McDonald, N. F. "'Desire Out of Order and Undo Your Door.'" *Studies in the Age of Chaucer* 34 (2012): 247–75.

Mills, Robert. *Seeing Sodomy in the Middle Ages.* Chicago: University of Chicago Press, 2014.

Neil, Bronwen, and Lynda Garland, eds. *Questions of Gender in Byzantine Society.* New York: Routledge, 2013.

Puff, Helmut. "Female Sodomy: The Trial of Katherina Hetzeldofer (1477)." *Journal of Medieval and Early Modern Studies* 30, no. 1 (2000): 41–61.

Pugh, Tison. *Sexuality and its Queer Discontents in Middle English Literature*. New York: Palgrave Macmillan, 2008.

Ringrose, Katherine. *The Perfect Servant: Eunuchs and the Social Construction of Gender in Byzantium*. Chicago: University of Chicago Press, 2004.

Roberts, Anna. *Queer Love in the Middle Ages*. New York: Palgrave Macmillan, 2005.

Rogers, Will, and Christopher Michael Roman, eds. *Medieval Futurity: Essays for the Future of a Queer Medieval Studies*. Kalamazoo: Western Michigan University Press, 2020.

Rollo, David. *Kiss My Relics: Hermaphroditic Fictions of the Middle Ages*. Chicago: University of Chicago Press, 2011.

Sauer, Michelle M. *Gender in Medieval Culture*. New York: Bloomsbury, 2015.

Sauer, Michelle M. "'Where Are the Lesbians in Chaucer?': Lack, Opportunity, and Female Homoeroticism in Medieval Studies Today." *Journal of Lesbian Studies* 11, nos. 3–4 (2007): 331–45.

Sautman, Francesca Canadé, and Pamela Sheingorn. *Same-Sex Love and Desire among Women in the Middle Ages*. New York: Palgrave, 2001.

Schibanoff, Susan. *Chaucer's Queer Poetics: Rereading the Dream Trio*. Toronto: University of Toronto Press, 2006.

Schultz, James A. "Heterosexuality as a Threat to Medieval Studies." *Journal of the History of Sexuality* 15, no. 1 (2006): 14–29.

Wade, Erik. "The Beast with Two Backs: Bestiality, Sex between Men, and Byzantine Theology in the *Paenitentiale Theodori*." *Journal of Medieval Worlds* 2, nos. 1–2 (2020): 11–26.

Warner, Lawrence. "'Woman Is Man's Babylon': Chaucer's 'Nembrot' and the Tyranny of Enclosure in *The Nun's Priest's Tale*." *Chaucer Review* 32, no. 1 (1997): 82–107.

Watt, Diane. "Read My Lips: Clipping and Kyssyng in the Early Sixteenth Century." In *Queerly Phrased: Language, Gender, and Sexuality*, edited by Anna Livia and Kira Hall, 167–77. New York: Oxford University Press, 1997.

Sexing the Archive

Gay Porn and Subcultural Histories

João Florêncio and Ben Miller

Pornography and the archive are twin children of modernity. While explicit words and images, and the practice of collecting itself, predate the advent of what's come to be known as modernity, the formalization of "pornography" as a taxonomical category in visual culture is inseparable from the development of modern archival practices.[1] As Walter Kendrick has shown, the simultaneous birth of "pornography" and the archive as modern phenomena—or the birth of pornography as a matter of concern for modern archiving—can be traced back to the discoveries of Herculaneum (1738) and Pompeii (1748) and the "lascivious" frescoes unearthed during those archaeological excavations. These raised a problem at a moment and in a place in which the history of European antiquity seemed to reveal itself as a "compelling spectacle of an unmediated vision."[2] If the uniqueness and thus archaeological value of these artifacts warranted their preservation, their "lascivious" content raised questions familiar to anyone working at an archive today: What can and should be displayed? What ought instead to be kept out of public sight and public histories? Emerging as a problem not only of archiving but also of visibility and its limits, these images demanded a new taxonomy: the term *pornographers* was eventually used a century later by Karl Otfried Müller in reference to the creators of these kinds of ancient relics.[3] *Pornography*, previously used in relation to literary or visual depictions of sex workers, became, by the mid-nineteenth century, a category for "obscene" content.[4] Importantly, the new taxonomy had more to do with access

Radical History Review

Issue 142 (January 2022) DOI 10.1215/01636545-9397115

© 2022 by MARHO: The Radical Historians' Organization, Inc.

than suppression. Rather than being used to keep those artifacts out of sight, it regulated who could examine them and under what conditions.[5] Pornography was not only a matter of content but also, given its perceived threat to the social body (from nineteenth-century moral panics to today's discourse about "porn addiction"), a matter of concern. This would eventually lead to the formalization of the concept in legal discourse and, consequently, to its criminal and juridical oversight.[6] In being constituted through selection, classification, and regulated access, both pornography and the archive were born synchronously and politically as forms of that administration of the visible and the invisible that Jacques Rancière called the "distribution of the sensible."[7]

Interestingly, negotiating (in)visibility also defines porn itself as a mature visual genre. As Linda Williams argues, in being guided by a principle of maximum visibility—that is, by seeking to make visible pleasure itself—pornography is forced to hit against the limits of its form. It is because it operates as an index for a pleasure that cannot be seen that the so-called money shot became the narrative climax of a pornographic sequence,[8] while in gay male porn produced during the AIDS crisis and before the development and normalization of antiretroviral therapies for management and prophylaxis of HIV, that same negotiation of (in)visibility also started fueling the ways in which visible semen started standing in for invisible HIV.[9] Porn is not straightforwardly a documentary record of how people have or have had sex. Nor is it merely a fiction about sex, a simple source to write histories of how societies and different actors within them have imagined sex. We argue that it is due to its complicated ontology "oscillating [between] registers of hyperbole and authenticity"[10] that porn is a difficult but potentially rewarding primary source for historians.

Despite porn's centrality to sexuality, when it comes to queer scholarship, scholars too often avoid writing about it. Other than critical histories of pornography, such as Walter Kendrick's, Lynn Hunt's, Linda Williams's, or Susan Stryker's,[11] porn too seldom appears as a source in historical work primarily focused in other, adjacent, objects of study. More than thirty-five years since Gayle Rubin declared that "the time has come to think about sex,"[12] and more than twenty-five years since Eve Kosofsky Sedgwick named "the exact, contingent space of indeterminacy . . . between the political and the sexual" as "the most fertile space of ideological formation,"[13] too many queer historians still remain reluctant to make these links explicit. Such reluctance can be at least partially explained by attending to the embrace of respectability politics in both LGBTQ+ lobbying and scholarship.[14]

Yet ignoring the pornographic body in the archive threatens queer history by writing sex out of it. Social and political histories of queerness are inseparable from the histories of queer sex and queer porn. Both sex and porn have been crucial to the processes of identification and recognition that brought queers together as a collective with political agency. Pornography itself has been an important tool in the pedagogy of queer bodies, pleasures, and desires.[15] "Porn," Richard Dyer writes,

"involves us bodily in that education [of desire]."[16] Queer porn is "a tool to educate and validate our lives," says adult performer Jiz Lee, calling it "one of the few mediums that can explicitly tell our stories."[17] Queer porn, just like queer sex, doesn't merely document worlds; it is "world-making."[18]

Two case studies from recent scholarship illustrate two seemingly different, but in fact related, queer historiographical approaches to the pornographic content that makes up so much of existing queer archives, whether private or institutionalized. Jim Downs's *Stand by Me* sheds light on often-obscured ideological debates between activists, and it is an admirable step away from some teleological histories in which promiscuity led ipso facto to the AIDS epidemic. Still, Downs makes the somewhat perplexing move of ignoring sex, on purpose. In the book's opening pages, he describes attending an early screening of Joseph Lovett's *Gay Sex in the 70s* and developing discomfort at the "film's narrative, [in which] gay liberation was the liberation of gay men's sexual urges."[19] He uses this discomfort to frame his goal: "to correct the hypersexual caricature" of gay liberation.[20] One particular observation—Downs's reaction to an ad for a masturbation machine placed next to an article about the Wages for Housework campaign in a September 1976 edition of the Canadian gay liberation newspaper *The Body Politic*—reveals the limitations of his approach. Noting the placement of the ad next to the article, Downs writes, "On a foundation of ads that promoted sex and sex toys, *The Body Politic* covered a wide range of issues."[21] The implication is that, unlike the article, the ad had nothing to do with the paper's politics. Yet a masturbation machine, as recent materialist feminist, ecocritical, and sexological theory can attest, is intimately related to the questions of labor (social, emotional, and sexual) around which Wages for Housework campaigners, and other socialist feminists, were organizing. For example, Paul B. Preciado's analysis of "the materiality of gender technologies" proposes sex toys as "[techniques] for fabricating sexuality"; a dildo (like a book, or an idea) is "a sexual body's assisted cultural technology of modification."[22] The machine is as related to the political work of the article as the sexual and bodily practices of gay liberation activists were to their political work. To his credit, Downs briefly concedes, in the book's conclusion, that "sex shaped, informed, and mattered to gay people" throughout the 1970s, claiming to want to avoid "sanitizing" the history of gay liberation despite decentering sex in his narrative. Yet his analytic frame inaccurately unsexes the politics of sexuality.[23]

In contrast, David K. Johnson's *Buying Gay* centers exchanges of and interactions with physique photography in gay male cultural life in mid-century United States, convincingly arguing that consumer culture was critical to the creation of affective communities of gay men. He makes a powerful case that physique consumers were not passive but active creators of sexual communities, and that their confrontation with both postal and criminal authorities represented "an act of political resistance—a confrontation with . . . censorship efforts."[24] He is, however, less

convincing when seemingly arguing for an uncritical celebration of physique con-
sumer cultures and indeed of the way in which capitalism "aided and abetted" the
development of gay identities.[25] Whereas Martin Meeker's monograph on commu-
nication technologies and the development of gay identities and subcultures is
happy to dismiss physique entrepreneurs as "publishers of pornography"[26] and
play down the magazines' circulation numbers, Johnson seems eager to uncritically
argue for their worth.

 Their differences notwithstanding, both histories uphold an axiomatic differ-
ence between sex and politics that obscures the symbiotic relationship between sex-
uality, embodiment, and political activity at gay liberation's heart. They both occlude
the way in which, in the words of Emily Hobson, gay liberation activists "saw sexual
liberation and radical solidarity . . . constituted within each other," and they avoid a
detailed critical study of the pornography that is at issue in both texts.[27]

 To a certain extent, such reluctance to engage with pornography is under-
standable. Pornography is a bodily genre; it moves the body, arouses it, and triggers
embodied modes of knowing.[28] When watching porn, our bodies resonate
affectively—precognitively—with the bodies in the pictures.[29] As such, it is perhaps
no surprise that pornography continues to be overlooked in a phallogocentric cul-
ture that continues to assume a disembodied mind as the privileged site of the high-
est, most valuable, kinds of knowledge. Yet, according to Roland Barthes, photogra-
phy itself also has a bodily dimension to it, one of the order of "an affective
intentionality, a view of the object . . . immediately steeped in desire, repulsion,
nostalgia, euphoria."[30] Still, historians have no such trouble with photographs.
Therefore, what we need is a way of approaching images in general—and pornog-
raphy in particular—that, in the words of W. J. T. Mitchell, "opens up the actual
dialectics of power and desire in our relations with pictures," allowing us to develop
"an idea of visuality adequate to their ontology."[31] Emphasizing desire and the social
nature of the visual reveals that "vision is as important as language in mediating
social relations, and it is not reducible to language, to the 'sign,' or to discourse."[32]

 Echoing Mitchell, Jennifer Evans has argued for the historiographic value of
thinking erotic images in a deeper and more interdisciplinary way, noting that "inti-
macy, pleasure, and desire, while fundamental to personhood and experience,
remain overlooked in most historical analyses."[33] She claims that, as subcultural
archives of affects and desires, erotic photographs "do not passively mirror historical
change but actively constitute claims to representation," being thus inseparable
from the construction of sexuality and the modern self.[34] Viewing erotic photogra-
phy as "an intellectual as well as subjective act of reclamation and discovery" can
help historians "recognize desire as a fundamental feature of historical self-
knowledge."[35]

 Historians shying away from this work due to the "volatile, contentious, and
highly fraught" nature of these sources need not worry.[36] The correspondence and

ephemera that serve as the source base for more traditional queer histories—never mind official state archives that serve as the basis for the most traditional histories of all—are also volatile, contentious, and highly fraught artifacts. Dealing with this is part of the job. The task of any history is to reflect and understand change over time, and to engage critically with the practices of archiving and commemoration under-girding the discipline. As Andi Zimmerman notes, methodological conservatism has no internal logic other than to be systematically deployed against the people—"most of us"—for whom traditional methods have failed.[37] As Evans reminds us, queer history should "render historical categories strange instead of assuming they apply more or less uniformly across time, to all people" and "draw on a wide array of conceptual tools—often from other disciplines—to lay bare common assumptions about the world in which our subjects lived."[38]

It is this kind of work that a queer history inclusive of pornography could accomplish. Rather than bemoaning porn's double ontology as both documentary and fantasy, historians could lean into that doubleness. Building on Mitchell's question, "what do pictures want?,"[39] the one thing pornographic pictures want from historians is an historiography that is adequate to porn's ontology: How did desires correspond (or not) with political questions? How did fantasies illuminate (or not) political and communal horizons of intimacy? Acknowledging and moving through the historically contingent barriers between pornographic and nonporno-graphic sources could bring historiographic analysis closer to what Zimmerman described, in reference to the intimate relationship between the archive and the histories we write, as the "*ars erotica* of the practice" of history.[40] Their reflections on "the desire we imagined through the past, dreamed fulfilled in the present" describe the effect of porn archives on contemporary historians, both as fixed sources and as still-powerful erotic objects that call us into relation.[41] The ways in which historians are not only interpellated but also implicated by the porno-graphic object can be the jumping-off point for the kind of analysis we are advocating.

In *Time Binds*, Elizabeth Freeman names "erotohistoriography," that prac-tice of using the body "as a tool to effect, prefigure, or perform" an encounter with the archive, to access a counter history of history itself—a practice that embraces "bodily responses [to archival materials], even pleasurable ones, that are themselves a form of understanding."[42] Queer theory can help provide a guide for navigating the complex ethics of this kind of archival encounter—from reflections on maintain-ing seemingly outdated categories in community archives as a method of preserving the archives of feeling embedded within those categories, to arguments about the ethics and practice of queer oral history.[43] In doing so, scholars must also remember the ways in which erotic and embodied relationships to archives have been "ethno-pornographic"—exoticizing and racializing, using erotics as an engine to entrap oth-ers in discourses of inferiority and supposed backwardness.[44]

It is precisely the affective allure of pornography—intimate and precognitive—that makes it such a rich source for the analysis of the complex and often contradictory processes of gay identity formation, especially when thought not alone as the creation of groups of heroic producers and consumers but instead critically, in conversation with other political, institutional, and sexual trends. Rather than isolating pornography in histories that uncritically celebrate the people who made it, or shoving it under the rug as inconvenient or unrelated to political questions or queer and feminist archival practices, attending to the pornographic body in the queer archive can illuminate the complex interfacing of desire, pleasure, consumption, media, identity, and politics that has historically sustained queer lives. If pornography and the archive are twin children of modernity, then it is perhaps in the queer archive that their shared history is still very much alive.

João Florêncio is senior lecturer in history of modern and contemporary art and visual culture at the University of Exeter. He is the author of *Bareback Porn, Porous Masculinities, Queer Futures: The Ethics of Becoming-Pig* (2020).

Ben Miller is a doctoral fellow in global intellectual history at the Friedrich Meinecke Institut of the Freie Universität Berlin, and a member of the board of directors of the Schwules Museum.

Notes

1. See Dean, "Introduction."
2. Kendrick, *Secret Museum*, 5–6.
3. Müller, *Handbuch der Archäologie der Kunst*, 602.
4. See Kendrick, *Secret Museum*, 1–32; Clarke, "Before Pornography"; Hunt, "Introduction," 12–18.
5. Kendrick, *Secret Museum*, 6.
6. Hunt, "Introduction"; Attwood, *Sex Media*; Sullivan and McKee, *Pornography*.
7. Rancière, *Politics of Aesthetics*, 12–19.
8. Williams, *Hard Core*, 94–95.
9. Aydemir, *Images of Bliss*; Dean, *Unlimited Intimacy*; Paasonen and Morris, "Risk and Utopia"; Florêncio, "Breeding Futures"; Florêncio, *Bareback Porn*.
10. Paasonen, *Carnal Resonance*, 191.
11. Kendrick, *Secret Museum*; Hunt, "Introduction"; Williams, *Hard Core*; Stryker, *Queer Pulp*.
12. Rubin, "Thinking Sex," 137.
13. Sedgwick, *Between Men*, 15.
14. See Shepard, "Queer/Gay Assimilationist Split"; Dean, "No Sex Please."
15. Paasonen, Nikunen, and Saarenmaa, "Pornification"; Warner, *Trouble with Normal*, 184–86.
16. Dyer, "Male Gay Porn." See also Burger, *One-Handed Histories*; Mercer, *Gay Pornography*.
17. Lee, "Uncategorized," 275. See also Pezzutto and Comella, "Trans Pornography."
18. Warner, *Trouble with Normal*, 177.
19. Downs, *Stand by Me*, 3.
20. Downs, *Stand by Me*, 6.

21. Downs, *Stand by Me,* 124.
22. Preciado, *Countersexual Manifesto,* 21–22.
23. Downs, *Stand by Me,* 195.
24. Johnson, *Buying Gay,* 65.
25. Johnson, *Buying Gay,* xiv.
26. Meeker, *Contacts Desired,* 87.
27. Hobson, *Lavender and Red,* 2.
28. Williams, *Hard Core.*
29. Paasonen, *Carnal Resonance.*
30. Barthes, *Camera Lucida,* 21.
31. Mitchell, *What Do Pictures Want?,* 34, 47.
32. Mitchell, *What Do Pictures Want?,* 47.
33. Evans, "Seeing Subjectivity," 433.
34. Evans, "Seeing Subjectivity," 435.
35. Evans, "Seeing Subjectivity," 436.
36. Evans, "Seeing Subjectivity," 433.
37. Zimmerman, "History, Theory, Poetry," 183.
38. Evans, "Introduction," 371.
39. Mitchell, *What Do Pictures Want?,* 47.
40. Zimmerman, "History, Theory, and Poetry," 184; McKinney, *Information Activism,* 153–204.
41. Zimmerman, "History, Theory, and Poetry," 186.
42. Freeman, *Time Binds,* 95.
43. McKinney, *Information Activism,* 163; Boyd, "Who Is the Subject?"; Boyd and Roque Ramirez, *Bodies of Evidence;* Blackman, "Affect, Performance, and Queer Subjectivities"; Gluck and Patai, *Women's Words;* Srigley, Zembryzycki, and Iacovetta, *Beyond Women's Words.*
44. Sigal, Tortorici, and Whitehead, "Ethnopornography as Method and Critique."

References

Attwood, Fiona. *Sex Media.* Cambridge: Polity, 2018.
Aydemir, Murat. *Images of Bliss: Ejaculation, Masculinity, Meaning.* Minneapolis: University of Minnesota Press, 2007.
Barthes, Roland. *Camera Lucida: Reflections on Photography.* New York: Hill and Wang, 1981.
Blackman, Lisa. "Affect, Performance, and Queer Subjectivities." *Cultural Studies* 25, no. 2 (2011): 183–99.
Boyd, Nan Alamilla. "Who Is the Subject? Queer Theory Meets Oral History." *Journal of the History of Sexuality* 17, no. 2 (2008): 177–89.
Boyd, Nan Alamilla, and Horacio N. Roque Ramírez, eds. *Bodies of Evidence: The Practice of Queer Oral History.* Oxford: Oxford University Press, 2012.
Burger, John R. *One-Handed Histories: The Eroto-Politics of Gay Male Video Pornography.* New York: Routledge, 1995.
Clarke, John R. "Before Pornography: Sexual Representation in Ancient Roman Visual Culture." In *Pornographic Art and the Aesthetics of Pornography,* edited by Hans Maes, 141–61. Basingstoke, UK: Palgrave McMillan, 2013.
Dean, Tim. "Introduction: Pornography, Technology, Archive." In *Porn Archives,* edited by Tim Dean, Steven Ruszczychy, and David Squires, 1–26. Durham, NC: Duke University Press, 2014.

Dean, Tim. "No Sex Please, We're American." *American Literary History* 27, no. 3 (2015): 614–24.

Dean, Tim. *Unlimited Intimacy: Reflections on the Subculture of Barebacking.* Chicago: University of Chicago Press, 2009.

Downs, Jim. *Stand by Me: The Forgotten History of Gay Liberation.* New York: Basic Books, 2016.

Dyer, Richard. "Male Gay Porn: Coming to Terms." *Jump Cut: A Review of Contemporary Media*, no. 30 (March 1985): 27–29. www.ejumpcut.org/archive/onlinessays/JC30folder /GayPornDyer.html.

Evans, Jennifer V. "Introduction: Why Queer German History?" *German History* 34, no. 3 (2016): 371–84.

Evans, Jennifer V. "Seeing Subjectivity: Erotic Photography and the Optics of Desire." *American Historical Review* 118, no. 2 (2013): 430–62.

Florêncio, João. *Bareback Porn, Porous Masculinities, Queer Futures: The Ethics of Becoming-Pig.* London: Routledge, 2020.

Florêncio, João. "Breeding Futures: Masculinity and the Ethics of CUMmunion in Treasure Island Media's Viral Loads." *Porn Studies* 5, no. 3 (2018): 271–85.

Freeman, Elizabeth. *Time Binds: Queer Temporalities, Queer Histories.* Durham, NC: Duke University Press, 2010.

Gluck, Sherna Berger, and Daphne Patai. *Women's Words: The Feminist Practice of Oral History.* Abingdon-on-Thames, UK: Routledge, 1991.

Hobson, Emily. *Lavender and Red: Liberation and Solidarity in the Gay and Lesbian Left.* Berkeley: University of California Press, 2016.

Hunt, Lynn. "Introduction: Obscenity and the Origins of Modernity, 1500–1800." In *The Invention of Pornography: Obscenity and the Origins of Modernity, 1500–1800*, edited by Lynn Hunt, 9–45. New York: Zone Books, 1993.

Johnson, David K. *Buying Gay: How Physique Entrepreneurs Started a Movement.* New York: Columbia University Press, 2019.

Kendrick, Walter. *The Secret Museum: Pornography in Modern Culture.* New York: Viking, 1987.

Lee, Jiz. "Uncategorized: Genderqueer Identity and Performance in Independent and Mainstream Porn." In *The Feminist Porn Book: The Politics of Producing Pleasure*, edited by Tristan Taormino, Constance Penley, Celine Shimizu, and Mireille Miller-Young, 274–78. New York: Feminist Press, 2013.

McKinney, Cait. *Information Activism: A Queer History of Lesbian Media Technologies.* Durham, NC: Duke University Press, 2020.

Meeker, Martin. *Contacts Desired: Gay and Lesbian Communications and Community, 1940s–1970s.* Chicago: University of Chicago Press, 2006.

Mercer, John. *Gay Pornography: Representations of Sexuality and Masculinity.* London: I. B. Tauris, 2017.

Mitchell, W. J. T. *What Do Pictures Want? The Lives and Loves of Images.* Chicago: University of Chicago Press, 2005.

Müller, Karl O. *Handbuch der Archäologie der Kunst.* Breslau: Josef Max und Komp, 1830.

Paasonen, Susanna. *Carnal Resonance: Affect and Online Pornography.* Cambridge, MA: MIT Press.

Paasonen, Susanna, and Paul Morris. "Risk and Utopia: A Dialogue on Pornography." *GLQ* 20, no. 3 (2014): 215–39.

Paasonen, Susanna, Kaarina Nikunen, and Laura Saarenmaa. "Pornification and the Education of Desire." In *Pornification: Sex and Sexuality in Media Culture*, edited by Susanna Paasonen, Kaarina Nikunen, and Laura Saarenmaa, 1–20. Oxford: Berg, 2007.

Pezzutto, Sophie, and Lynn Comella. "Trans Pornography: Mapping an Emerging Field." *TSQ* 7, no. 2 (2020): 152–71.

Preciado, Paul B. *Countersexual Manifesto*. New York: Columbia University Press, 2018.

Rancière, Jacques. *The Politics of Aesthetics: The Distribution of the Sensible*. London: Continuum, 2006.

Rubin, Gayle S. "Thinking Sex: Notes for a Radical Theory of the Politics of Sexuality." In *Deviations: A Gayle Rubin Reader*, 137–81. Durham, NC: Duke University Press, 2011.

Sedgwick, Eve Kosofsky. *Between Men: English Literature and Male Homosocial Desire*. New York: Columbia University Press, 2015.

Shepard, Benjamin H. "The Queer/Gay Assimilationist Split: The Suits vs. the Sluts." *Monthly Review* 53, no. 1 (2001): 49–62.

Sigal, Pete, Zeb Tortorici, and Neil L. Whitehead. "Ethnopornography as Method and Critique." In *Ethnopornography: Sexuality, Colonialism, and Archival Knowledge*, 1–37. Durham, NC: Duke University Press, 2019.

Srigley, Katrina, Stacey Zembrzycki, and Franca Iacovetta. *Beyond Women's Words: Feminisms and the Practices of Oral History in the Twenty-First Century*. Abingdon-on-Thames, UK: Routledge, 2018.

Stryker, Susan. *Queer Pulp: Perverted Passions from the Golden Age of the Paperback*. San Francisco, CA: Chronicle Books, 2001.

Sullivan, Rebecca, and Alan McKee. *Pornography*. Cambridge: Polity, 2015.

Warner, Michael. *The Trouble with Normal: Sex, Politics, and the Ethics of Queer Life*. Cambridge, MA: Harvard University Press, 1999.

Williams, Linda. *Hard Core: Power, Pleasure, and the "Frenzy of the Visible."* Berkeley: University of California Press, 1999.

Zimmerman, Andi. "History, Theory, Poetry." *History of the Present* 10, no. 1 (2020): 183–86.

Teaching the History of Sexuality with Images

Sarah Jones

For the past seven years or so, I have taught a broad range of topics around histories of gender and sexuality at both the University of Exeter and the University of Bristol. While I also teach specifically around my own particular research into print culture and "popular" sexual science in the modern context, many of these courses have been quite survey-like in nature—often introducing students at different levels to broad critical discussions and theoretical explorations of sex and sexuality for the first time. Increasingly, I am turning toward visual sources to help me do this: moving away from what Brian Goldfarb has described as a pedagogical approach in which images are simply treated as the "visual icing on the textual cake," and toward sessions that look specifically at the politics, ethics, and methods of working with these kinds of sources.[1] As I push students to work with these materials beyond mere illustration, the in-depth engagement with visual archives has become a core aspect of my teaching as students are asked to find, interpret, analyze, organize, and also to create different kinds of visual sources in order to develop their understanding of the past and how we study it.

This approach, I will argue, has given me important tools to help balance the complex aims of teaching this kind of history: working closely with visual materials allows students to develop academic skills, to think critically about the archives and sources that shape and are shaped by historical research, but also make space for personal reflection and discovery, as well as broader discussions about the

Radical History Review

Issue 142 (January 2022) DOI 10.1215/01636545-9397130

© 2022 by MARHO: The Radical Historians' Organization, Inc.

complicated ways in which societies construct and manage knowledge around sex and sexuality. Here I reflect more broadly on some of these attempts, thinking through some of the most pressing problems, and also highlighting areas in which an engagement with the visual archives of sex has been particularly meaningful or productive.

.

Teaching the history of sexuality often means having to find ways to handle what Timothy Stewart-Winter calls the "confessional impulse": to manage students' emotional reactions, personal investments, and strongly held opinions when teaching a topic that can feel so "natural" and often urgent to many of them.[2] For example, one of the most important ways visual sources have played a role in my classes has been as a way of "breaking the ice," helping open up discussion and make space for speculation and debate in a classroom in which students might otherwise feel embarrassment or discomfort.

This approach has been shaped in part by sex education initiatives like the Sex and History project at the University of Exeter, which asks young people to engage with a range of historical objects as a "distancing technique" to encourage open and confident discussion about their own thoughts and feelings about sex.[3] While my approach uses visual sources instead of objects, working with these sources serves a similar purpose in the undergraduate classroom—engaging students with historical material in a way that feels comfortable and accessible, while also offering them a supportive space to work through early feelings of curiosity and embarrassment, and to reflect on their own assumptions and responses. Students are encouraged to speculate and make "educated guesses" about the material, which works especially well to free up conversation; students are certainly more willing to think independently and creatively about the sources and their own reactions to them when it feels like there is no "right" or "wrong" answer. This seems to work especially well with pornography or erotica. At first, we start off discussing these materials in broad, almost abstract ways—we talk, in particular, about the fact that we often know little to nothing about the images and, informed by background reading, wonder aloud about where these images were made, who they were made by, who is depicted, and how they might have been viewed and consumed. We also share our early responses to the material, reflecting on how sexualized images might confirm, challenge, or change our assumptions about sex and how it has changed (or not) over time.

I've also found that using these materials opens up interesting conversations about what is considered "appropriate" archival material. While I provide some examples drawn from such key texts as Lisa Sigel's *Governing Pleasures* and Cait McKinney's excellent article on the Lesbian Herstory Archives in this journal, I also encourage students to track down some of their own.[4] Given the vast array of materials now freely available online, most of them tend to come across sources on

popular Twitter and Instagram accounts such as Kate Lister's *Whores of Yore* or via the websites of private collectors, while others, despite the great swaths of digitized material they have access to, struggle to find this kind of material in "reputable" academic repositories.[5] In addition to opening up and relaxing them into broader conversations about histories of sex, asking students to track down this kind of material themselves acts as an early catalyst for discussions about what we mean when we talk about archives: what kind of material is included in what they often see as "real" archives, what is left out, and, especially at a digital moment when unimaginable amounts of data are only a click away, what "counts" as an archive at all.

But even as visual sources can offer critical distance, many of my students have reported that continuing to work in greater depth with images, and especially photographs, can serve to have the opposite effect—making the past feel very close, or somehow more real than when they look at textual sources. Reflecting what Johan Huizinga might see as a "historical sensation," a kind of "immediate contact with the past," they comment on how seeing the real bodies and faces of historical actors— the stretch marks, pubic hair, and cellulite—makes the past feel all the more immediate and authentic.[6] The same can be said for photos that they feel give them glimpses into intimate lives and relationships, what on the surface looks to them like a direct window into the past: students have described the immersive experience of working with materials like the candid photos in the Digital Transgender Archive or Brassaï's photographs of the inside of the notorious lesbian bar Le Monocle, for example, as akin to "looking history right in the eye."[7]

For some, this can be a very positive and joyful thing, and at numerous points students have remarked on how satisfying and validating it is to see bodies, behaviors, relationships, and communities that resonate with their own represented in the historical sources they are asked to work with. The liveliest, most impassioned, and insightful discussions, though, often happen around images that cause different kinds of reactions— images they find arresting and provocative, that have potential to shock and offend, to elicit emotional reactions that students don't expect, and perhaps even purposefully make them feel uncomfortable. While it is impossible to know what a particular class will react to, certain topics and activities nevertheless usually incite a very strong response: seeing older men having sex with much younger women, explicit depictions of oral and anal sex between men, images that show fat or disabled bodies, and sexualized portrayals of racialized peoples all reliably provoke intense and sometimes heated discussions. Pubic hair is also usually controversial: vintage erotica that shows untamed pubic hair is most often met with an initial wave of outrage and disgust.[8] This acts as a catalyst for often spirited debates about changing ideals, body image, and gendered double standards in both the past and present.

As Genevieve Lively has argued, such images can have a profound and transformative effect on students: it is through such sources that some might see same-sex

sex for the first time, they might end up discussing subjects that feel sensitive or embarrassing with their peers, or they may come "face to face" with scenes concerning rape or sexual coercion.[9] They also might have uncomfortable or unexpected reactions, sometimes in contrast to those of their friends and classmates. In the past, scholars of sexuality like Robert Nye have told students to avoid classes that include any materials that might offend.[10] I do, of course, also include warnings about content from the start of any course and want to make it clear here that I do everything I possibly can to avoid causing or perpetuating trauma.[11] Materials are always provided in advance, and any student can miss any session with no ramifications or questions asked. However, following educators like Lively, Peter Lehman, and Page DuBois, I find images to be a powerful pedagogical tool because they have the potential to challenge, discomfit, or offend—to force students to confront, or at least acknowledge, their own attitudes and assumptions about sex in both the past and present.[12]

However, while working with and encouraging students to think critically about visual archives has been hugely helpful in shaping my teaching practices, I have also found this shift replete with obstacles. As my practice has transformed and visual sources have become central to more of my classes, I have begun to address my own misgivings about some of the materials and activities my students and I engage with in different ways. I am profoundly unsure, for example, about the ethics of reproducing and disseminating images of people in such a way that might, as Jane Nicholas reflected in her work into researching historical photographs, make me complicit in upholding different "legacies of inequality and vulnerability," particularly around race and gender.[13] This is particularly clear when asking students to work with something like a pornographic image, produced in the imperial context, that depicts the bodies of colonized peoples. As Lisa Sigel has noted, many of these images "played up the exoticism of foreign sexuality" and helped construct and disseminate contemporary ideas about racial and sexual hierarchies.[14] Following scholars like Matthew Rarey and Sadiah Qureshi, I am therefore trying to be more aware of how reproducing such images of the sexual exploitation of colonized people—often in classrooms that are predominantly white—runs the risk of being almost voyeuristic, unwittingly perpetuating racist stereotypes, and replicating the power structures the images were originally meant to serve.[15]

While I want to challenge and confront students, in making space for personal and emotional reactions to the sources I relinquish any real control over the way they react and respond. While together we make rules about appropriate behavior, I cannot police feelings of excitement, titillation, or even arousal—I also cannot stop them taking images they find funny, images of people who can be seen to have been exploited and objectified, and then sharing them with their friends, or posting them on the internet as some of them choose to do. I am concerned that, while pushing them to work with images they find engaging and provocative might help make

them braver, more creative, more ambitious scholars, if I don't do it right, I run the risk of enabling mere voyeurism, perpetuating harmful fascinations with the bodies of marginalized peoples, and upholding—rather than challenging—structures of power.

As historian of historical photography Susan Crane argues in her reflections on teaching with atrocity images, negotiating a room in which students might find potentially problematic images funny, exciting, or even arousing is a difficult, perhaps even insurmountable task.[16] Crane herself argues that perhaps we should ultimately "choose not to look" at images that potentially perpetuate violence, even if they are intellectually useful.[17]

The questions I continue to wrestle with, then, are really those that many who teach with these kinds of images find themselves addressing—how can I find a balance between the good parts of teaching with these images, the particular strength of them as tools for vital, engaging, and versatile pedagogy, with the ethical issues of doing so? How can my pedagogical practice encourage and make space for students to think critically and sensitively about their responses to historical sexual imagery while also recognizing and navigating the potentially problematic nature of the source base?

In response to these questions, I have worked closely with my students to come up with approaches, activities, and guidelines that might allow us to address these issues. First, I have tried to democratize and open up my teaching preparations: rather than making decisions as an educator to use particular sources, I now include students in a more open process in which we decide together what to look at, what materials to use, and how to approach them. Rather than using what Paulo Freire calls the "banking model of education" in which students are just passive receivers of knowledge, in which the onus might be entirely on me to tease out what *I* think the complexities of the visual archive are for them, I have found that asking them to play a key role in choosing materials and what we do with them encourages everyone in the room—including me—to think more critically about the kinds of archives we are engaging with.[18]

In a recent class for final year undergraduates that explored imperial pornography, for example, it was the students who decided that it would be productive to find ways to complicate, disrupt, or make conscious the act of looking at visual sources in the teaching room. Following a close reading of Qureshi's exceptional article on Sara Baartman and the ethics of putting the bodies of colonized peoples on public display,[19] a group of students provided different kinds of sources, including a selection of pornographic images, in sealed envelopes that their peers could choose to look at or not look at. Some of the participants decided to open the envelopes and analyze the visual sources; others decided against it and were tasked with working with "obscene" texts such as Charles Carrington's *Untrodden Fields of Anthropology* that covered similar themes.[20] We then came together to discuss the different

perspectives offered by visual and textual sources, and how and why we might handle and use them differently in scholarship. While by no means a flawless exercise, the activity sparked a remarkably frank and sophisticated conversation about what ethical historical research might look like, and the benefits and limitations of using images of real people in our scholarship. By putting students in charge of making decisions about what material to use, and making looking at visual sources a conscious act, students reflected in anonymous feedback on the class that they felt much more aware of the politics of their own historical practice, the ethical complexities of working with visual material, and how consuming visual sources can't be seen as a neutral act.

Building on this, my students and I have also experimented with other approaches that disrupt or make conscious the act of looking at visual sources: this includes trying to find ways to avoid reproducing the images at all. Inspired by such work as the *Erased Lynchings* series by Ken Gonzales Day (who alters historic images of lynching in America to remove the rope and the body of the victim), we have experimented with altered images in which bodies were obscured or cropped out.[21] An altered image from the case of Amanda/Amandus B. from the work of the sexologist Magnus Hirschfeld, for example, sparked an insightful conversation about the ethics of reproducing medical photographs in the classroom, the issue of historical actors and consent, as well as broader discussions about modern society's almost obsessive and often invasive curiosity about trans bodies.[22]

Perhaps the most productive part of this whole exercise, however, has been discussing students' own criticisms of it. They have (completely, justifiably) challenged anyone's right to alter historical sources; argued about why some people should be able to see the images while they were deemed as not appropriate for the classroom as a whole; and (the most impassioned criticisms of all) questioned whether by obscuring bodies we are denying those depicted power and agency, or inadvertently creating a teaching space that is prudish, restrictive, or sex negative. While making my own approaches the locus of criticism was initially a little bruising for the ego, I now actively encourage strong criticism of and reflection on the sources and how they are being used in the seminar room. I consciously use my pedagogical approach as a provocation, and their misgivings about the exercise act as a spark for valuable conversations about historical practice, while confronting bigger questions about censorship and agency.

Other groups have chosen to move away from using different depictions of "real" bodies at all, and instead have worked with a variety of comics, cartoons, and illustrations. In feedback, students reported that these sessions helped them navigate sources they previously felt were "frustratingly blurry" and encouraged them to develop clearer and more sophisticated understandings of texts that often had competing and overlapping uses and multiple, sometimes ambiguous aims. While these sessions often shifted away from the discussion of ethical historical method, they

nevertheless resulted in lively sessions that provided students with numerous help-ful insights. They were particularly effective for bringing the visual and textual together—a great deal of our time was spent exploring how analysis of text can be changed and enriched by looking at the visual as well. In a class on early twentieth-century sex advice, for example, an illustration of a bare-breasted, provocatively posed woman in a sex manual can easily be seen to belie an author's earnest claim that his advice was meant only for consumption by serious medical men trying to improve their knowledge of sexual science.

This also paved the way for some more creative practice. In one session, for example, we worked with some "Tijuana bibles"—pocket-sized comic books con-taining pornographic images popular in mid-twentieth-century America—and then drew our own.[23] After putting them together, we then switched tack and tried to think like a contemporary censor, taking out red pens and censoring each other's work. This exercise led to a lot of laughter but also to spirited, sometimes heated discussions about what would have been censored and why, as students attacked or defended the images they created. This active, participatory approach to working with images certainly added energy to the room, but it also added another layer to their understanding of this rich material. Following such sessions, I found students were more able to authoritatively discuss and analyze the complex, ambiguous, multidimensional content of such sources in their assessments, and they were also more willing to offer compelling considerations of how and why these sources might have been created and consumed. As education specialist Timothy Gangwer has noted, this process of "dynamic translation"—of taking ideas and expressing them in new forms—can allow learners to process and understand those ideas in deeper, more meaningful ways.[24] The process of working with, inter-preting, creating, and censoring their own cartoons and illustrations—a process through which complex ideas are "made manifest"—seems to allow students to develop more nuanced and confident responses to visual material as a whole.[25]

.

This is not meant to be a comprehensive take on how to teach sexuality with images. I am keenly aware that scholars who work more closely with historical photographs or other aspects of visual culture in their own research have long been teaching with visual archives in innovative ways. Instead, I wanted to reflect on my own shifting and developing practice—to consider, in particular, how a deeper engagement with the visual archives of sex has helped me enrich and refine my pedagogy in a variety of ways, and to take a more ambitious view of what is achievable in an undergraduate classroom. At the very least, following these sessions, my students report that they feel like stronger, more rigorous historians: able to reflect on their own methods and approaches, more aware of archives and how they can shape research, and more will-ing to think critically about existing historical scholarship around sex and sexuality.

Sarah Jones is lecturer in the history of sexuality and gender at the University of Bristol. Her most recent work has investigated the "popular" life of sexology in print, including the history of popular, mass-produced sex advice literature. A monograph, *The Science of Sex Advice: Popular Sexology in Early Twentieth-Century America*, is currently in the works.

Notes

1. Goldfarb, *Visual Pedagogy*, 20.
2. Stewart-Winter, "Navigating the Confessional Impulse."
3. Fisher, Grove, and Langlands, "'Sex and History,'" 31.
4. Sigel, *Governing Pleasures*; McKinney, "Body, Sex, Interface."
5. See, for example, Lister, "Vintage Erotica." Many students also stumble across images on sites like Pinterest, Instagram and Twitter. Privately owned websites like Vintageporncollector.com also feature heavily.
6. Huizinga, "Het historisch museum," qtd. in Siewart, *Performing Moving Images*, 108.
7. The Digital Transgender Archive. Images of Le Monocle abound online, and many students bring them to class having found them through a Google image search. Some of the images, such as *Fat Claude and Her Girlfriend at Le Monocle* (see Brassaï, *Fat Claude*) can be found in the online collections of the Met Museum.
8. The top right-hand image in the Whores of Yore collection of nineteenth-century erotica has proved especially provocative. Lister, "Victorian Erotica."
9. Lively, "Pedagogy and Pornography," 148.
10. Nye, "Innovations in Education."
11. Helpful guidance on providing content and trigger warnings can be found at the website of the LSA Inclusive Teaching Initiative, University of Michigan. See LSA Inclusive Teaching Initiative, "Introduction to Content Warnings."
12. See Dubois, "Teaching the Uncomfortable Subject of Slavery," 195.
13. Nicholas, "Debt to the Dead?," 140.
14. Sigel, *Governing Pleasures*, 126–30.
15. Rarey, "Counterwitnessing the Visual Culture"; Qureshi, "Displaying Sara Baartman."
16. Crane, "Choosing Not to Look," 311. See also Bormann, *Ethics of Teaching*, especially chap. 3, "'And Now You Are Going to See Something Shocking,'" 33–47.
17. Crane, "Choosing Not to Look," 311.
18. Freire, *Pedagogy of the Oppressed*.
19. Qureshi, "Displaying Sara Baartman."
20. French Army Surgeon, *Untrodden Fields of Anthropology*. This book was published by Carrington, a pornographer, in 1898. It allegedly traces the travels of a man named only as "A French Army Surgeon" throughout Africa, Asia, and Australia. The author goes into significant, explicit detail about the apparent sexual habits and inclinations of different racial groups, while also discussing topics like female genital mutilation and marriage by capture.
21. Gonzales Day, *Erased Lynchings*.
22. Hirschfeld, *Sexualpathologie*, 20. This text has been digitized by the Wellcome Collection and contains a number of medical photographs that have been useful for teaching. Jana Funke has also written a blog on photographs and sexual science that students found helpful. Funke, "Photographs as Evidence."
23. As above, I often ask students to track down their own sources for this. They usually bring examples from the Internet Archive, online magazine articles, or privately owned websites like Tijuanabibles.org.

24. Gangwer, *Visual Impact, Visual Teaching*, 3. Gangwer's work is targeted at school-age children but utilizes research into broader educational principles.
25. Kirtley, Garcia, and Carlson, *With Great Power Comes Great Pedagogy*, 83.

References

Bormann, Natalie. *The Ethics of Teaching at Sites of Violence and Trauma: Student Encounters with the Holocaust*. Basingstoke, UK: Palgrave Macmillan, 2018.

Brassaï. *Fat Claude and Her Girlfriend at Le Monocle*. The Met. www.metmuseum.org/art /collection/search/283310 (accessed January 28, 2021).

Crane, Susan A. "Choosing Not to Look: Representation, Repatriation, and Holocaust Atrocity Photography." *History and Theory* 47, no. 3 (2008): 309–30.

Digital Transgender Archive. www.digitaltransgenderarchive.net (accessed February 1, 2021).

Dubois, Page. "Teaching the Uncomfortable Subject of Slavery." In *From Abortion to Pederasty: Addressing Difficult Topics in the Classics Classroom*, edited by Nancy Sorkin Rabinowitz and Fiona McHardy, 187–98. Columbus: University of Ohio Press, 2014.

Fisher, Kate, Jen Grove, and Rebecca Langlands. "'Sex and History': Talking Sex with Objects from the Past." In *The Palgrave Handbook of Sexuality Education*, edited by Louisa Allen and Mary Lou Rasmussen, 29–51. London: Palgrave Macmillan, 2017.

Freire, Paulo. *Pedagogy of the Oppressed*. 30th anniversary ed. New York: Continuum, 2005.

A French Army Surgeon. *Untrodden Fields of Anthropology: Observations on the Esoteric Manners and Customs of Semi-civilized Peoples; Being a Record of Thirty Years Experience in Asia, Africa, America, and Oceania*. Paris: Charles Carrington, 1898.

Funke, Jana. "Photographs as Evidence." *Wellcome Collection* (blog), March 13, 2015. wellcomecollection.org/articles/WqfysCUAAKsrVsYn.

Gangwer, Timothy. *Visual Impact, Visual Teaching: Using Images to Strengthen Learning*. Thousand Oaks, CA: Sage, 2009.

Goldfarb, Brian. *Visual Pedagogy: Media Cultures in and beyond the Classroom*. Durham, NC: Duke University Press, 2002.

Gonzales Day, Ken. *Erased Lynchings*. kengonzalesday.com/projects/erased-lynchings/ (accessed September 7, 2020).

Hirschfeld, Magnus. *Sexualpathologie: Ein Lehrbuch für Aerzte und Studierende*. Bonn: A Marcus and E. Webers Verlag, 1921. Wellcome Collection. wellcomecollection.org/works /h57g6aup (accessed February 1, 2021).

Huizinga, Johan. "Het historisch museum." *De Gids* 84 (1920): 251–62.

Kirtley, Susan E., Antero Garcia, and Peter E. Carlson. *With Great Power Comes Great Pedagogy: Teaching, Learning, and Comics*. Jackson: University Press of Mississippi, 2020.

Lister, Kate. "Victorian Erotica." The Whores of Yore. www.thewhoresofyore.com/1800s (accessed January 16, 2021).

Lister, Kate. "Vintage Erotica." *Whores of Yore*. www.thewhoresofyore.com/vintage-erotica .html (accessed September 8, 2020).

Lively, Genevieve. "Pedagogy and Pornography in the Classics Classroom." In *From Abortion to Pederasty: Addressing Difficult Topics in the Classics Classroom*, edited by Nancy Sorkin Rabinowitz and Fiona McHardy, 139–51. Columbus: University of Ohio Press, 2014.

LSA Inclusive Teaching Initiative. "An Introduction to Content Warnings and Trigger Warnings." College of Literatures, Science, and the Arts, University of Michigan. www.sites .lsa.umich.edu/inclusive-teaching/inclusive-classrooms/an-introduction-to-content -warnings-and-trigger-warnings/ (accessed October 12, 2020).

McKinney, Cait. "Body, Sex, Interface: Reckoning with Images at the Lesbian Herstory Archives." *Radical History Review*, no. 122 (2015): 115–28.

Nicholas, Jane. "A Debt to the Dead? Ethics, Photography, History, and the Study of Freakery." *Histoire Sociale/Social History* 47, no. 93 (2014): 139–55.

Nye, Robert. "Innovations in Education: Teaching the History of Sexuality." History of Science Society. www.hssonline.org/resources/teaching/teaching_coe_sex/ (accessed October 27, 2020).

Qureshi, Sadiah. "Displaying Sara Baartman, the 'Hottentot Venus.'" *History of Science* 42, no. 2 (2004): 233–57.

Rarey, Matthew. "Counterwitnessing the Visual Culture of Brazilian Slavery." In *African Heritage and Memories of Slavery in Brazil and the South Atlantic World*, edited by Ana Lucia Araujo, 71–108. Amherst, NY: Cambria, 2015.

Siewart, Senta. *Performing Moving Images: Access, Archives, and Affects*. Amsterdam: Amsterdam University Press, 2020.

Sigel, Lisa. *Governing Pleasures: Pornography and Social Change in England, 1815–1914*. New Brunswick, NJ: Rutgers University Press, 2002.

Stewart-Winter, Timothy. "Navigating the Confessional Impulse." *Notches* (blog), September 11, 2014. notchesblog.com/2014/09/11/notches-goes-back-to-school/.

"The Cost of That Revealing"

Interview with Derek Conrad Murray

Alexis L. Boylan

Alexis Boylan: *It seems crucial to start by asking how are you managing? How is your community and family? How are you finding yourself as a scholar/thinker/ writer in this moment?*

Derek Conrad Murray: Thanks for this question, which I believe is so important during these very difficult and bizarre times. I would say that I'm getting along just fine, all things considered. The biggest adjustment has been the inability to see family, and of course, the abrupt shift to online learning—not to mention the incessant Zoom meetings. That said, my family and close friends have not been directly affected by COVID-19 thus far, so I feel very fortunate. It's been somewhat difficult to reconcile my incredible privilege in having employment that affords me the opportunity to work from home through the pandemic—contrasted with the many Americans who have lost employment, and are facing evictions, foreclosures, the loss of healthcare, as well as food insecurity. Many tenured academics tend to view themselves as increasingly threatened by neoliberalism and the corporatization of universities, yet the very dire financial impacts of the pandemic have put our respective situations into stark perspective. I admit I've experienced persistent stress and a lingering sense of dread that has taken its toll over the months, which, needless to say, has been exacerbated by the chaotic political climate.

As a scholar, it has been difficult to work at times, especially with the ongoing political instability. When the George Floyd murder occurred, the global response

Radical History Review

Issue 142 (January 2022) DOI 10.1215/01636545-9397144

© 2022 by MARHO: The Radical Historians' Organization, Inc.

to it was truly something to witness. It really shook the students I was teaching at the time. I spent a lot of time speaking with them about it and just working through our feelings collectively. That was definitely a challenging moment but, with any hope, something transformative will materialize. In terms of my own research, these past months have been relatively productive, but I know my morale was impacted. That said, while being at home all the time has been a challenge in many ways, it's afforded me the time to attend to my health and general well-being, so there are bright sides. Overall, it's just been an incredibly stressful and dismaying year for everyone.

ALB: *What is your impression of the visual moment we find ourselves in? What has stayed invisible and what threatens to be visually overdetermined in future archives?*

DCM: Visual culture is incredibly complex these days. We're inundated with so many images that it's hard to discern what's actually happening to us. Over the past decade, I've been thinking a great deal about cameras, and their ability to not simply record but also shape culture. The use of cell phone cameras to capture forms of injustice occurring spontaneously in the public sphere has—as we have seen—often disturbing and profound societal implications. The very notion of a tiny cell phone camera as a political weapon has added new layers of complexity to my understanding of the medium's social function. Of course, throughout modernity, there was always skepticism (and rightly so) about the ubiquity of cameras—but this moment is truly unprecedented. We're also living in a time when photography is incredibly popular with the general public. Everyone wants to document everything, and there is a greater interest in aesthetic sophistication. You can see this on Instagram and VSCO in particular, where young people, especially, are competing to create the most enticing social media feeds. The more opportunity there is for profit, the greater investment goes into image quality, and the attainment of advanced imaging equipment.

I often wonder what scholars engaged with the historical legacy of photography will say about this moment. The individual right to wield the camera (as a powerful and dangerous technology) has often been either contested or denied certain constituencies throughout history and in many cultural contexts—but the global ubiquity of the cell phone, combined with the power of the internet, has transformed our understanding of the camera's societal, polemical, and political impacts. There has been some truly transformative scholarship about the cultural impact of the camera during the Civil Rights movement in the United States, the period of African independence, or in the context of Japanese internment, for example—but I suspect scholars in the arena of photographic histories will struggle to comprehend this moment, when the camera is so ubiquitous and so powerful a means to document literally everything.

When I think about what should be captured, what I fear will get lost, what has stayed invisible, and what threatens to be visually saturated, I actually find that representation is too invasive, too panoptic and voyeuristic these days. In many respects, the politics of race unfolding today has made me interrogate the invasiveness implicit in our current culture of ceaseless observation. In response to this phenomenon, my impulse is to disappear, so to speak, to resist the logics of constant visibility. In that regard, what comes to mind most readily (for me, at least) is the refusal of the gaze: what could be characterized as the right to not be understood, or what Édouard Glissant termed "the right to opacity."[1] The right to not be translatable into the logic of techno-consumerism is, I believe, to disallow or to deny access to one's interiority—and to disavow the violence of fetishization and objectification, so often heaped upon the bodies of marginal subjects in representational contexts. For me, there is a kind of stripping bare that is demanded of the body politic, that is fueled by the internet. This mandate uniquely impacts minoritized communities, who are so often objectified visually and over-defined ideologically. Whether it's in photojournalism, or high art, the Black body (in particular) is always on display—nothing can be hidden or preserved. It is all for public consumption, and this troubles me.

There is so much effort placed these days on the imaging of Black people as dignified, as having produced a rich visual culture. This effort is largely about a conjunction between being seen and attaining justice, one that attempts to foreground a history of photographic representation of African Americans. While I fully understand the import of these efforts, I have a lingering concern about the overexposure of African-descended folks worldwide, who find themselves the subject of a rapacious Western image culture that consumes Black bodies for entertainment purposes. As cynical as this sounds, I think the dominant culture likes to gaze upon Black and Brown bodies (and othered bodies in general) as entertainment: as an affective visual spectacle. In many respects, that societal thirst—and the plethora of images it generates—is confused for racial progress because it grants visibility and provides support and pathways to success for a select few. If we look at African American life as a totality, and not just the elite (who produce this image-making regime and its related discourses), we obviously see a disjuncture between the deluge of images of Black bodies, contrasted by rampant disenfranchisement.

I feel the right to opacity can function as resistance to imposed legibility and ideological reduction. In fact, I tend to view this impulse as a necessary refusal of legibility entirely, and as a defense of the unknowable. In our current moment, there is a great interest (and desire) in Black subjectivity representationally as a marker of ennobled suffering. But this archetype is a simplification and a cliché. All of this has been heightened by Black Lives Matter and its fight against the extrajudicial killing of Black people in the United States. The very idea of an unknowable Blackness that I'm advocating for (something that is porous/shapeless or defined by a quality of

semiotic vulnerability) is an ideological contradiction—especially considering recent trends in Black representational practices. It would seem that the modus operandi of Black visuality in the twenty-first century is to put Black subjecthood on display as a corrective image: as a representational argument against degradation and erasure—and as a means to create a space to value Black beauty and humanity. But what is the cost of that revealing, a stripping bare that opens oneself up to these objectifying and fetishizing forms of evaluative scrutiny?

ALB: *As an art historian/visual culture scholar, where does that put you? I hear exactly what you are saying, and whiteness has often accrued, and has been visually marked by, power, in its ability to hide in plain sight, to be everything and nothing. Yet at the same time, representation and visibility for BIPOC seem to be increasingly understood and valued within popular culture, as you phrase it, as an empowering "corrective."*

 Can one hide anymore? Remain unseen and unknowable? Conversely, can a body visually mean nothing? Meaning not a corrective, not a symbol, just . . . nothing. Or will representation just never let us go?

DCM: These are loaded questions. I've never thought of whiteness as something that hides in plain sight. On the contrary, I think of it (at least in Europe and North America) as an overbearing and unavoidable pestilence that consumes just about everything. James Baldwin once said satirically, and I tend to agree with him, that "whiteness is a metaphor for power, and that's just another way of describing Chase Manhattan Bank."[2] To that point, I've always acknowledged a disconnect between so-called white people and whiteness—just like being of African descent is not inherently synonymous with Blackness. Of course, the racial designation of being white is no guarantor of whiteness in terms of power—as any disenfranchised, poor white American could tell you. As we are all aware, these are social constructs and reductions.

 I'm not certain that having visibility is the same thing as being seen. That's what I was trying to get at in my response to the previous question. To be exposed, in representation, is not always fueled by a desire for understanding, or an acknowledgment of worth. In actuality, it's often motivated by a need to expose, objectify, to willfully mischaracterize forms of difference, or simply to be entertained. I don't necessarily believe the increasing visibility of Black people in popular culture is inherently a sign of progress, largely because the dominant understanding of Black people's lives in the United States is generally a fiction. Recently, several major newspapers, like the *Los Angeles Times* and others, published apologies for decades of racially biased reporting targeting Black and Brown communities. These apologies acknowledged that the derisive characterization of these communities was intentional and methodical.

Of course, Black and Brown folks have always known this: that while we often dominate the local and national news for our apparent pathologies and dysfunctions, the realities of our lives are much more diverse and complicated. Representation has always been weaponized against Black and Brown people, as a means to overdetermine what their narrative is. But these forms of social programming victimize white society as well, perhaps even more so. It's an extremely rare occurrence that I encounter a representation of the African American experience that resembles what I know it to be. And this is despite the fact there are probably more people of African descent in popular visual culture than ever before. In the realms of cinema and television, we're seeing more and more Black-oriented programming, but I question their sincerity. There are exceptions, of course, but I am generally very distrustful of representation because most images of Black people are actually designed to pander to a limiting set of legible scripts. But what is most troubling is that it's generally defined through the lens of struggle and suffering—so visual culture largely reflects this very limiting generality. The culture industries traditionally refuse (or are hesitant) to support narratives that break from existing stereotypes—which places Black cultural producers in a precarious position. They can either tell the truth, and labor in obscurity, or they can churn out stereotypes and receive support and sometimes acclaim. It's an impossible choice. I am not arguing against the presence of visual culture that takes on forms of injustice, like mass incarceration and police violence, but rather we must begin to look at the true diversity of people of African descent and avoid such limited framings.

Yes, I do believe one can remain unseen and unknowable. I think race (and difference in general) creates a kind of ideological blindness that enables society to look, but not to see and know. I advocate for this unknowability, which I realize contradicts the popular expectation that to have visibility is to ultimately have humanity. I used to believe that, but now I disagree with that sentiment. While I decry the falsity of popular Black representation, I believe it is that failure to actually see/ know Black people (that opacity) that has enabled people of African descent to survive in a hostile world. I acknowledge, these are contradictory notions, but nonetheless important to ponder. Representation is a trap, but resistance is never an impossibility. Every generation manages to resist and to use the tools of control and subjugation against those very forces. While I don't know what that resistance will look like, it always manages to surprise.

ALB: *I wanted to briefly touch on your work on selfies. What motivated your initial interest into critically engaging with selfies?*

DCM: I stumbled across the topic while coteaching a photography course at the University of California, Santa Cruz, in the early 2010s. I was invited to function as a critic to help a small group of senior photography majors sort out their final projects.

There were several female students who were engaged with self-portraiture. Their work tended to have a critical dimension that dealt with a range of themes like body positivity, fashion, unhealthy beauty standards, eating disorders, racism, and sex positivity, among other topics. The other students, many of whom were men, would often ridicule them, accusing them of being narcissistic and just generally too self-absorbed. These young male students were often quite cruel in their critiques, but it was also evident that the confronting nature of the work was a trigger as well. The overall sentiment among the students was that the concerns of identity in general were an intrusion into aesthetic concerns—but it was really the fact that these women were utilizing their own bodies confrontationally and with an unrepentant obstinance.

I found the work empowering and socially engaged, and with a pulse that most of the student work didn't exude. It felt new and energetic and had a sensibility that was radical, yet distinct from earlier iterations of feminist body art and performative self-portraiture, particularly of the 1970s. That quality of newness was in fact the result of trends emerging in social media. There were a couple of female students who were very active on the social media site Tumblr, which was extremely popular at the time. Vivian Fu, whom I've written about, was one of those students who had a sizeable following on the site. Through her, and a few other students, I was introduced to a thriving online blogging culture, in which young women around the world were forming deep bonds around their shared interest in selfie taking. These images seemed to function as a visual language in many ways, with their own signifiers and visual codes, but the manner with which they dealt with sexuality was a dominant feature.

There was palpable assertiveness to their claiming and taking ownership of their desires and sexual idiosyncrasies, in a manner I had not seen before. They were bold and unapologetic about sexuality, but they were also thinking seriously about racism, misogyny, homophobia, and general body issues. Interestingly, though, many of these young women were extremely serious about photography. And they invested a significant amount of time and money on equipment and studying the craft. Over the years, they would organize group exhibitions, while others have since received significant media attention, and have built successful careers as commercial photographers, photojournalists, and fine art photographers. It was truly a movement, not just in photography but in representation in general. In most respects, it's been successfully commoditized as large companies aggressively seized upon the popularity of bloggers and have monetized their online presence. Now we have the influencer economy, which I think, in many respects, has neutralized the radical and socially transformative dimension of the form.

In terms of my scholarship, I felt that this phenomenon truly represents a radical shift in both representation as well as the social function of the photographic medium. The trivialization of self-imaging in mainstream culture is problematic and

careless because selfie taking is a symbol for a larger cultural shift that is quite profound. The access to the means of production of images afforded by these imaging technologies, which is aided by the internet, has changed society profoundly, and we are just now struggling to catch up and fully grasp what all of it means. All of the digital images being produced are going to become archives of such immensity, I believe our entire relationship to representation is being reformulated.

ALB: *Your new book,* Mapplethorpe and the Flower: Radical Sexuality and the Limits of Control *(2020) begins by essentially arguing that photography itself is not up to the challenge of truly, as you phrase it, "fully illuminat[ing] the messy intricacies of the human condition."[3] Is focusing on flowers a way of moving around the failure of photographs (and thus scholars of photography) to really ever see bodies? Are flowers better for speaking with clarity the problem that you later describe as "excavat[ing] what often goes unseen"?[4] Can you expand on that?*

DCM: It's widely believed that Mapplethorpe's flower photographs were a concession, or capitulation (on the part of the photographer) to market forces—and by extension, are thought to have provided a way for the artist to create salable objects for uptight collectors. Several noted scholars, critics, and curators have arrived at this conclusion, which I feel is both careless and patently false. It was within the flower photographs that Mapplethorpe was able to illustrate his historical acumen and sophistication as an image maker and symbolist. As I discuss in the book, there is a lengthy history of loaded symbolism around the flower, especially the visual conjunction of identity and the floral. There is a powerful way that the conjunction of these elements bounce off and reveal one another; their associations are deeply bound in histories of repression—sexual, racial, and otherwise.

I don't feel that flowers are necessarily better at speaking with clarity than bodies, but I do know that bodies (especially those that are othered or minoritized) are so overdetermined, ideologically speaking, that, despite what they reveal, they can have a certain opacity that disallows one to see beyond their societal framings. I see this especially with Mapplethorpe's photographs of S&M and the Black male nudes. These images are widely misread, especially in terms of their literary and religious references—and are instead read either through a moralizing or classicizing lens, both of which are insufficient. Closer to the artist's death, when he was producing the most flower photographs, their symbolism became more overt and loaded—but when we look at the flower's representational history in visual art, poetry, literature, photography, and so forth, we can see how Mapplethorpe was operating within a rich historical sign system that has much to reveal to us about the complexities (and perils) of representation.

ALB: *What made you want to write about Mapplethorpe now?*

DCM: There are several interlocking reasons why I chose to write this book. Generally, I'm not interested in scholarly trends, which I believe dictate much of the writing that is produced these days. There are more trendy topics that address various culturally urgent concerns, but I also notice themes that arrive, are quickly exhausted, and then fade away. There appears to be a great sense of urgency to take on the most hip and politically relevant topics, but not always the most enduring ones—and these shifts always tend to reflect the current, de rigueur (and notoriously flighty) obsessions of Twitter-based wokeness. I know this sounds a bit snarky and judgmental and I am being somewhat cynical—though I do think we should acknowledge the manner in which social media trends have impacted scholarly tendencies. Again, this may be an unfair assessment, but I try to provocatively push discourses and histories into new places, and into areas of sensitivity and discomfort. My goal is always to make an intervention into my discipline and field. In my view, art history and visual studies have not yet adequately attended to the complexities of difference (in terms of race, gender, and sexuality), both historically and in the present. I often encounter the notion that identity was a multicultural era obsession, and that we're somehow past all that now. For me, Mapplethorpe's flowers have something very important to say about visual culture that is especially pertinent to our current moment. I'll add that, I tend to write from a very emotional place, and that I am driven by an intense attraction for the topic, but also an interpretive process that is spontaneous and reveals itself organically in the process of writing. Many colleagues of mine methodically map out their book projects to the degree that it's entirely configured before the writing even begins. I could never work that way. But this is all just to say that, in writing this book, I was driven by an instinct, but not a clear sense for where I would wind up.

As a white gay artist, Mapplethorpe straddled the line between social acceptance and marginalization—which was actually a status he tended to embrace. Though, while there is a sense that Mapplethorpe has been done to death, so to speak, there has (until my project) never been a book-length critical study of his work. There are exhibition catalog essays, academic and journalistic articles, but no critical, or theoretical studies in book form. So, to that end, the book was never intended to be timely or trendy—but to be generative and to meaningfully engage with theories of representation, difference, and their impacts on the methodologies and value systems of art historical discourse. But what truly motivated this study was the fact that he had a huge impact on the development of contemporary art and particularly Black art. I discussed this at length in my first book, *Queering Post-Black Art*. Mapplethorpe's *Black Book* series generated such ire among the Black intelligentsia (especially by Black queer artists and intellectuals) that it inspired an entire generation of African American artists (and a vibrant critical discourse) that was aggressively engaged in a project of self-representation and image resuscitation. Much of the contemporary Black art that emerged in the late 1980s to 1990s—

particularly the work of artists like Lyle Ashton Harris, Glenn Ligon, and others—was formulated in response to the perceived ideological violence of Mapplethorpe's racialized images. When I was conducting research for my first book, *Queering Post-Black Art*, I encountered a memoir by the writer Jack Fritscher, who was a partner of Mapplethorpe's. Fritscher spoke about going to the movies with Mapplethorpe and seeing the William Friedkin film *Cruising* (1980), a police procedural about a serial killer targeting lower Manhattan's underground gay scene in the 1980s. There is a very odd scene in the film, in which the police enlist a Black officer to intimidate a suspect during interrogation. It's a powerful and bizarre moment that injected race (albeit in an unspoken way) into a narrative in which it was, up until that point, absent. Fritscher recounts Mapplethorpe's obsession with that scene—which he describes as the catalyst for the photographer's fascination with the representational power of the Black male body. I'm very interested in these types of entanglements between artists. Almost always, these creative legacies are overlooked in the service of separating artists along the lines of identity into tidy—but misleading—art historical categories.

That said, when reading scholarship and especially criticism of Mapplethorpe's work, I was astonished by the levels of overt homophobia, racism, and a kind of smug dismissive moralizing, directed toward his artwork and personal life. And this writing was produced by many of the most esteemed critics. Moreover, the predominating critical assessments of his oeuvre, I believe, have blind spots, and tend to neglect the complexity of his images. This reality, in many respects, is the result of overt and regressive homophobia, combined with a sense that Mapplethorpe was both a bigot and a degenerate. Both of these notions have only been exacerbated by a political correctness on the Left, which refuses to even look at something that may be deemed offensive to one group or another. I also see this response as profoundly disingenuous and the foundation of the very hypocritical forms of liberal tolerance that now permeate academia. For me, Mapplethorpe was the perfect historical artist to discuss art history's often-troubling attitudes about identity and difference. One of the fallacies that plagues discussions of equity and diversity is the notion that difference is most readily defined in terms of racial difference. Art history's problems with acknowledging gender, race, and sexuality are well known, yet not reconciled. Within the last decade, there have been some distinctly revisionist assessments of Mapplethorpe's legacy by various scholars and writers, like Patti Smith, Jonathan Weinberg, Jonathan Katz, and Richard Meyer, among others. There is a movement toward recuperation that has been attempting to reposition Mapplethorpe beyond the reductive, and often demeaning, characterizations that have misinterpreted the photographer's work and legacy.

Among the issues impacting the critical neglect of Mapplethorpe are the forms of identity-based tribalism and essentialism often encouraged in academia. We're encouraged to stay in our lane, more or less—even if this mandate is

largely unspoken: Black artists tend to be the domain of African American scholars, women artists the domain of female scholars, and so on. Though, I would say white scholars generally have (or they more or less feel that they have) the freedom to gain expertise and authority in whatever they are passionate about. I have a certain exhaustion around the segregating logics of scholarship, because it tends to both falsely categorize artistic production and the lived realities of artists as separate. It also genders or racializes the idea of who may be considered expert in a given area. In many ways, these strictures are self-imposed and are often meant to be reflective of solidarities and a sense of pride in one's history and culture. During graduate school, I made the decision to be an Americanist. In many respects, that choice was rooted in the belief that American culture is my legacy; it is what I know best. All of it, not only the African American experience. Mapplethorpe is as much my cultural legacy as Jacob Lawrence—so therefore, I will discuss and analyze whatever I see fit, especially since my engagement with the culture has always been multifaceted. I cannot limit my intellectual curiosity (and my deep appreciation for American culture and history) to serve the segregating structural and institutional values that currently dominate Leftist thinking.

It is my view that until we're able to look at culture and history through a more holistic lens, we won't cure this enduring problem of discrimination in academia. Overall, I feel everyone should have the freedom to write about anything they want, but I'm always struck by the degree to which one's identity dictates one's perceived expertise, access—as well as one's legitimacy in relation to certain topics. Mapplethorpe is one of the most impactful artists of his generation, especially in terms of his engagement with the complexities of visual culture—and his impact has yet to be fully unpacked. My book is meant to get a conversation started.

ALB: *The first chapter is a much-needed confrontation with the critical scholarship on Mapplethorpe's images of Black men. You detail the ways art historians/visual culture critics have not been able to look at the images and come to terms with Mapplethorpe as the maker. What did it mean for you to confront this literature and intervene in it?*

DCM: It was difficult to confront for sure. Much of the earlier literature on Mapplethorpe is painful and hard to digest, but his work and life were also fraught, so it was definitely an emotionally draining experience. I don't know which was worse, the homophobia or the racial insensitivity, but I knew going in, based on the topic alone, this would be a challenging book. In terms of race, there is an inability for much of white America to confront its history and present-day realities of racism with any honesty or clarity. And the African American experience is culturally codified along the lines of either pathology and struggle, or as a form of ennobled suffering. These are overwrought clichés that are indeed absurdities and reductions,

but they dictate public perceptions and have far-reaching impacts on Black life in the United States. For that reason, I found the response to his Black male nudes to be especially problematic, because of the apparent inability to really look at Black men in such a direct way. These sitters were all too often interpreted as either victims, or as exuding an air of menace. They were not given any agency, they were not perceived as collaborators, or interlocutors in any way—which of course, they were.

But this interpretive and ideological problem extends into our current moment as well. Within contemporary Black art discourse (to a much lesser degree in the humanities), there is reticence around confronting homosexuality and queerness in general. The historical roots of this neglect have been written about by scholars for decades, but it hasn't been attended to in the arts. I have written before about how respectability politics and Black class distinctions inform how African American art is engaged with and historicized. Its aims are always recuperative, celebrating, and ennobling, as opposed to critical. There is not enough engagement with the messy intra-cultural complexities of the African American experience, especially if those realities undercut the mandate to recuperate. In short, there isn't enough introspection or self-criticality. And the kind of over-fixation on image maintenance, once advocated for by W. E. B. Du Bois (which was often viewed as elitist and out of touch), is still the prevailing ethos among many of the Black art intelligentsia. There are many who are offended by this assessment, a fact that, in itself, is a kind of tragedy—but it's an important critique to be made nonetheless. I have written before about African American satire, which isn't a popular genre because it deals with the American racial melodrama by utilizing self-deprecation as a political and polemical tool. I am hoping a discourse will emerge that takes this on more directly. Yet I was pleased to see that the brilliant art historian Richard Powell recently published a terrific book on Black satire in art and visual culture, and there have been recent book-length studies on African American satire by scholars Derek C. Maus and James J. Donahue.

In the place of more honest and diverse representations of Black people, a distinctly liberalist visual culture has emerged, which is defined by a kind of empathetic benevolence and sympathy for Black suffering. This has become a leitmotif of contemporary visual culture that creates a distinct set of tensions. We see this across the spectrum of the visual, but it has also come up in the critical response to recent visual art like in Arthur Jafa's *Love Is the Message, the Message Is Death* (2016), or in artist Richard Mosse's video installation *Incoming* (2014–17) for example. These works, while powerful and formally brilliant, speak to a cultural thirst for a kind of trauma porn that permeates the visual realm, especially within art, photography, photojournalism, film, and television. This is not to indict the artists as opportunistic or engaged in exploitative behavior—but rather to shed light on a culture industry that demands certain types of spectacles. Both artists are committed to shedding

light on injustice and exploitation, and they have found powerful visual means to do so, though we must still have an earnest conversation about what the totality of these expressions means, while also pondering their broader societal impacts. There are cameras constantly trained on the disenfranchised in the most demeaning and voyeuristically penetrating way. There is definitely a romance with the representational suffering of Black and Brown people that needs to be interrogated and discarded. This representational and image-making machine is justified as an empathetic gaze, as something that reveals humanity and dignity of the disenfranchised, but in actuality it tends to expose a kind of ideological deadlock, as well as a racialized spectacle that denies any real insight or possibility for reciprocity.

My point, simply, is that there are ideological barriers that block our ability to see ourselves honestly—so my aim in writing this book was to attempt to break through these strictures and model new interpretive possibilities.

ALB: *One point that you also make great use of is how much the positionality of condescension and/or defensiveness marks the intersecting actors and their narratives about race, sexuality, ethics, art, and so forth: Mapplethorpe is condescending to his models/lovers, critics are condescending to Mapplethorpe, critics are condescending to other critics, models and friends defend Mapplethorpe, Mapplethorpe defends his own vision, critics defend Mapplethorpe, critics defend the choices of the models/lovers.*

Yet here you are working against the archive; you have to basically clear out most of the "noise" of all the copious writings about Mapplethorpe to get to something you can use in terms of radical potential. Can you talk about tussling with the archive in this sense and returning to the object for grounding?

DCM: You ask a great question because I have a distrust of art historical archives. I think there is a distinction between an archive of art historical materials (something that needs explication, order, and legibility), versus an archive that has been organized and thoroughly codified around an artist's life and work—one that has successfully cemented a particularized historical framing and legacy. I am indeed very skeptical of the latter. Until very recently, the Mapplethorpe archive was problematically framed, but that is beginning to change, largely due to a series of major exhibitions and new critical interpretations. In general, I tend to battle with these types of archives, because of their omissions. Much of my skepticism is the result of having studied archives in great detail, only to encounter narratives and interpretations that willfully mischaracterize an artist's oeuvre to suit a specific agenda or worldview. I've arrived at the conclusion that, in many instances, we don't really understand the histories of art (and specific canonical artworks, in particular), especially in terms of iconography—due to the intentional obfuscation and disavowal of a range of cultural concerns and subjectivities. In many instances, societal attitudes have

impacted scholarly willingness to address, for example, the concerns of gender, race, and sexuality—which are so central to the lives and work of artists historically. The examples of this are too extensive to recount here, but a perfect exemplar is Andy Warhol, whose creative output for many decades was misread because of an unwillingness to honestly discuss his homosexuality. There was also a long-standing failure to acknowledge the diversity of his creative practice, beyond his interventions within the genre of painting. The films, the screen tests and performances, the photography, and so on (not to mention the boldness and performativity of his personal life) are so important to understanding his iconographic approach and the gravity of his cultural impacts.

Aside from the more conservative writing on Warhol, concerned primarily with his painting practice, recent scholarship has emerged characterizing the artist in more critical terms, as someone who was a celebrity sycophant, a lover of consumer capitalism, and a purveyor of lower-culture kitsch objects. But the subtext of these critiques was an unspoken engagement with his uniquely queer brand of campiness—which, in many instances, was used to chip away at the work's legitimacy as "high art." There are so many articles/essays written by esteemed critics and scholars that castigate the artist (and pop art in general) for the work's superficial realism, its engagement with low images, so to speak—or that, in its visual repetitions, exudes a technological brand of fascism.[5] There are inflammatory assessments, but, more importantly, they do not tap into what is most germane about Warhol's oeuvre.

There are so many preeminent art historians whose assessments continue to have a major impact on our understanding of art historical archives, genres, and legacies, and that need serious reevaluation. And with *Mapplethorpe and the Flower*, as you mentioned, in reading against the archive, I am bridging the gap between canonical framings that have defined artistic legacies, and the archives themselves—which often have much more to offer from an interpretive standpoint than we might have been led to believe. Over the years, I've had to unlearn the kinds of devotion and deference toward the ideas of preeminent thinkers, so I could actually locate the omissions, blind spots, and erasures that have, in many instances, led us astray. Throughout my graduate school years, I was often told that my critiques of key concepts by esteemed scholars breached some unwritten etiquette, as if I shouldn't even utter their names, unless my intention was to be appropriately reverential. These instances were humorous, though I imagine not unique when we attempt to make interventions within discourses, histories, or frameworks where canons have been erected. The history of art has become a theology in many ways, so it can be difficult to push through dogmas and reassess historical legacies.

Mapplethorpe and Warhol are two relatively contemporaneous examples, but if we look deeper into the histories of art, we will see that this interpretive challenge is extensive. When I teach pop art and Warhol, students are often surprised

that, from an art historical/critical standpoint, pop art was a contested genre, despite its contemporary popularity and branding. Yet we need to always interrogate and push against the types of analyses that inform the narratives that produce canons, because they often have significant blind spots or omissions that erase entire perspectives. This has become a major issue in my work because there are traditions in the criticism and historiography of art that take unwavering stances against the use of identity politics, Marxist approaches, and cultural theory—even though those very tools have effectively interrogated Western art discourse's colonialist, Eurocentric, and ethnocentric biases. Diverse opinions and contrasting critical framings are essential to debate, but when we examine both the archives and canons of art, there are predominating narratives that overdetermine our understanding of the past.

On many levels, my work is taking on an interpretive quandary, largely wrought by a vast range of misreadings, intentional omissions, and dubious critical framings. So ultimately, yes, I do believe we must read against archives, as well as return to the object, because there has always been a tendency among some scholars to use artworks to illustrate their own politics, aesthetic leanings, theoretical obsessions, and moral positions—as opposed to letting the works speak for themselves. With *Mapplethorpe and the Flower*, I attempted to do just that: to allow the photographs to lead the way, and to tap into their semiotic vulnerability.

ALB: *What I was not perhaps expecting from a book about Mapplethorpe, but was so eager to engage with, is your damning, brilliant, and frankly urgent critique of how our field has eagerly and cravenly participated in the narratives of "diversity" at the neoliberal university. [And to the reader who might not yet have Murray's book, it's not a throw-away line in the conclusion—it's a support beam throughout the book.] You argue that "the institutional rhetoric of diversity often functions as a politically correct means to disseminate the values of exclusion and management."*[6] *What made Mapplethorpe the best vehicle to engage the weaponry of "diversity" in the disciplinary, educational, and visual?*

DCM: The core disciplinary critique in *Mapplethorpe and the Flower* has found its way into everything I write these days that is art-historical and visual-culture oriented. It's an ever-evolving commitment that I imagine will always be present to some degree, especially when embarking on revisionist projects. The work is part of an ethical critique of liberal tolerance that is influenced by scholars Wendy Brown, Slavoj Žižek, Sara Ahmed, and others. In philosophy and cultural theory, there is beginning to be a more robust discussion on the contradictions of liberalism, which I believe is extremely pertinent to the arts. Diversity, specifically, has become a bureaucratized mandate that is often implemented in superficial ways institutionally. I think we're all familiar with the way diversity functions as a statement of values

(often derisively termed "virtue signaling"), meant to show an institutional commitment to vulnerable communities, or to the underrepresented. But even these forms of performativity tend to conceal deeper structural inequalities that often go unchallenged.

Diversity mandates often focus on cultural programming, but not equitable hiring. Or they may be evidenced in the creation of symposia, speaker series, exhibitions, while not addressing equity in promotion and salary, and so on. These types of institutional optics abound in moments of societal trauma, like in the aftermath of the George Floyd murder, and ensuing protests. Office doors became collages of politically correct statements, university chancellors and presidents send impassioned emails to the campus community, the homepages on department websites contain pro–Black Lives Matter statements. But despite these expressions (many of which are indeed sincere), there is simply a glaring contradiction between the vociferous statements of solidarity and continued institutional inaction regarding structural change. If one looks at campus demographics across the United States, they will surely encounter that African Americans make up too small a fraction of the community. For example, in my institution, African Americans make up roughly 2 percent of the campus community across the board, as compared to being just above 13 percent of the national population—so how should we reconcile these vigorous campus declarations against anti-Black racism, with an institutional culture that statistically does not model that commitment?

What I want to make clear is that a university's challenges in this area are not somehow disconnected from what happens within disciplines themselves—particularly within their methodologies and value systems. For example, the manner in which certain minoritized histories and discourses are situated within a department's hierarchies of importance is connected to the institutional values that house and support these departments. What I think is so incredibly important to acknowledge is that universities, disciplines, histories, and methods are intimately connected. As academics, we sit in meetings where departments prioritize their needs in terms of subject areas, but these decisions are not just departmental, disciplinary, or even divisional. They rely on institutional funding and support that have agendas and priorities as well. The interconnected dimension of institutional priorities is what often leads to departments hiring multiple faculty to cover Europe, or more traditional areas, but then refuse to hire in underserved areas like South Asian art, African American/African diaspora, queer visualities, or in contemporary Latinx, for example. If there are minority faculty present, they are most likely isolated or untenured and not able to speak freely. For underrepresented faculty (for lack of a better term), it is very clear how every dimension of the university bears down on their experience: financially, how it impacts career progression, in terms of community and collegiality, as well as the level of value placed not just on your presence within the institution but also on your scholarship.

Mapplethorpe is actually a perfect example of an artist whose work is known and recognized, and who has been studied, but ultimately cannot be fully understood if the value systems of art history demand that we elide certain things about him—or refuse a broader understanding of his life and work. A more inclusive application of art historical methodologies—and a little less deference to the canon—can yield a great deal of new knowledge and complex insights into both Mapplethorpe's work and what art history may strive toward.

All of the above considered, I do believe there is a slippage in the notion that there would be a contradiction between a disciplinary critique of diversity and the methodological employment of formal analysis in my work. But I also greatly appreciate that line of inquiry because it opens up a needed conversation. I think it's dangerous to ignore (or fail to see) the fact that institutional dynamics, and their value systems, inform historical narratives, canon formation, and the financial support given (or not given) particular areas of study. Institutions and departments can vary greatly; some being very progressive, while others are stuck in the 1950s—but overall, this remains a serious (but not insurmountable) disciplinary challenge.

In a way, I think you're also asking me about a tension between pain and pleasure in my methodological approach. The idea of expressing consternation about the omissions of art history grates against the forms of pleasure communicated in my engagement with formal analysis. There is a famous statement by the filmmaker Melvin Van Peebles that I've quoted several times in previous writings, where he suggests that the role of the Black cultural producer is to "show your pain. Show that the system has made you suffer."[7] But what if one hasn't suffered? What if your life has not been defined by suffering or struggle? Art history has always been a source of pleasure for me—but it was the economic and educational privilege of my youth that made this profession a viable option for me. Art history hasn't made me suffer; it's the discipline itself that suffers. My work is an effort to preserve the discipline I love from the total obsolescence and oblivion it's rapidly hurtling toward. As cynical as it sounds, it would appear that, for some art historians, obsolescence, while sad, is for them a better option than seeing it diversify. And that is a tragedy. As society changes, becomes more diverse, globalized, and dependent on new technologies, universities are responding by embracing corporate models and placing further emphasis on the STEM fields. As a result, art history programs are struggling to justify their existence and relevance to a changing world. Yet this lack of relevance is the result of a discipline that still has elements fighting tooth and nail to stay mired in its Eurocentric and colonialist roots—even despite the many progressive strides being made. Ultimately, I just don't think of myself as a beleaguered guest, or an angry outsider, who is struggling for recognition in an exclusionary discipline. Art history is as much mine as it is anyone else's—so I claim agency over it in terms of both my criticisms as well as the enjoyment I derive from its methods. I admit, there are many positive changes happening every day, so I feel positive about the future.

Alexis L. Boylan is the director of academic affairs of the University of Connecticut Humanities Institute (UCHI) and a professor with a joint appointment in the Art and Art History Department and the Africana Studies Institute. She is the author of *Visual Culture* (2020) and *Ashcan Art, Whiteness, and the Unspectacular Man* (2017).

Derek Conrad Murray is professor of history of art and visual culture at the University of California, Santa Cruz. He is the author of *Mapplethorpe and the Flower: Radical Sexuality and the Limits of Control* (2020) and *Queering Post-Black Art: Artists Transforming African-American Identity after Civil Rights* (2016).

Notes

1. Glissant, *The Poetics of Relation*, 189–94.
2. Peck, *I Am Not Your Negro*.
3. Murray, *Mapplethorpe and the Flower*, 2.
4. Murray, *Mapplethorpe and the Flower*, 21.
5. Kuspit, "Pop Art." 38.
6. Murray, *Mapplethorpe and the Flower*, 11.
7. Melvin Van Peebles. Quote from the documentary *How to Eat Your Watermelon in White Company (and Enjoy It)*.

References

Angelo, Joe, dir. *How to Eat Your Watermelon in White Company (and Enjoy It)*. Breakfast at Noho LLC, 2005, 86 min.

Glissant, Édouard. *The Poetics of Relation*. Ann Arbor: University of Michigan Press, 1997.

Kuspit, Donald J. "Pop Art: A Reactionary Realism." *Art Journal* 36 (Autumn 1976): 31–38.

Murray, Derek Conrad. *Mapplethorpe and the Flower: Radical Sexuality and the Limits of Control*. London: Bloomsbury, 2020.

Peck, Raoul, dir. *I Am Not Your Negro*. New York: Magnolia Pictures. 2016.

Carol Leigh, a.k.a. Scarlot Harlot

Carol Leigh

The term *whore gaze* was recently coined by PJ Starr and Sonyka Francis to center the point of view of sex workers, whose perspectives had been and continue to be censored, excluded, and criminalized.[1] The focus on the experiential context of the whore launched a new chapter in political art in the late 1960s and mid-1970s. I am most known for my part in developing the new identity at the center of this politic, coining the term *sex work*.[2] When I started doing sex work and creating art from this perspective, the shape of my work became instantly clear, as I reflected on how sex work would impact my art and life. Centered around prostitution, my life-art project has come to embody an archive of the "whore gaze."

My background as a flower child, red-diaper baby, and devoted feminist shaped my contribution to the whore genre. As a Jewish daughter of the Holocaust generation, I was surrounded by my generation's urgency to shape a new world. This seemed like the next logical step for a born leftist, Vietnam War protester, and hippie. I have met quite a few Jewish intellectual red-diaper babies who also grew up to become rebel prostitutes.

This story documents the varied series of archives I have since developed, contained within the Sex Worker Media Library, originally collaborating with the Center for Sex and Culture, with funding provided by the Creative Work Fund in 2006.[3] This introduction touches on my own relationship to sex worker activism, as well as cultural and political contexts, movements from the feminist sex wars to queer movements, and AIDS and anti-trafficking activism. The representations

Radical History Review

Issue 142 (January 2022) DOI 10.1215/01636545-9397159

© 2022 by MARHO: The Radical Historians' Organization, Inc.

included here are based on this experiential politic, documenting pivotal moments in the development of this *whore genre*.

Feminism was my first devotion, with my primary focus on sexual politics and sex. Looking back, I was an essentialist feminist, attaching myself to "the rise of the female principle." My feminist cohorts introduced me to women as goddesses via Merlin Stone.[4] It was natural that I would become a supplicant of the whore archetype.

A few contradictions launched my sensitivity to sexual stigmatization. My family spoke openly about sexuality, emphasizing the realities of sexual diversity, so I was empowered to be resolute regarding my sexual choices. There was one restriction, however. I could only date boys who were Jewish—and there were almost no Jewish boys in Oakdale! Also, I identified as bisexual since puberty, which made me a renegade among feminists, both lesbians and straight women. Straight women rejected me politically, regarding me as an embarrassment. Lesbians rejected my romantic overtures, wary that I was fucking men.

As a young person I was frustrated, and I never felt that I would find my way. I lived on the edge financially, in an underground community, selling pot, etc. I wasn't looking toward sex work as a solution to my artistic frustrations. I just needed money and didn't want to be a cog in the capitalist machine.

I started doing sex work in the late 1970s. After my first day at the massage parlor, I remember riding home on the BART underground and staring at my reflection in the dark glass. I thought, "Now there's a prostitute." I realized that I was the same person, and that there was no real line between the prostitute and other women (this was when gender was understood as polarized, and my politics reflected that). I understood that this separation was a way to institutionalize divisions, but it took quite some time before I understood the diversity of whore experiences. Existing on the front lines and at intersections of class, race, gender, and economic oppressions, this position offers some wisdom.

Prostitutes' rights leaders were, most often, artists and primarily informed by labor, feminist, LGBT, civil rights, and anti-war political histories. My interests quickly turned from sexuality in general to the criminalization of prostitutes/whores who, I came to understand, were constructed and targeted based on gender, race, immigration status, and poverty.

My older siblings were pro-sex feminists like Gayle Rubin, Patrick Califia, and others exploring sexual representation (porn) and sexual power exchange practices (S&M). From my recollections, prostitutes' rights advocates seemed somewhat marginalized in the free speech wing of the women's movement. Prostitution politics were obscured by the focus on pornography. From my observations, attention to prostitution issues within feminism expanded late in the sex wars, in the late 1980s after the general failure of the anti-porn ordinance campaigns in the United States. By the mid-1980s, Katheen Barry's analysis on the sexual exploitation of women was attracting a growing international audience.[5]

The year 1992 marked a turning trend in the feminist sex wars. Catharine MacKinnon, faculty member at the University of Michigan law school, was involved in the censorship of Carol Jacobsen's art exhibit at a conference at the University of Michigan. *Porn' im'age'ry* included a display of found objects, a photographic exhibit, and a video installation with my work *Outlaw Poverty, Not Prostitutes*, among several others.[6] The American Civil Liberties Union's Marjorie Heinz took the case and eventually our exhibit was reinstated as part of a settlement with the university.[7]

Tracing back the positions of sex workers within the sex wars, in the early 1980s my prostitute friends were in a different universe than the erotic performers or S&M practitioners/advocates. COYOTE (Call Off Your Old Tired Ethics) even had a contingent in the 1978 Take Back the Night March in San Francisco, which aimed to address violence against women, but it had a history of anti-porn advocacy and a lack of inclusion of sex workers. In 1978 Take Back the Night marched through North Beach, San Francisco's red-light district. Some feminists carried signs condemning the performers who stood outside the clubs as targets of this invasion. A decade later my video, *Sex Workers Take Back the Night* (1990), chronicled the clashes between anti-porn feminists and sex workers, allied with pro-sex feminists.[8] Ultimately, many of us embraced an identification as "sex radical feminists."

Sex worker is a label for the political aspect of the whore. Inspired by Robin Lakoff, I created a term that would unite broad sectors of commercial sex, performers, and prostitutes.[9] In the late 1970s and early 1980s I produced a solo theatrical play, *The Adventures of Scarlot Harlot*, eventually featured at the National Festival of Women's Theater. Negotiating stigma, using the term *sex worker*, was the centerpiece of the play. Scarlot Harlot enters with a paper bag on her head, lifts the bag, and proclaims, "Sex Workers Unite! . . . We won't remain anonymous!" As she proceeds on her journey of self-revelation, she confronts and conquers stigma.

The issue of sex worker rights also thrust me into a world of other artists who were proclaiming various sexual and other renegade rights and identities: transgender, queer, drug users, anarchists, artists, and more. I was inspired by like-minded collaborators, including cannabis activists; the Sisters of Perpetual Indulgence, Unincorporated; Sadie, Sadie the Rabbi Lady; ACT UP (AIDS Coalition to Unleash Power); Annie Sprinkle; and Jovelyn Richards. The images here capture glimpses of my street performances, dressed in costumes designed by Gilbert Baker, who established the Rainbow Flag as a symbol for queer communities. My "billboard" purses were designed by Dee Dee Russell-Lefrak, also a collaborator in performance art. The archive also includes event posters, as well as photos of perfume, stickers, T-shirts, and other entertaining items that I designed and distributed while I educated the world about sex worker rights.

My work as a performance artist provides the most visual representations of my progress, but my attention was drawn equally to political action, organizing, and community building as founding member and sometimes leader of numerous

organizations and projects such as SWOP (Sex Workers Outreach Project) USA, BAYSWAN (Bay Area Sex Worker Advocacy Network), and many more. My work on the San Francisco Board of Supervisors Prostitution Task Force led me to invitations to consult, where I often also performed, in Taiwan, Italy, Hungary, Hong Kong, Brussels, Canada, and more.

In the midst of this work, I began acquiring a wide range of technical skills for video production. As a community-centered political figure, I was afforded unusual access within many contexts. I documented everything, from international conferences to personal interviews, to parties and events addressing concerns within queer communities. This resulted in hundreds of hours of video of sex worker demonstrations, interviews, and conferences from around the world.

The sex worker movement has struggled to center those who are most impacted by criminalization, violence, racism, migration laws, gender, and economic discrimination. At home in the 1990s my priority became to recognize and work with diverse sex workers, seeking community and learning how to empower and support sex workers who were not represented in current sex worker movements. The San Francisco Bay Area Sex Worker Film and Arts Festival was a vehicle through which our production team (myself, Laure McElroy, and Erica Fabulous) collected and screened movies addressing sex work from around the world, bringing these diverse representations to the San Francisco Bay Area.[10] We produced week-long events with workshops, performances, political actions, and art shows for twenty years.

The sex worker rights movement grew from a few small communities to a huge international movement, with many hundreds of thousands of self-identified and organized sex workers—movements with common goals based on a recognition of labor rights of sex workers and using the term *sex work* in multitudes of languages. As the decades passed, it became clear to me that this life-art path would necessarily entail assembling collections and libraries of this movement. This also necessitated the development of specific ethics and methodologies to access what had historically been forbidden (and criminalized) communication.

The Sex Worker Media Library archives originally comprised my documentation of international sex worker cultures, local queer politics, and AIDS activism.[11] The access is through a location-based, pathfinder-based delivery system, prepared for scholars, students, sex workers, and other activists. The Sex Worker Media Library has since expanded to include two additional libraries: videos by sex workers around the world in tandem with the San Francisco Bay Area Sex Worker Film and Arts Festival and *Collateral Damage: Sex Workers and the Anti-Trafficking Campaigns*.

My most recent video work has focused on the impact and histories of US anti-trafficking campaigns and policies on sex workers internationally. *Collateral Damage* is a teaching tool, presenting a range of short lessons on trafficking from sex worker rights perspectives as well as a library of mainstream media

representations.[12] This work reflects a cross-section of issues that have informed the sex worker movement, framed by the cyclical public discourse on women's vulnerability and the white savior complex.

Efforts to archive sex workers and related issues are taking root and burgeoning within our international communities. The archives that I have assembled are only a portion of these efforts. They are part of a shift in our collective vision as we include, respect, and center the whore gaze.

Carol Leigh has been a writer, performer, video maker, and sex worker activist since the late seventies when she coined the term *sex work* (www.bayswan.org/sexwork-oed.html). Leigh's activism spans decades, as a COYOTE member, an original member of AIDS Action Pledge (ACT UP in the SF Bay Area), SWOP (Sex Workers Outreach Project), co-founder of BAYSWAN (Bay Area Sex Worker Advocacy Network) and the San Francisco Sex Worker Film and Arts Festival (sexworkerfest.com), which just passed its twentieth anniversary. Leigh was lead writer for the San Francisco Board of Supervisor's Task Force on Prostitution (1994–96). In addition to multiple ongoing activist projects, for several years she has been focusing on an educational video resource, *Collateral Damage: Sex Workers and the Anti-Trafficking Campaigns*, www.sexworkermedialibrary.org/CollateralDamage.

Notes

1. Starr and Francis, "'I Need $5 Million.'" Evolving from a history of cinematic criticism, this term also applies to broader sex worker cultural representations. "The term whore is used to flag the transgressive nature of the creative pursuits . . . ," 585.
2. NSWP, "Carol Leigh Coins the Term 'Sex Work.'"
3. Leigh, "About: Sex Worker Digital Library"; and Phillips, "Carol Leigh."
4. Stone, *When God Was a Woman*.
5. Barry, *Female Sexual Slavery*.
6. Leigh, *Outlaw Poverty, Not Prostitutes*.
7. Jacobsen, "Who's Afraid."
8. Leigh, *Sex Workers Take Back the Night*.
9. Lakoff, *Language and Woman's Place*.
10. Leigh, Sex Worker Film and Arts Festival Movies. This festival was launched in 1999.
11. Juhasz, *Compulsive Practice*. *Compulsive Practice* contextualizes my documentation of ACT UP and COYOTE's resistance to the mandatory HIV testing and quarantine of prostitutes.
12. Leigh, *Collateral Damage*.

References

Barry, Kathleen. *Female Sexual Slavery*. New York: New York University Press, 1984.

Jacobsen, Carol. "Who's Afraid of the Big, Bad Sex Workers?" *Exposure* 29 (1995): 14–26. bayswan.org/article_archive/BigBad.pdf.

Juhasz, Alex, producer. *Compulsive Practice*, 2016. http://visualaids.org/events/detail/day -without-art-2016-compulsive-practice (accessed April 1, 2021).

Lakoff, Robin T. *Language and Woman's Place*. New York: Harper & Row, 1975.

Leigh, Carol. "About: Sex Worker Digital Library Preserves History of a Movement." Sex Worker Media Library, Center for Sex and Culture, December 24, 2010. www .sexworkermedialibrary.org/.

Leigh, Carol, dir. *Collateral Damage: Sex Workers and the Anti-Trafficking Campaigns*. Center for Sex and Culture, July 22, 2014. sexworkermedialibrary.org/CollateralDamage/.

Leigh, Carol. *Outlaw Poverty, Not Prostitutes*. Vimeo video, 21:20. vimeo.com/89320800 (accessed April 1, 2021).

Leigh, Carol. Sex Worker Film and Arts Festival Movies. Archives. www.sexworkerfest.com /videos/ (accessed April 1, 2021).

Leigh, Carol. *Sex Workers Take Back the Night 1990 by Scarlot Harlot*. Vimeo video, 30:24. April 1, 2021. vimeo.com/81459961.

NSWP (Network of Sex Work Projects). "Carol Leigh Coins the Term 'Sex Work.'" www.nswp .org/search?site_search=Carol+Leigh+Coins+the+Term+ (accessed April 1, 2021).

Phillips, Frances. "Carol Leigh and the Center for Sex and Culture." Creative Work Fund, May 15, 2015. creativeworkfund.org/?portfolio=carol-leigh-and-the-center-for-sex-and-culture.

Starr, PJ, and Sonyka Francis. "'I Need $5 Million': What Sex Workers Making Media Tell You That No One Else Can." In *Routledge International Handbook of Sex Industry Research*, vol. 1, edited by Susan Dewey, Isabel Crowhurst, and Chimaraoke Izugbara, 584–97. New York: Routledge, 2018.

Stone, Merlin. *When God Was a Woman*. New York: Harcourt Brace Jovanovich, 1978.

CURATED SPACES provides a focus on visual culture in relation to social, historical, or political subject matter.

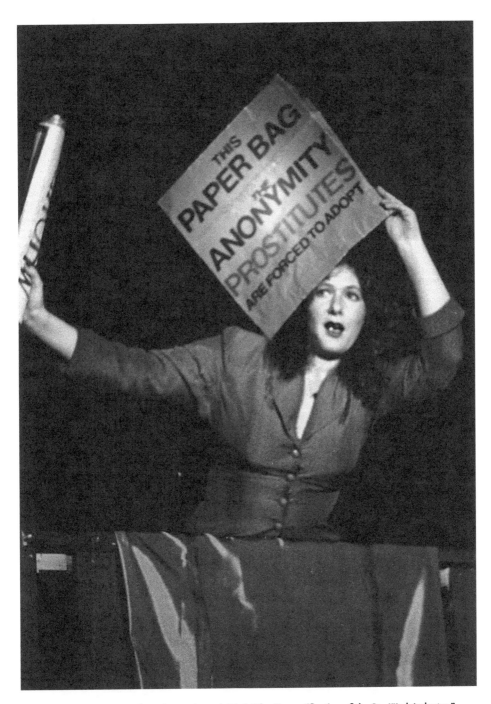

Figure 1. *The Adventures of Scarlot Harlot*, subtitled "The Demystification of the Sex-Work Industry," launched the term *sex worker*, as Scarlot emerges with a paper bag on her head that reads: "This paper bag symbolizes the anonymity prostitutes are forced to adopt!" She casts off the bag and proclaims, "Sex Workers Unite! . . . It is an outrage that there are laws in this country which deny a woman's right to receive payment for sexual services." National Festival of Women's Theater, Santa Cruz, CA. Photo by Charles Kennard (1983).

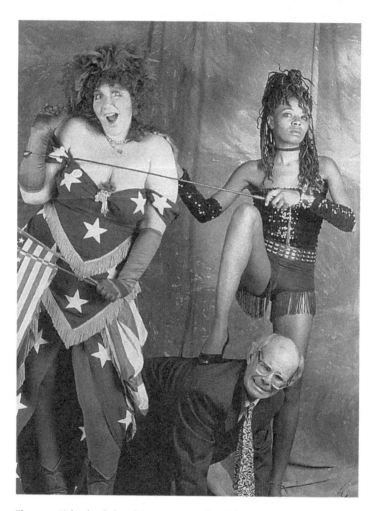

Figure 2. Richard Lefrak and Dee Dee Russell-Lefrak presented this
multimedia odyssey staged by and starring Dee Dee Russell-Lefrak and
featuring Scarlot Harlot in *Jesse Helms' Nasty Ass Nieces*. Helms (Stoney
Burke) is forced to confront his familial deviance, enduring punishment for his
anti-obscenity regulations for National Endowment for the Arts (NEA) funding.
Helms's NEA regulations prohibited NEA funding, thereby censoring art
considered homoerotic, obscene, or depicting S&M or sex acts. Performed on
May 3, 1990. Photo by Laura Wagner (1990).

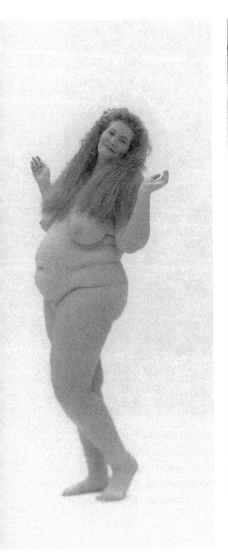

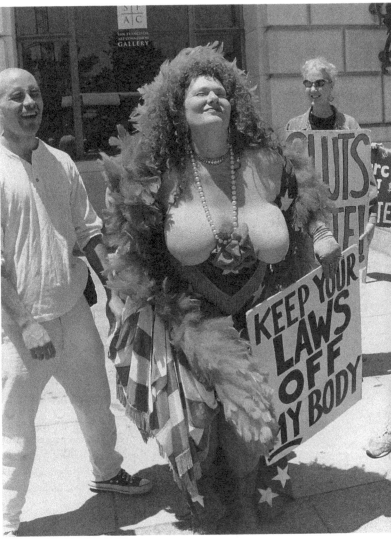

Figure 3. Photographer Michele Clement presents Scarlot Harlot in unabashed fat nakedness. Photo courtesy of Michele Clement (2000).

Figure 4. In front of San Francisco's City Hall/War Memorial on June 9, 1996, sex workers unite to protest "bashings, police abuse, and restricted civil rights" in an action titled *69* with Vic St. Blaise, Laura Anderson, and Scarlot Harlot. "No, it's not the pre-Stonewall gay community," the flyer states. "It's today's sex industry. Take a stand for adult consensual sexual transactions." Photo by Kerri Lemoie, courtesy of the *Spectator Magazine* (1996).

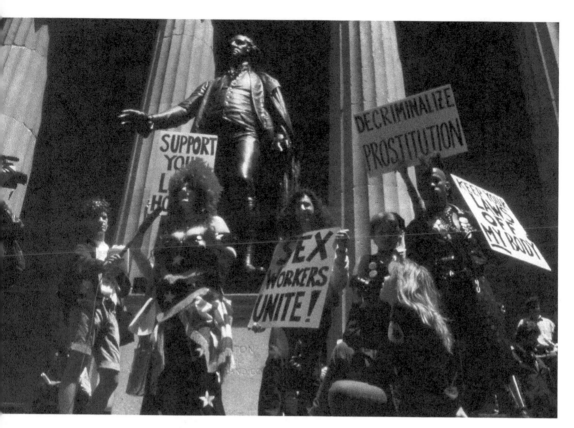

Figure 5. On May 24, 1990, Scarlot performed the Interstate Solicitation Tour at the New York Stock Exchange. Scarlot committed civil disobedience, soliciting crowds of spectators as she offered various sex acts at very reasonable prices (a misdemeanor in most states, including New York). "$50 for a hand job, with a condom, and I leave my clothes on." Members of ACT UP, PONY (Prostitutes of New York), and others joined in this street theater protest of prostitution criminalization. Photo courtesy of Annie Sprinkle (1990).

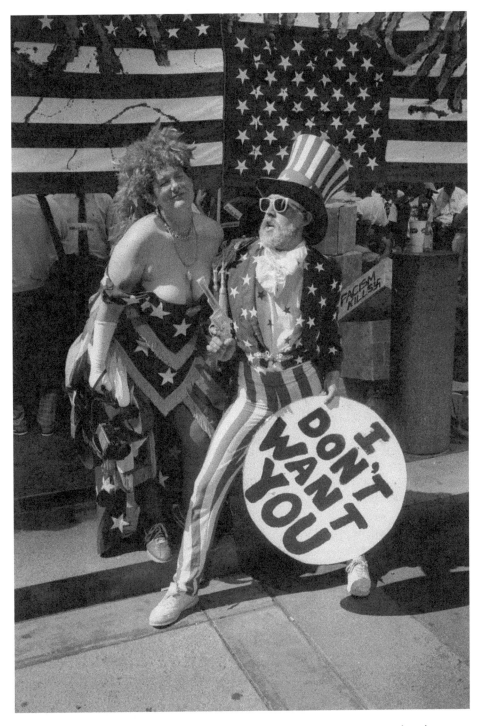

Figure 6. *I Don't Want You*, Gilbert Baker aka "the Betsy Ross of the Gay Community" and Scarlot Harlot in a sexy satire of US attitudes, protesting US Immigration restrictions against people living with HIV/AIDS during the Sixth International AIDS Conference in San Francisco. Photo courtesy of Jake Peters (1990).

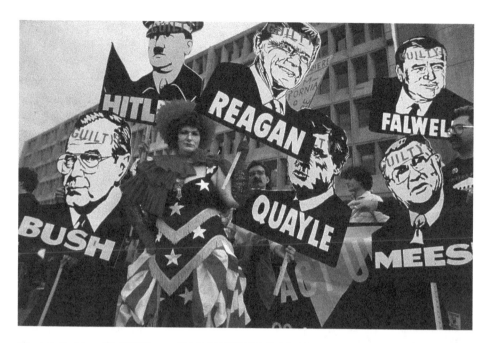

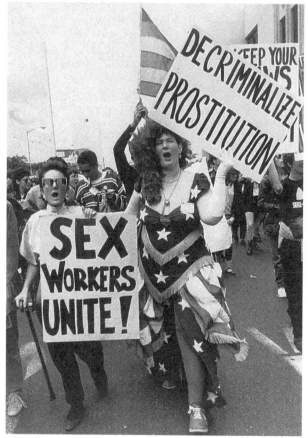

Figure 7. (top) In 1988, ACT UP converged on Washington, DC, in the first large-scale national AIDS action at the Food and Drug Administration headquarters, protesting the indifferent federal response to the AIDS crisis. Photo by Marc Geller (1988).

Figure 8. (right) *Who's Afraid of the Big, Bad Sex Workers?* From the pivotal *Porn'im'age'ry* exhibit. In Carol Jacobsen, *Exposure*, vol. 29 (1995). Prostitutes and supporters march in protest during the Sixth International AIDS conference in San Francisco. Photo by Leon Mostovoy (1990).

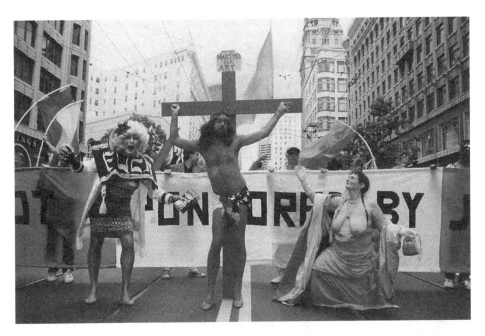

Figure 9. Gilbert Baker as Pink Jesus flanked by Scarlot Harlot and Sister Sadie, Sadie, the Rabbi Lady. San Francisco International Lesbian and Gay Freedom Day Parade, 1990. Photo by Robert Pruzan; Robert Pruzan Papers (1998), courtesy of Gay, Lesbian, Bisexual, Transgender Historical Society (1990).

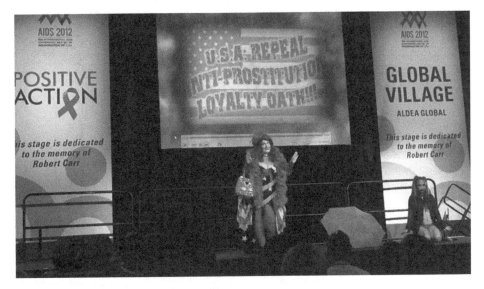

Figure 10. PJ Starr documents Scarlot joined by Mariko Passion, performing "Bad Laws" to the tune of Donna Summers's "Bad Girls" at the 2012 International Aids Conference in Washington, DC. "See them doing it in broad daylight. Hoping they don't catch the latest blight. They don't get laid 'cause their butts are too tight, and so they make it a crime." Photo by PJ Starr (2012).

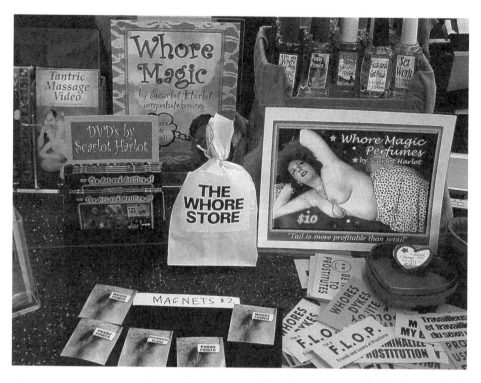

Figure 11. (top) *The Whore Store.* Whore artifacts, T-shirts, perfumes, pussy magnets, and other whore chachka. Photo by Carol Leigh (2005).

Figure 12. (right) *Unrepentant Whore, Collected Works of Scarlot Harlot*, published by Last Gasp, 2004. Photo by Merwelene van der Merwe, cover design by Katharine Gates, image colorization by Carol Leigh. Courtesy of Carol Leigh (2004).

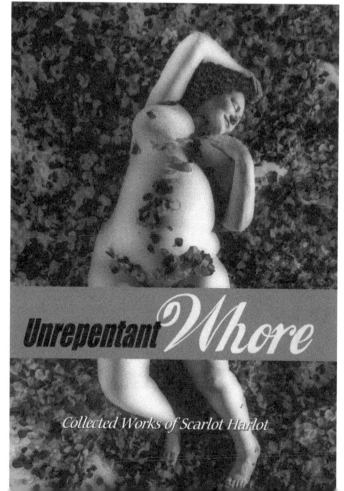

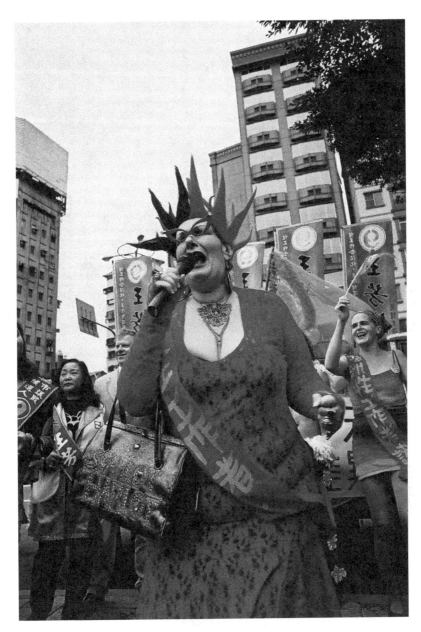

Figure 13. Leigh sings "Bad Laws" at the International Sex Workers Cultural Festival. Sex worker artists from around the world hopped in the back of a truck and toured various commercial districts, as COSWAS explained, "bringing awareness of the plight of sex workers to Taipei's middle class." Photo courtesy of COSWAS (Collective of Sex Workers and Supporters, Taiwan) (2001).

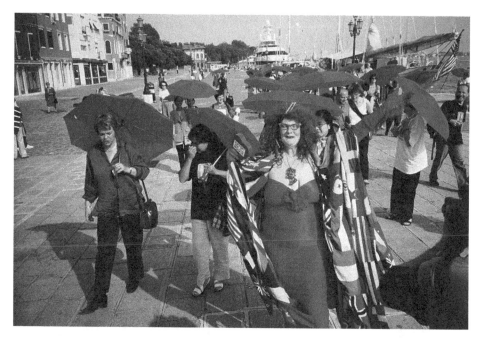

Figure 14. Tadej Pogačar's *CODE:RED* at the Venice Biennale in 2001, with the World Congress of Sex Workers, launched the original Red Umbrellas March. As a result, in 2005 the International Committee on the Rights of Sex Workers in Europe proclaimed the Red Umbrella as a symbol of revolt and collective struggle against stigmatization of sex workers and for the promotion of their basic human rights. Photo by Dejan Habicht; courtesy of Tadej Pogačar (2001).

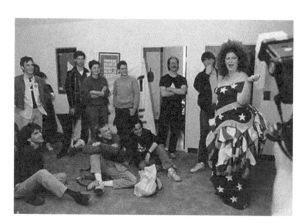

Figure 15. Entertaining the troops— ACT UP lobbies Senator Alan Cranston. Photo courtesy of Rick Gerharter (1990).

Keep up to date on new scholarship

Issue alerts are a great way to stay current on all the cutting-edge scholarship from your favorite Duke University Press journals. This free service delivers tables of contents directly to your inbox, informing you of the latest groundbreaking work as soon as it is published.

To sign up for issue alerts:

1. Visit **dukeu.press/register** and register for an account. You do not need to provide a customer number.

2. After registering, visit **dukeu.press/alerts**.

3. Go to "Latest Issue Alerts" and click on "Add Alerts."

4. Select as many publications as you would like from the pop-up window and click "Add Alerts."

read.dukeupress.edu/journals